Realities

RONALD
VENTURA

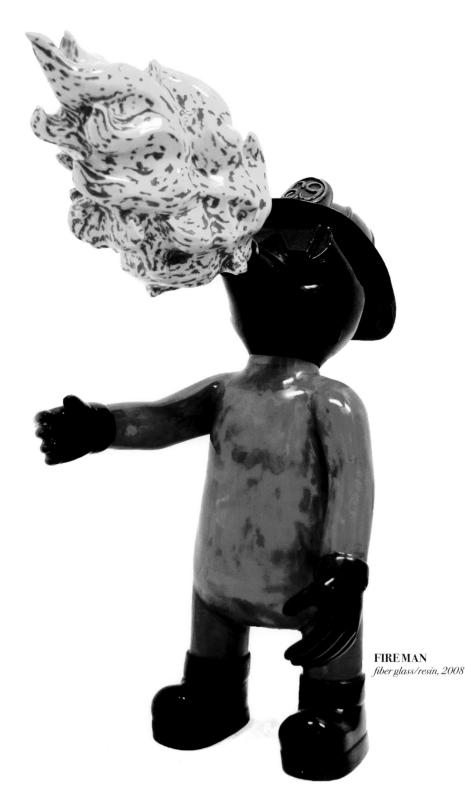

Realities

RONALD
VENTURA

© Damiani 2011
© The Authors for the Texts
© Ronald Ventura for the Artworks

DAMIANI

Damiani editore
via Zanardi, 376
40131 Bologna, Italy
t. +39 051 63 56 811
f. +39 051 63 47 188
info@damianieditore.it
www.damianieditore.com

Printed in August 2011 by Grafiche Damiani, Bologna, Italy.

ISBN 978-88-6208-177-1

FIRE MAN
fiber glass/resin, 2008

contents

FOREWORD *7*
Primo Giovanni Marella

Morphisms
Adjani Arumpac
11

Human study and the politics of gender
Alice G. Guillermo
33

Creative storyteller live from the global world
Daniela Palazzoli
75

A TRIP DOWN RONALD VENTURA'S *hyperrealist highway*
Igan D' Bayan
105

Grayness series
Adjani Arumpac
123

Fragmented Channels
Ramon E.S. Lerma
139

ARTIST CV *168*

ACKNOWLEDGEMENTS *171*

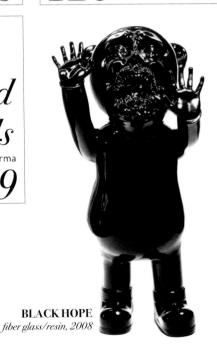

BLACK HOPE
fiber glass/resin, 2008

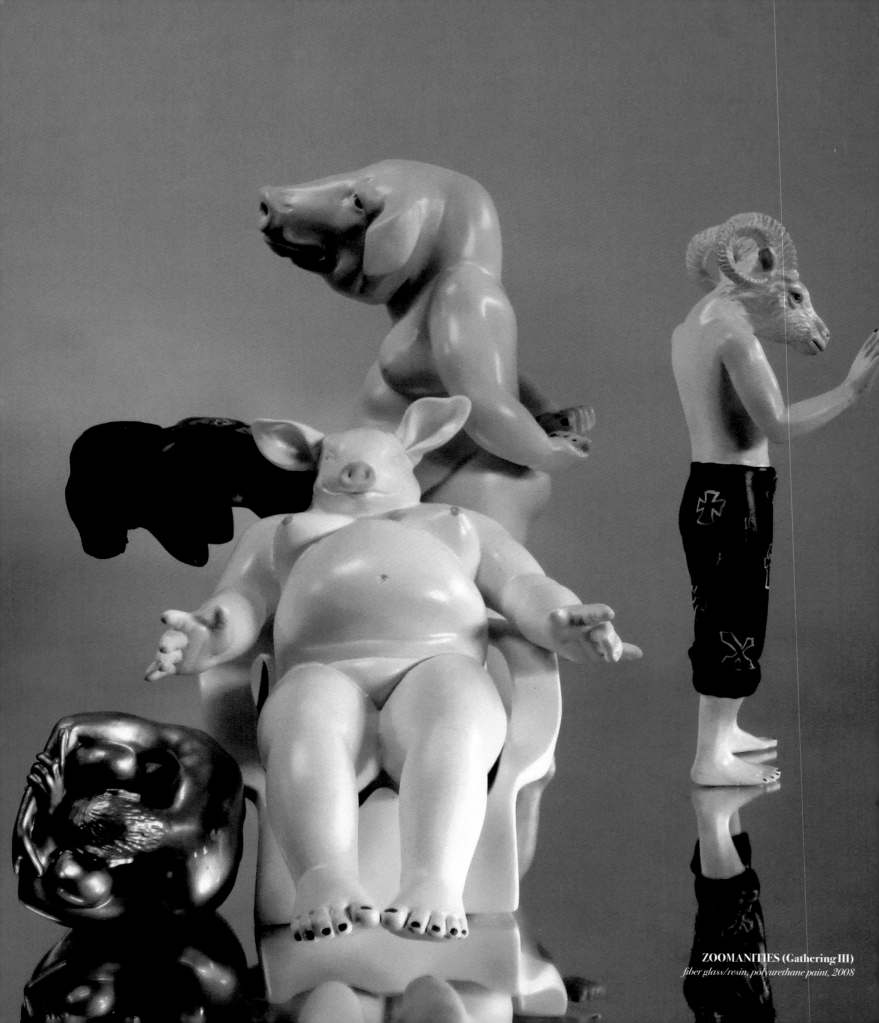

ZOOMANITIES (Gathering III)
fiber glass/resin, polyurethane paint, 2008

foreword

Primo Giovanni Marella

ZOOMANITIES (series)
fiber glass/resin, 2008

After several years of collaboration with Ronald Ventura and thanks to Damiani publishing house we have successfully managed to launch the first monograph on the Filipino artist illustrating the pivotal moments of his artistic career.

In the recent years Ventura was participating to key events in Asia and his works have obtained extraordinary results at Asian auctions; those facts made him recognized internationally as one of the most acclaimed artists from South-East Asia.

His artworks feature multilayering of images and his language spams from Leonardo to Dürer, from Lonely Tunes to Walt Disney, from Iperrealism to Classical art, up to Symbolism and pop.

This stratification becomes a metaphor for Filipino identity. An identity built over time and imbued with several cultures other than the local one.

Through his imaginative universe Ventura epitomizes a sensual "pastiche" of western and eastern world, a rich blend of past and future.

Ronald Ventura is an expert connoisseur of human nature and when he describes it he overcomes the strictly local episodes achieving a touch of global culture.

Ventura's artistic research becomes then a way to portray historical identity. It mirrors the cultural legacy poured down in everybody's DNA.

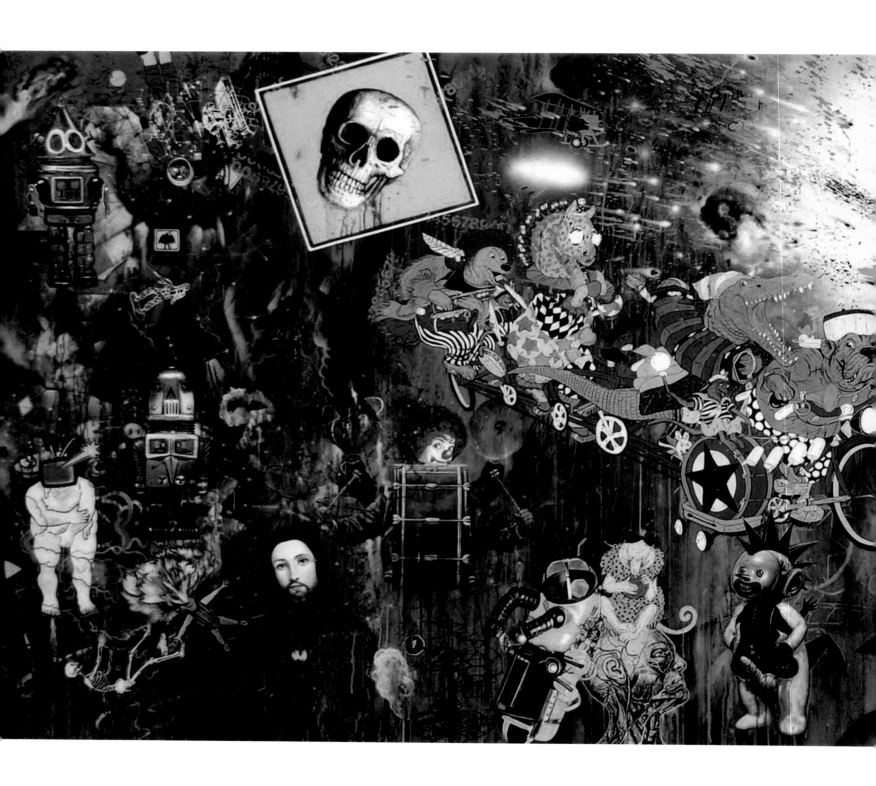

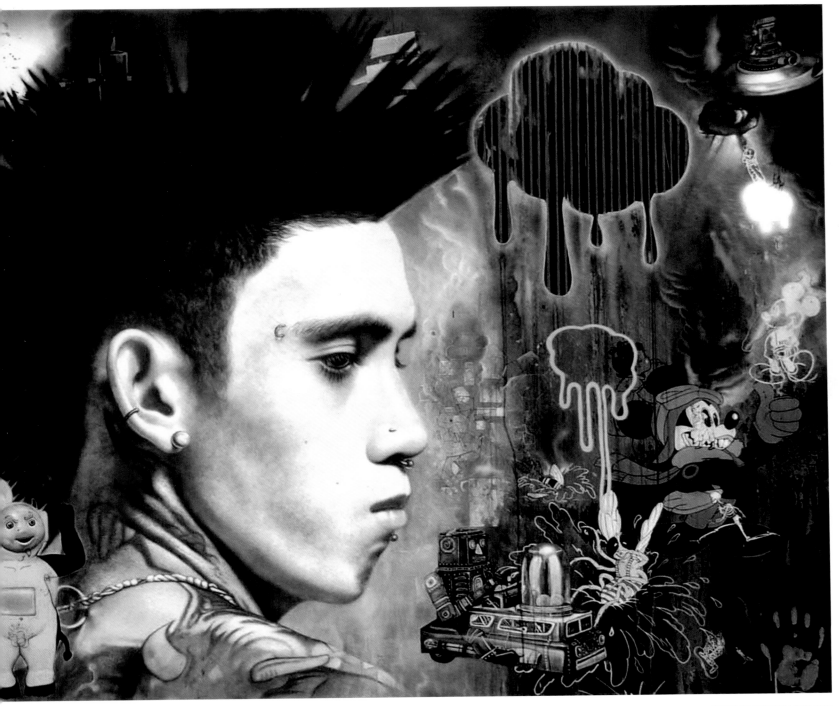

UNDER THE RAINBOW
152x365cm
oil on canvas, 2007

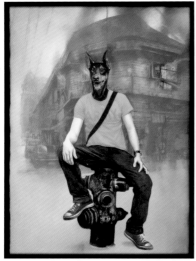

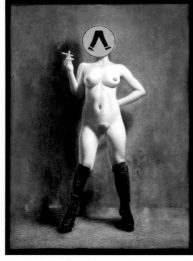

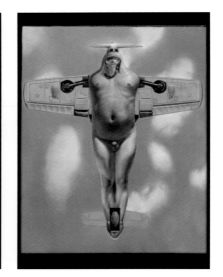

HEAT
91 x 61 cm
oil on canvas,
2006

NIGHT WALK
122 x 91 cm
oil on canvas,
2006

MEMORY OF FLIGHT
152 x 122 cm
oil on canvas,
2006

PENITENT CROSSING
152 x 122 cm
oil on canvas, 2006

Morphisms
Adjani Arumpac

11

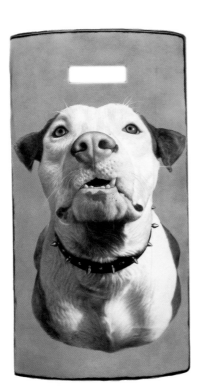

SHIELD
oil on riot shield, 2006

"What man has to do in order to transcend the animal, to transcend the mechanical within himself... is often anguish." Haraway

It was probably midday. A child was playing by a roadside canal. Dirty water swirling through, perhaps, a stick he was dipping. He was wondering how deep the water was, how deep until the stick refuses to dig in. And then a chide. His grandmother, perhaps taking a siesta in the veranda, telling him off, prodding him to play somewhere else cleaner, more appropriate. Ronald Ventura vaguely remembers this transgression or the logic behind it. It is probably this sense of violation wherein he sources his persistence, recreating indiscretions, albeit in different forms and feelings, in his various projects featuring figures often deemed as monstrosities, seeking the rationale behind a shame unfounded.

Ventura's penchant for fusing human and animals, and flesh and machine is a two-fold exploration of a dying and an emergent culture. Before the three-century colonization by the Catholic missionaries from Spain, Filipinos worshipped a pantheon of nature gods and spirits. The body was a fluid medium that could be inhabited and transformed by the gods. The arrival of the Church froze the body as a repentant sinner, bringing flesh down "to the level of the organism"[1] through ceaseless confession. It is within this context that Ventura is aware of his transgression, creating blasphemous fusions of human and non-human.

1 Foucault, M. (1990/1978/1976). The History of Sexuality: Volume 1, An Introduction. (Translated from the French by Robert Hurley.) Vintage Books, New York. p.117

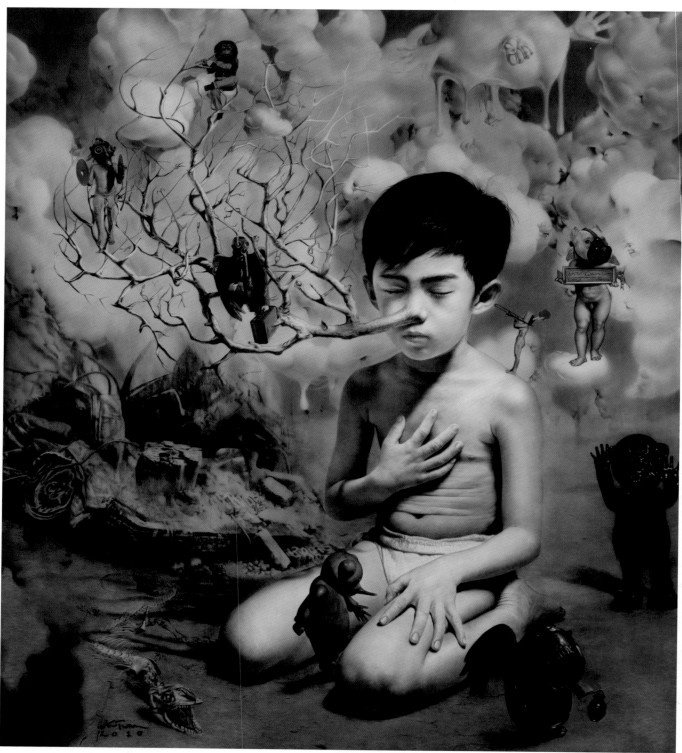

NATURAL LIES
244 x 213.5 cm
oil on canvas, 2010

The artist's trangressions are not eccentricities but symptoms of the contemporary condition

But the simplistic notion of blaspheming does not suffice. The three hundred years of Hispanic colonial rule ended with the coming of the United States imperialism, whose reign continues today through neocolonial policies. Currently, more than half of the Philippine population survive on below-the-minimum wages, all the while being bombarded by dreams of becoming offered by multinational communicational networks that permeate the country's skyline.

Ventura is located here—a decaying space with dissolving borders, wherein, ironically, bodies remain bound by social practices and conditions. From this perspective, the artist's trangressions are not eccentricities but symptoms of the contemporary condition. He is seeing through the halting transformation. He is squinting through the blur that was the landscape, now "no longer experienced intensively, discretely but evanescently, impressionistically—panoramically, in fact."[2] He is squinting through that blur and he has is seeing disembodied bodies.

Ventura takes on the posthuman emergent ontology, locating humanness in the vast so-called postmodern wilderness by grabbing bodies out of the flux to represent what he has seen: humanimals and cyborgs—struggling humans being rewritten, wandering while transforming in ways that mankind has explicitly dreamed of, whilst surrounded by a space that itself is mutating. Humans who live within this monstrous expanse could not keep up with its evolution, hence a fragmentation.[3] Ventura picks up these fragments and fuses them to form his third world pastiche. The artist's posthumans tell a story of co-optation, co-evolution and compromise that has eventually led to an interconnection between and among separate entities, ironically reinforcing and reaffirming the meaning of the surviving human at its core. Ventura's animals are those that have been reduced and isolated

2 Schivelsbuch, W. (1986) The Railway Journey. The Industrialization of Time and Space in the 19th Century, University of California Press, Berkeley. p.198
3 Jameson, F. (1991) Postmodernism, of the Cultural Logic of Late Capitalism, Verso, London.

14

humanimal

to "productive and consuming units."[4] The same process of reduction have been applied on humans, as "nearly all modern techniques of social conditioning were first established with animal experiments."[5] Both rendered without power, man and beast are intrinsically one, as explored by Ventura's two-dimensional works, as well as his sculptures in "Zoomanities" (2008).

Installed on the gallery walls are his trademark flawless bodies rendered hyperreallistically in graphite on paper. "Ikinakambal (Paired)" features two males with arms linked together. Behind these humans, grasping their limbs, are fowls. The birds' feathers have distractingly covered one man's face and the other's arm and torso. As if the men and the fowls have fused together. In similar fashions, "Ibinabalik (Returned)" features a bodybuilding ape in between a human skeleton and an ape skeleton; while "Inseparable" is a diptych juxtaposing the symbol of the rabbit/bunny against a sultry pinup beauty.

On the floor, is a throng of anthropomorphized sculptures made of fiberglass, resin, plastic, metal, silver, and bronze. These are the monsters that have increasingly populated his somber monochromatic 2-dimensional works, done in Japanese superflat aesthetics.

4 John Berger, "Vanishing Animals," New Society. 31 Mar. 1977: p.864.
5 Ibid.

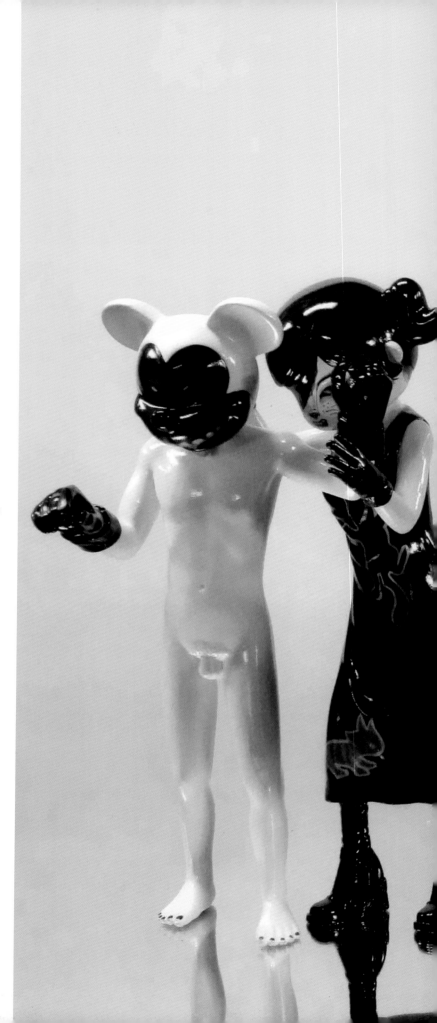

ZOOMANITIES (Gathering II)
fiber glass/resin, polyurethane paint, 2008

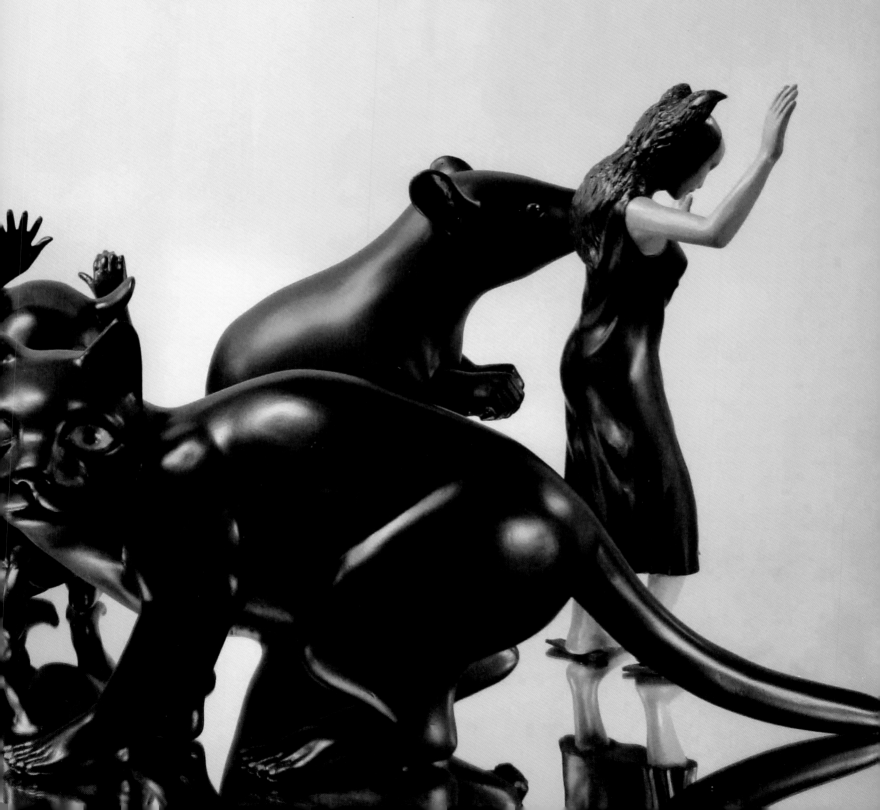

The artist's posthumans tell a story of co-optation, co-evolution and compromise

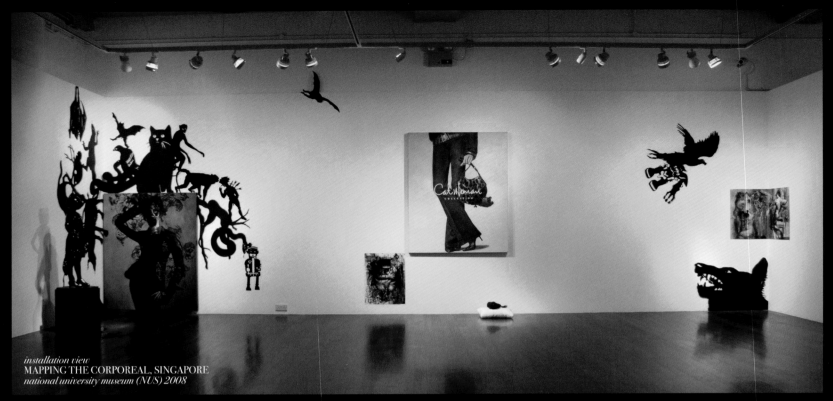

installation view
MAPPING THE CORPOREAL, SINGAPORE
national university museum (NUS) 2008

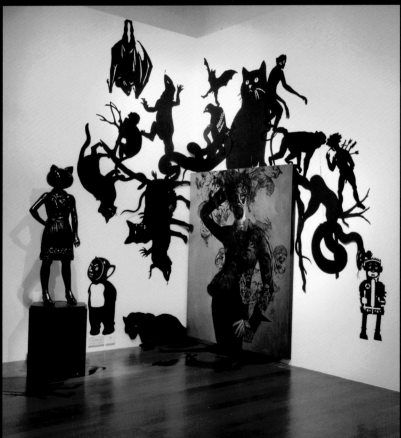

BEASTIALITY
122 x 152.4 cm
oil on canvas, 2008

Ventura's animals are those that have been reduced and isolated to "productive and consuming units"

The monsters were "humans with animal heads, animals with human feet, pinup pigs, playgirl bunnies, monkey men, skeletons with wings, and fiberglass rhinos."[6] The whole project took two years to finish, enabling the artist to collect an abundance of bric-a-bracs from everyday living such as religious and media icons. Mixing a commonplace form to another startlingly created what the artist dubbed as his "creatures of discomfort." Inspired by the horde of monsters, reworks of these anthromorphs were later created for his exhibit "Mapping The Corporeal" (2008), which also featured installations incorporating shadows of animals/ humanimals in and around 2D works with images of disembodied humans seemingly afflicted by decay through the artist's random smacks, dab, and trickles of paint down the canvasses.

It is interesting to note that even Ventura's techniques display a fusion of sorts, combining different media to better capture dissolving and overlapping boundaries. Case in point, a cursory glance of Ventura's recent works reveals a mounting fascination with layering, as was literally evident in his exhibition "Major Highways, Expressways and Principal Arterials" (2009). Taking up the discourse on the marginalization of animals, Ventura goes on to tackle the animals of the mind, animals as metaphors co-opted as spectacles for observation wherein "the more we know, the further away they are."[7]

6 Igan D'Bayan, "Adventures in Skinny-Dipping," catalogue note for Metaphysics of the Skin, a solo exhibition by Ronald Ventura at Tyler Rollins Fine Art, New York (September 17 - October 31, 2009)
7 Berger, loc.cit., 865.

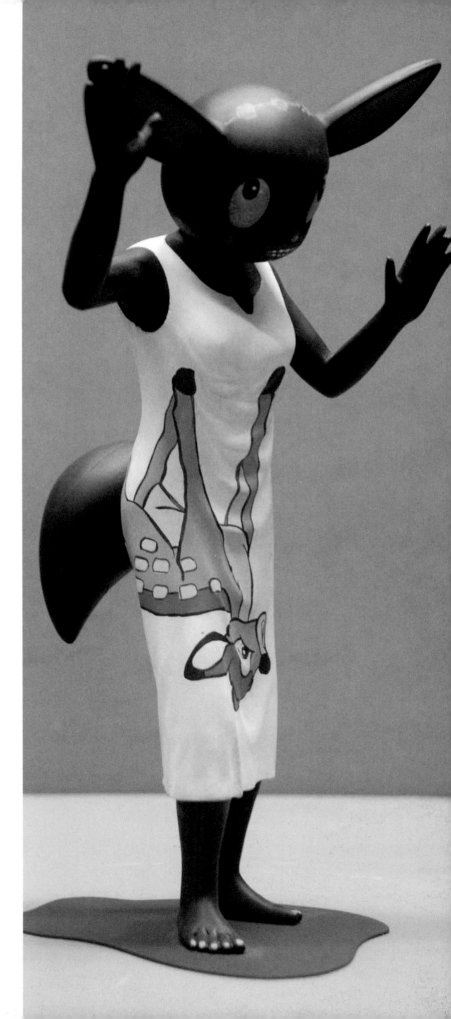

ZOOMANITIES (Series)
fiber glass/resin, 2008

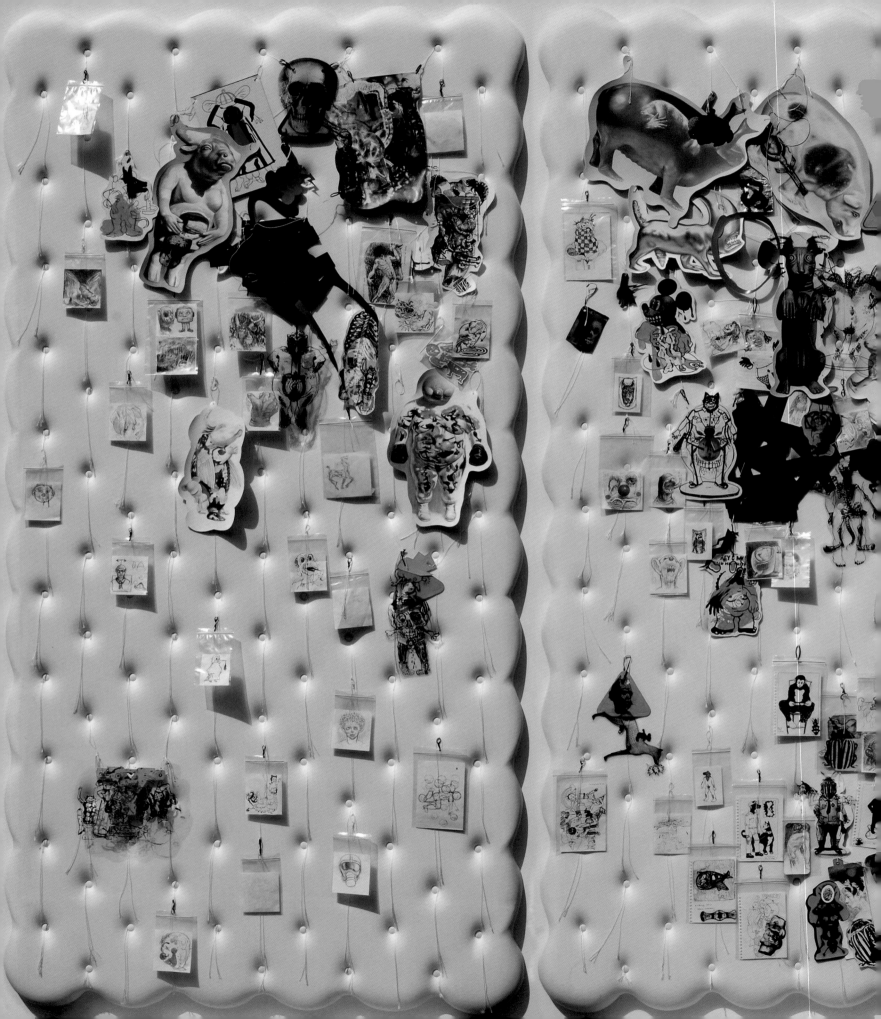

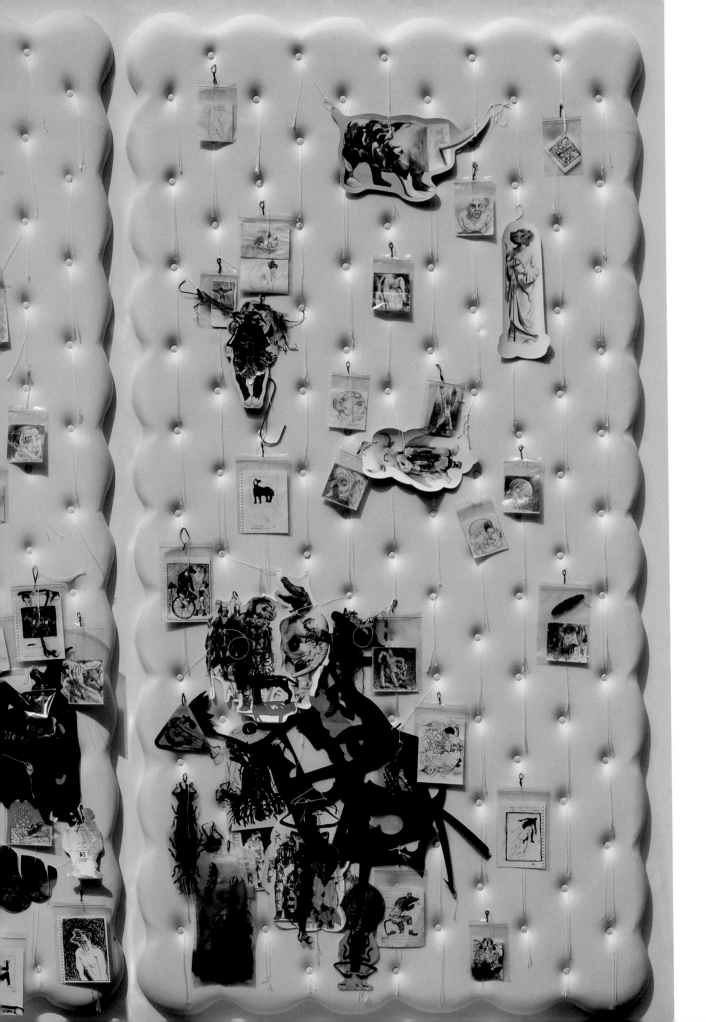

BRAINSTORM
244 x 366 x 10 cm
mixed media, 2008

Both humans and animals are under observation, exposed to the system's exploitative gaze

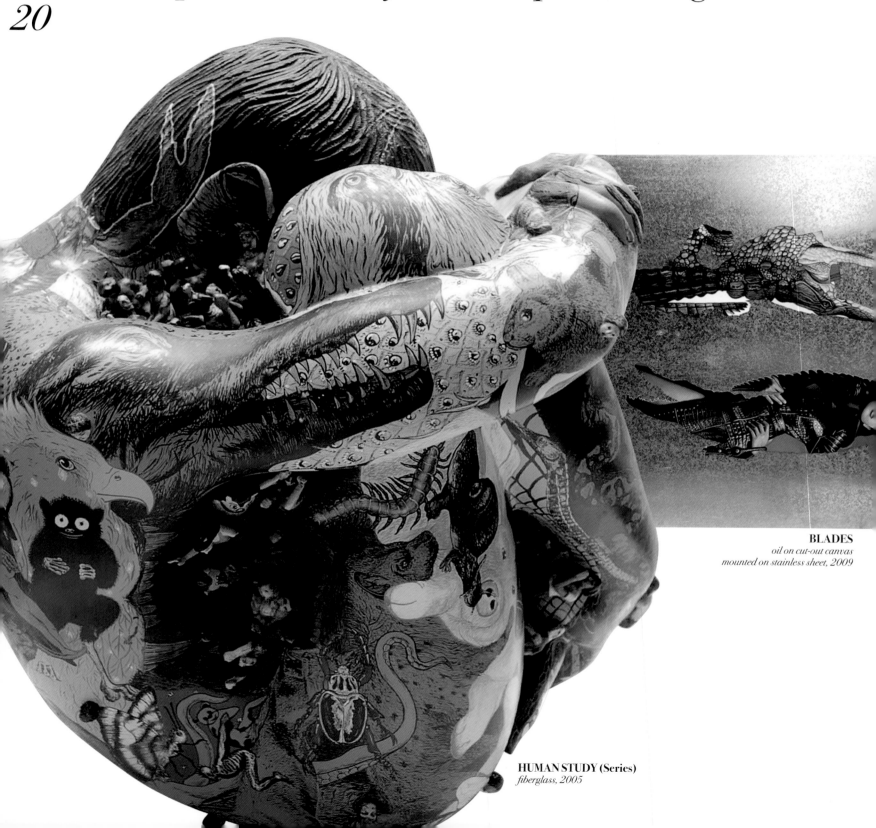

BLADES
oil on cut-out canvas
mounted on stainless sheet, 2009

HUMAN STUDY (Series)
fiberglass, 2005

Ventura easily turned this myth around, creating mixed media works "(Avenue, Blades, Farm, Honey, and Nature)" that featured silhouttes of humans traced from actual images and photographs borrowed from medical manuals and fashion magazines. He then put these outlines adjacent to another layer of nuanced pictures and prints of wild animals, and vice versa, to achieve yet another approach to fusing man and animal.

HONEY
140 x 82 cm
oil on cut-out canvas, 2009

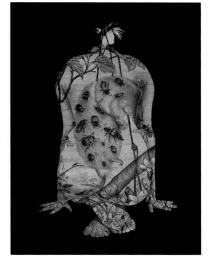

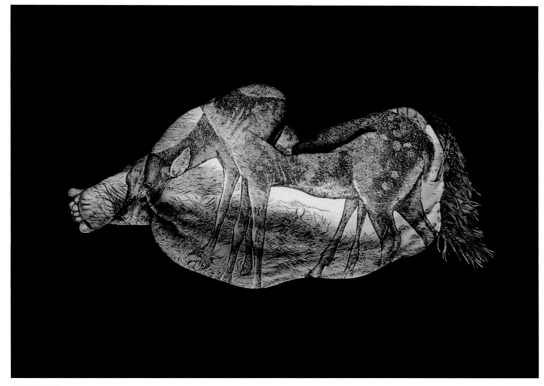

NATURE
oil on cut-out canvas, 2009

In his narrative, both humans and animals are under observation, exposed to the system's exploitative gaze. If the index of power lies in knowledge, the system has successfully homogenized human and non-human to determine conditions best for generating discipline and profit from both. In "Major Highways, Expressways and Principal Arterials", high fashion juxtaposed against wildlife produce a different kind of animality and cool passive-aggressiveness that only the disempowered and subjugated could convey without words.

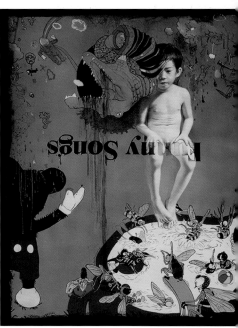

FUNNY SONGS
122 x 91 cm
oil on canvas

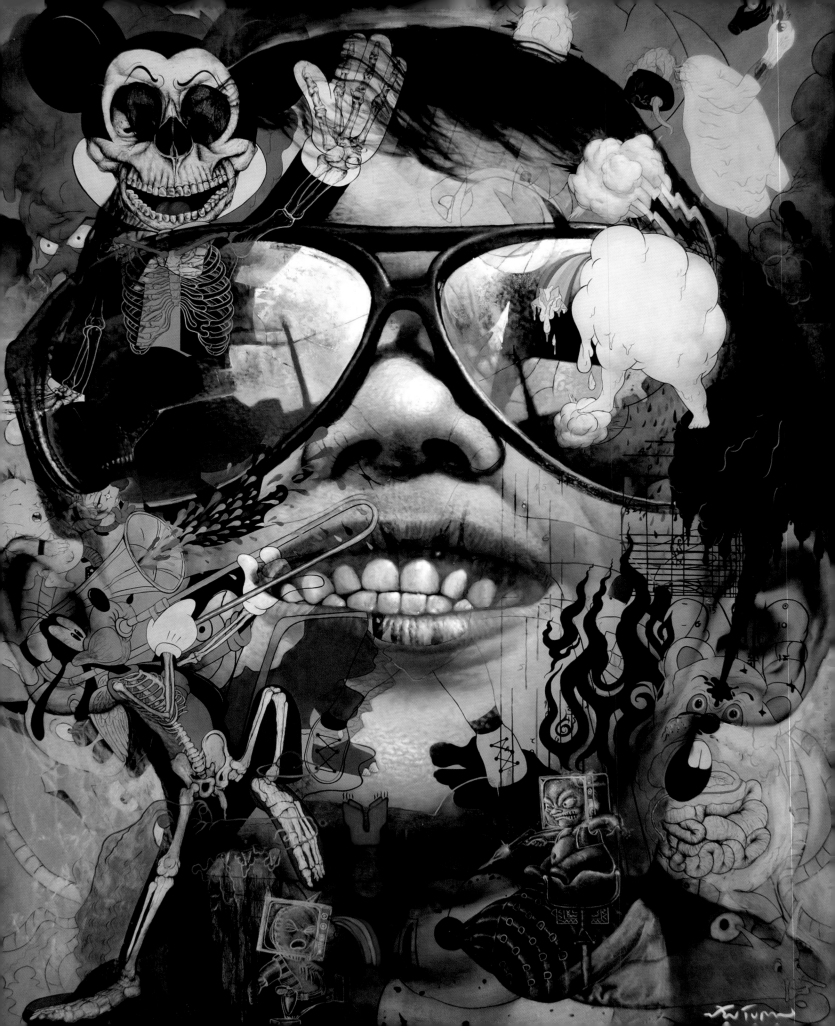

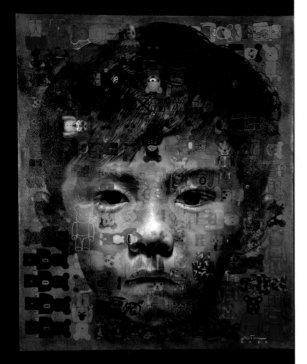

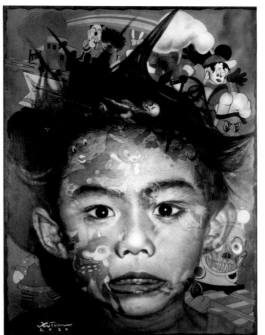

cyborg

A "Duad at Play" (2010) is both a tender and terrifying tribute of the artist to his son. In "High at Five I" done in oil on canvas, a beaming child wearing oversized sunglasses is inundated by the artist's brand of iconic monsters. "High at Five II" and "High at Five III" also feature the photorealistic face of the same boy, similarly drowned in a cacophony of caricatures. Around the gallery space, anthrophomorphic astronauts stand by, while the installation "Skyrocket Heights" shows a giant white robot sullenly sitting on a corner. An ad on a wall nearby tells of how "the world's only fighting robots battle it out." The white one apparently lost. The machine's defeat sets the tone in this peculiar playground, suffusing a poignancy usually not reserved for non-humans.

HIGH AT FIVE (I)
122 x 152.4 cm
oil on canvas, 2010

HIGH AT FIVE (II)
122 x 152.4 cm
oil on canvas, 2010

HIGH AT FIVE (III)
91.5 x 122 cm
oil on canvas, 2010

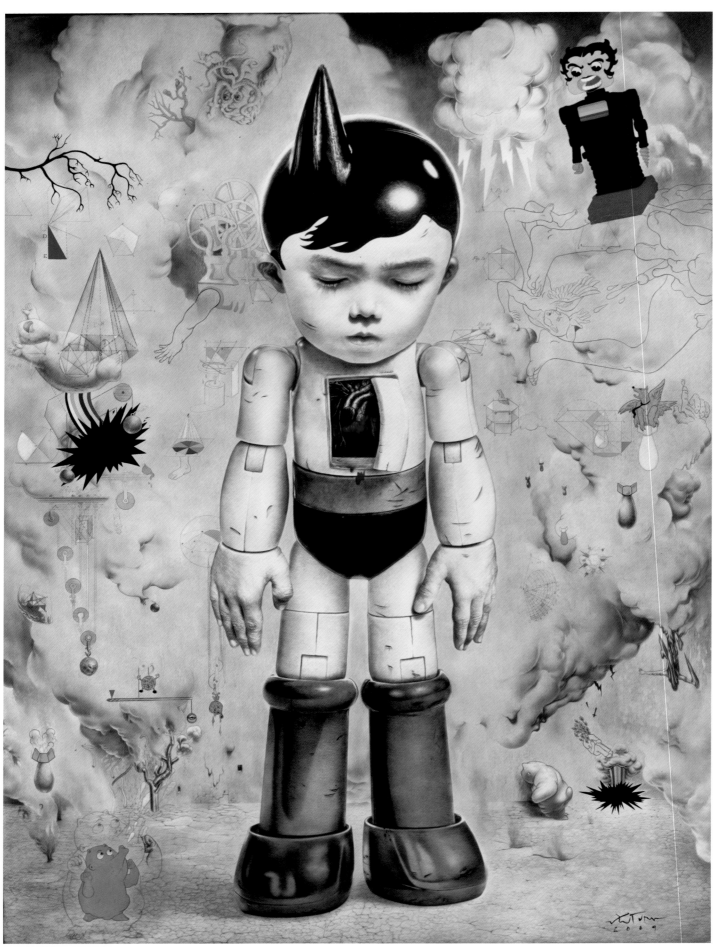

OH! BOY!
274 x 202 cm
oil on canvas, 2009

In his narrative, both humans and animals are under observation, exposed to the system's exploitative gaze

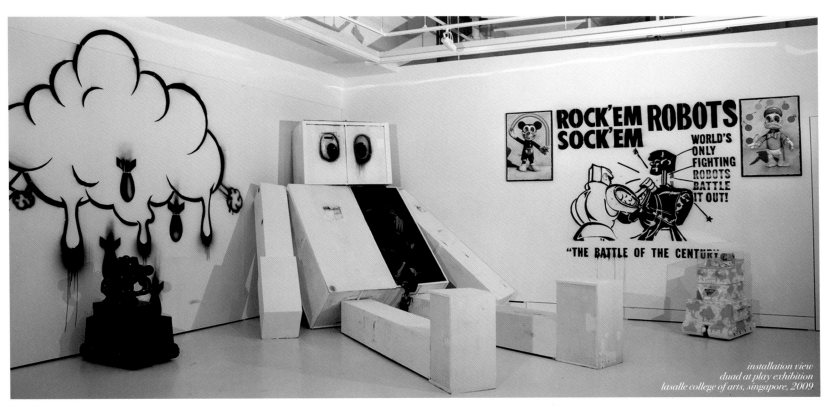

installation view
duad at play exhibition
lasalle college of arts, singapore, 2009

Contrary to Ventura's handling of his humanimals which usually elicit a feeling of callous mockery, his cyborgs/ man-machines exhibit a sense of vulnerability. Fragmented Channels (2010) is a display of such humanness, depicting men in various states of dreaming and discontent inside emptied television sets, beholden to the promises streamed through this ubiquitous box. All the characters inside these dioramas "are put inside intimate spaces such as bedrooms, kitchens and living rooms, inciting strong feelings of voyeurism from viewers. We are put in a position of power and judgment, omniscient with the knowledge of a furious desire in each of these characters, struggling to live within their metaphorical limited spaces."[8]

Cyborgs, in the posthuman context, are new kinds of bodies "which are marked by a refiguring of human potential and an increasingly abstract awareness of the body as network and system."[9] These posthumans are products of certain conditions endemic to modern life[10], basically comprised of a flow of power through networks that intersect and conseqently, condense spaces,; collapsed boundaries; and a brutally

8 Adjani Arumpac, "Disconnected Dioramas," catalogue note for Fragmented Channels, a solo exhibition by Ronald Ventura at Primo Marella Gallery, Milan (June 24 – 30 July, 2010)
9 Armstrong, T. (1991) The electrification of the body, Textual practice, Vol. 8, pp 16-32.
10 Thrift, Nigel, "Inhuman Geographies: Landscapes of Speed, Light, and Power," Writing the Rural: Five Cultural Geographies, eds. Paul Cloke et al. (Liverpool: London, 1994) 218.

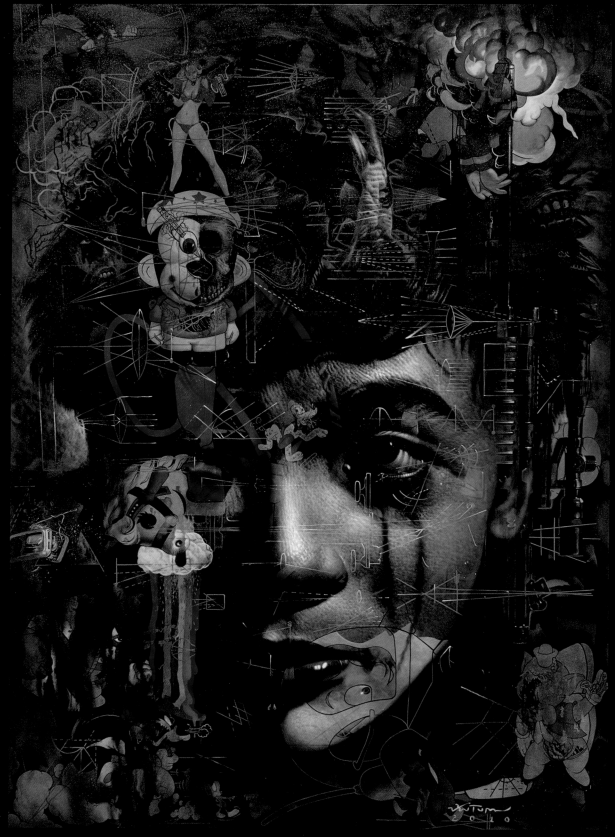

REBEL OPTICS
oil on canvas, 2010

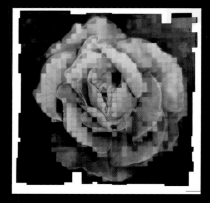

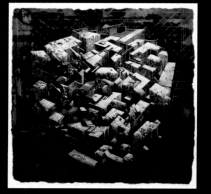

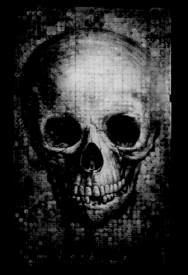

CONVERGING NATURE 1
122 x 122 cm
oil on fiber glass sheet

CONVERGING NATURE 2
122 x 122 cm
oil on fiber glass sheet

CONVERGING NATURE (Circle of Death) 3
153 x 91 cm
oil on fiber glass sheet

accelerated time that is the root cause of this total mobilization of urban life, swirling in agitation, impatience and desire.

Ventura's most beguiling cyborgs, intriguingly, are almost always portrayed as children, as shown in his High at Five series. Oh Boy! is a forlorn figure of a mechanized Astroboy. There is also the androgenous child gazing out through the network of optic diagrams and icons in Rebel Optics. Framed is a portrait of a sleeping child, fast engulfed by a wave of colorful flat pop commercial caricatures. These children stand still, metamorphosizing in the tempest. And

The transformation is only a prelude to the continuity of homogeneity

the artist can only portray their morphisms, adding layer upon layer of techniques, as if in a desperate attempt to disrupt the represented reality of transforming bodies. The child's/human transformation is imminent if he is to survive in this world fast becoming mechanized. Western cyborgian theories predict this as the enhancement of the human potential through technological augmentation. But in Ventura's context, the transformation is only a prelude to the continuity of homogeneity perpetuated by state and economic mechanisms. The human in realization certainly alters to cope, but his cyborg form is that of a usurpation of identity by the machinery, motivated by an insistent need to fulfill the most basic of needs. Go through the faces of Ventura's cyborgs and a pinched look lingers, as if something has been lost somewhere.

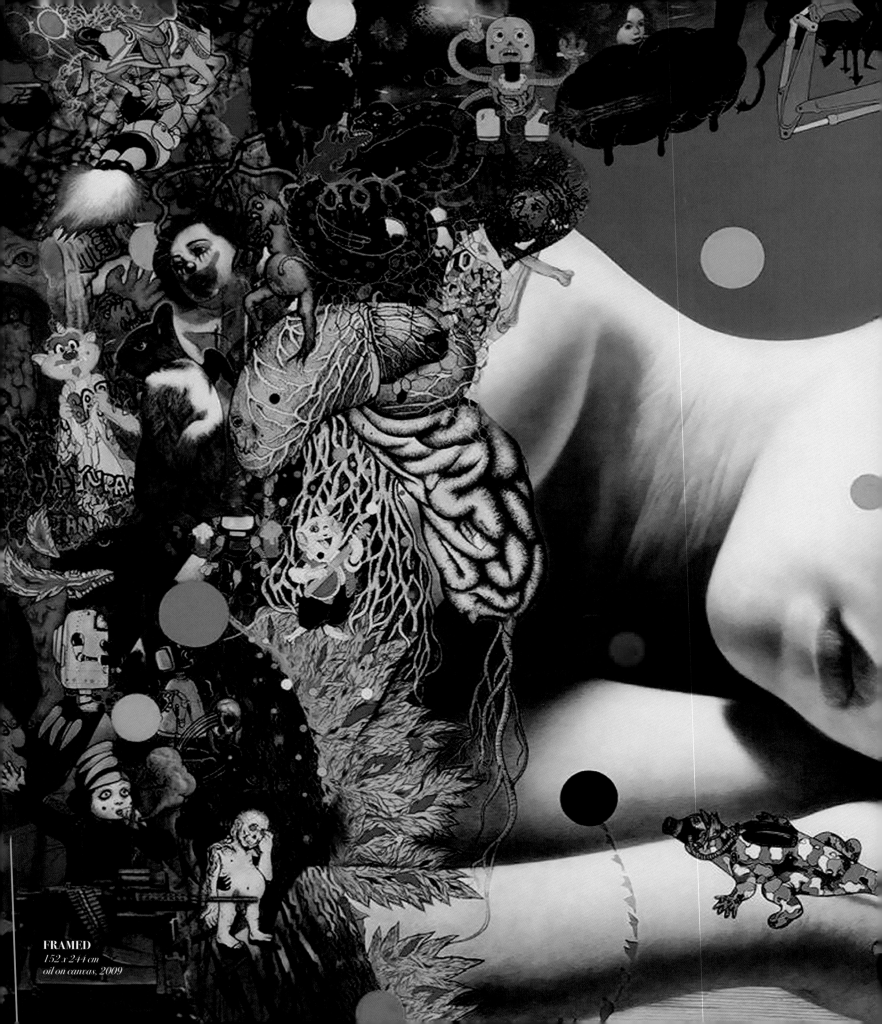

FRAMED
152 x 244 cm
oil on canvas, 2009

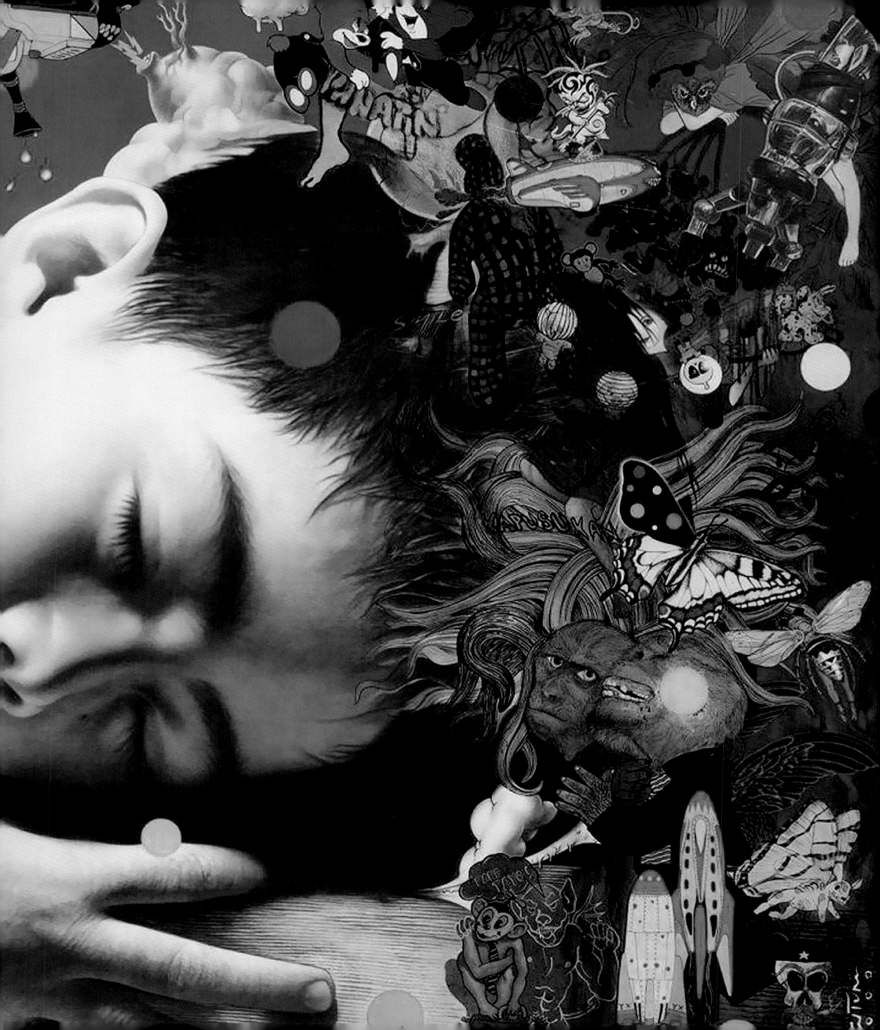

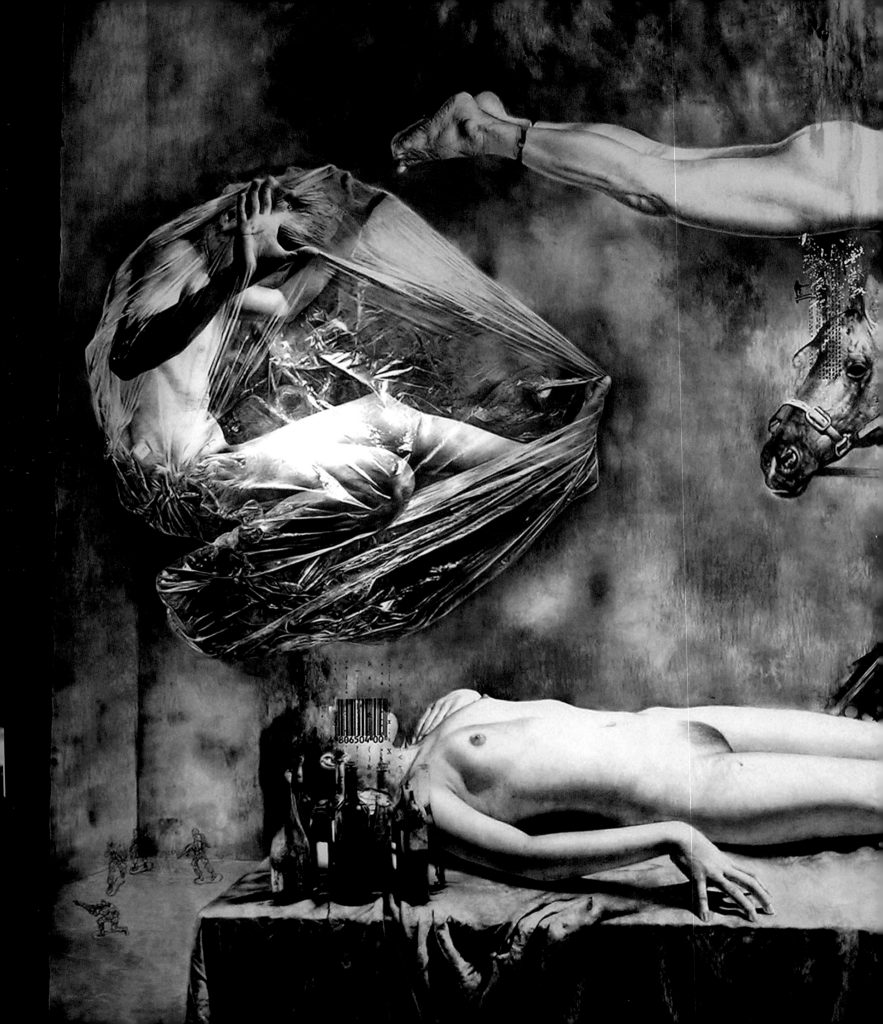

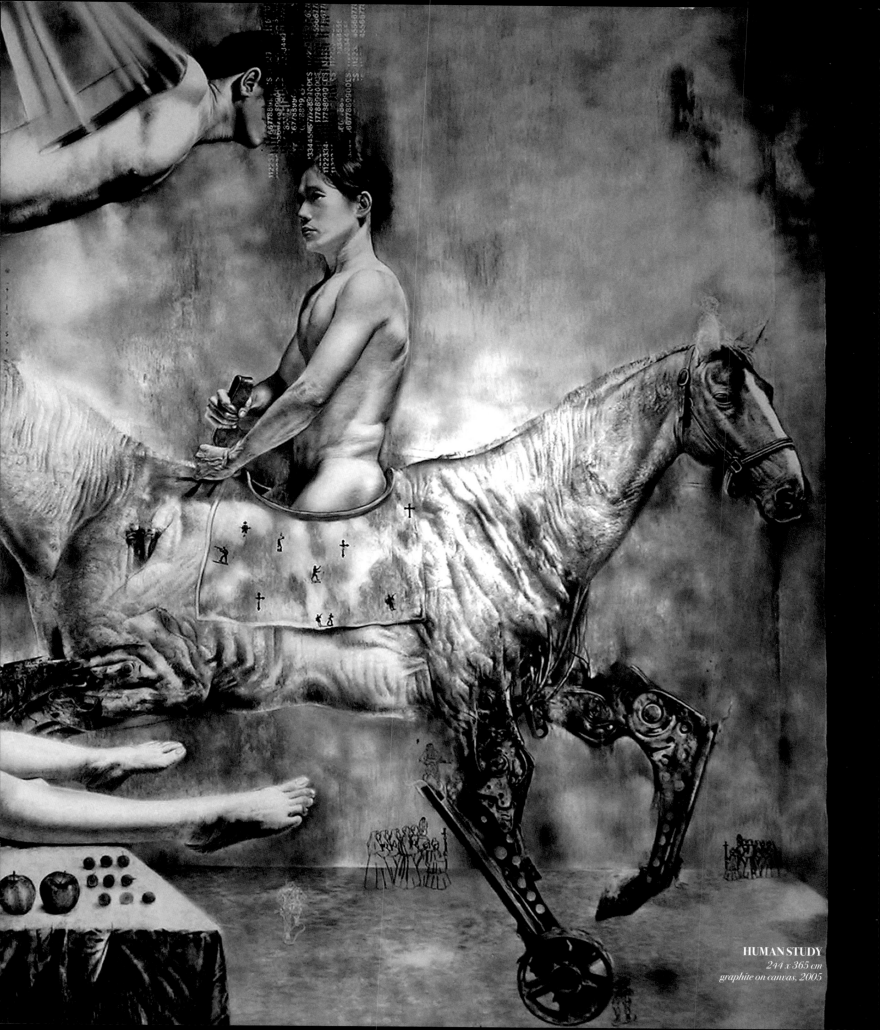

HUMAN STUDY
244 x 365 cm
graphite on canvas, 2005

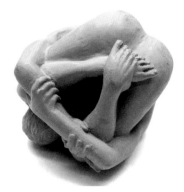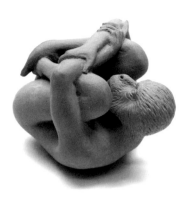

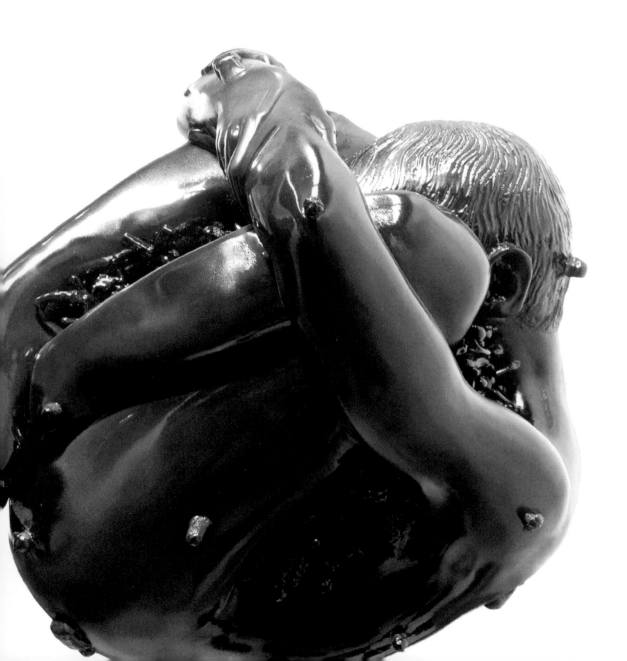

ANTIPODE (Human Study Series)
fiber glass-resin, polyurethane paint, 2007

Human study and the politics of gender

Alice G. Guillermo

33

In black-and-white the image of Roland Ventura's 1995 major work exhibited at the Art Center in SM Megamall, Mandaluyong, Quezon City leaps at the viewer from the central gallery wall which coincides with the space of the work itself.

This amazing mural-size work which measures 144 x 96 centimeters is one of the three prize-winning works of the 2005 Ateneo Art Awards with the artist particularly chosen for the workshop in Sydney, Australia. Simply entitled "Human Study", it is executed, not with the usual oil pigments, but with graphite on canvas. But what makes it closer to a painting rather than a drawing is the use of canvas for ground, its extraordinary range of tones from dark grays to luminous whites creating the illusion of volume and perspective, as well as the richness of its significations. The treatment of its theme only brings out the irony of the simple title as the work itself could refer to the contemporary hell in which humans live.

The "mise-en-scene" for the various figures is a stone chamber, seemingly enclosed, but to the viewer more like a stage in a theater or even a hall in a prison-house where mysterious encounters take place. The walls are plain with grimy stains and shadowy oscillations that create a constant, subtle movement denying the static.

The first of the human characters is a female nude lying on a single piece of furniture, a dining table draped realistically, although with eerie suggestions of hidden, clutching hands. On the table along her

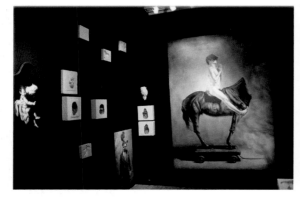

installation view
CONTRIVED DESIRES EXHIBITION 2004
west gallery, megamall, philippines

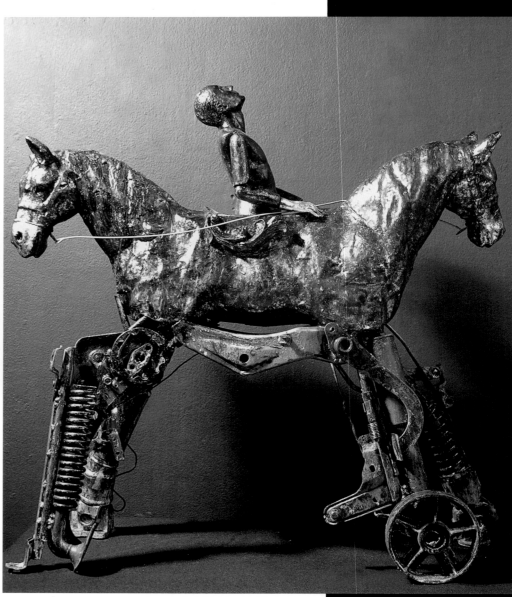

MACHINISM
mixed media, 2005

feet is a formal drawing exercise as of a fruit from faint outline to full three-dimensionality while beside it are rows of similar fruit, but much reduced in scale, with tiny shadows, as though to show the delicate processes which the work went through.

As T.S.Eliot's "nude anaesthetized upon a table", it is the female disrobed subject herself, lying supine upon the table which also serves as her bed that draws our attention irresistibly. Classical in her proportions, she displays a flawless form from her high breasts to her smooth pubis and her legs and bare feet extended in a tense, straight line beyond the table. Preternaturally, light seems to emanate from her figure, rendering it radiant, luminous, and white against the surrounding grays of the Wasteland. But, alas, the beautiful young woman does not exist in an ideal world.

Subverts the perfection of the classical to reveal his dark underside

Her face is ruthlessly obliterated by a bar code, signifying her commodification, even as bottles of alcoholic drink mingle with her hair. She has apparently fallen into dissolute ways and to the deceptively pleasurable numbing of the senses in anodyne. Although more importantly, however, she does not lie inert and passive, succumbing to a virtual non-existence. Indeed, as in a state of suspended animation, her body floats above the table (a long shadow marks the space beneath it), but so as not to lose her moorings in the real world altogether, her right hand presses down upon the table as a gravitational anchor.

Our modern Sleeping Beauty is, like in the traditional folktale, visited by Prince Charming on his high horse. Noble of face and bearing, he strikes a messianic and commanding pose.

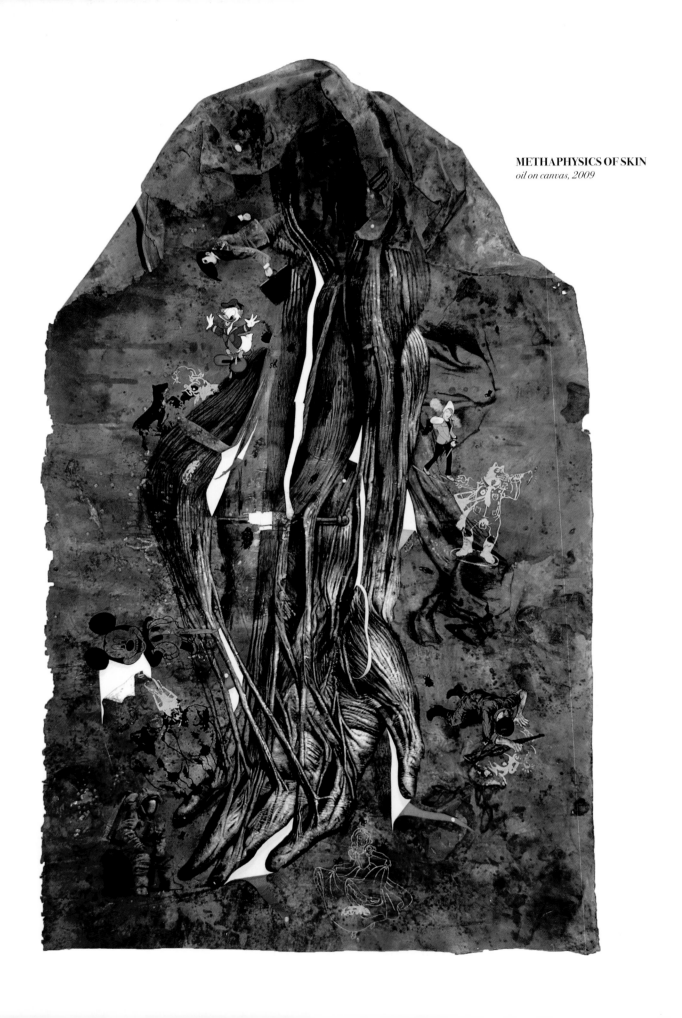

METHAPHYSICS OF SKIN
oil on canvas, 2009

The purity of his original appeal

But his horse betrays his real character in its double Janus-heads facing opposite directions, signifying the ambiguity and futility of his mission, whether for good or ill. He is immobilized by his false hobby horse, one head smooth-maned the other rough and wrinkled; its four legs, likewise, are a ludicrous assemblage of machine parts. Will she awaken at his call even if his presence no longer holds the purity of his original appeal?

There are two other figures in the nightmarish scenario. These have completely lost their moorings. The one on the left floats within a transparent plastic bubble, rendered with amazing technical virtuosity, in which he is helplessly ensconced, thrown about willy-nilly in space without succor. Above him in a horizontal plane, the other figure, also a male nude wrapped in transparent casing, seems to lunge towards the riding male, their foreheads touching, bar codes sprouting out of their heads. He, too, is irrevocably lost, his body claimed by King Commodity and hopelessly reified: his arms are cleanly cut away at the sides like a puppet figure and his loss of human agency is signified by his legs surgically disjointed above the ankles. Meanwhile, scattered in the ground below are tiny, shadowy soldiers engaged in chronic warfare which can only result in the victimization of humans and their alienation from their nature.

What adds to the elegiac effect of the work is the style itself which feeds on the perfection of the classical but subverts its values

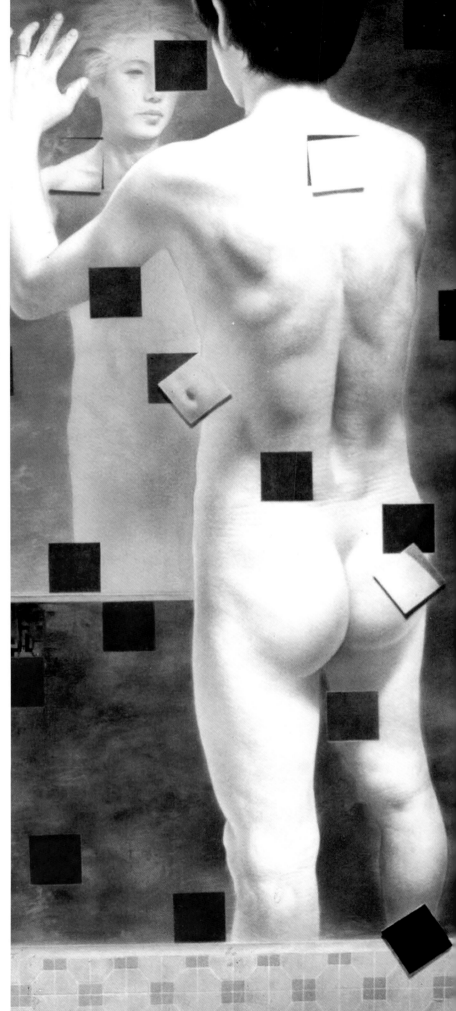

SHOWER OF MIRRORS
oil on canvas, 2003

Ideal beauty betrayed by capitalist alienation

CROSSED
oil on canvas, 2003

to reveal its dark underside—ideal beauty betrayed by capitalist alienation and the widespread plague of war that has eroded human life. There are likewise individual paintings which extend the themes of Ventura. Of these are "Temptation" showing a nude standing girl who puzzlingly examines the apple proffered by the serpent in Eden and the irony of the character @ of contemporary computer technology which is stamped upon her pubis—an allusion to the corruption of woman in the new forms of cybersex and white slavery through computers. A work entitled "Insecured" is a virtuosic execution of the figure of a dog-man, a composite figure, clutching a bone. The anatomy of the human torso and limbs is so flawless that it is indeed startling to see the alert and wary dog-head sniffing for enemies. Paranoia has transformed the human into an animal in a jungle where he guards his property be it only a bone.

But Ronald Ventura's creativity will not limit itself to creating the illusion of volume on a two-dimensional surface, for he chooses aspects of his visual narrative and projects them in three-dimensional form. This he does for the two-headed horse which he executes out of discarded metal parts. The legs especially are made of a variety of gears and springs and sundry elements culled from machines. In the sculptural form, the two heads create a striking symmetry with their two poles, but the rider with his back arched and head upraised reintroduces a tension that subverts the equilibrium of the symmetrical form. The artist also creates metal figures on the theme of flying derived from the levitation of the figures of the "Human Study". Here the horse becomes a large winged figure reminiscent of Icarus and the hubris that threw him back to earth. Or it can have a robotlike appearance as it strides forward menacingly. The same flying

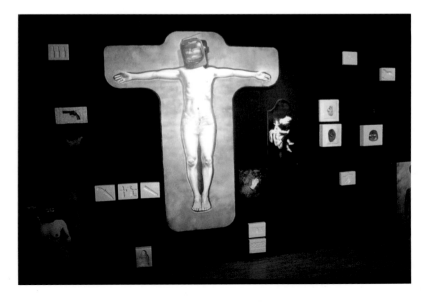

installation view
CONTRIVED DESIRES EXHIBITION
west gallery, megamall, philippines

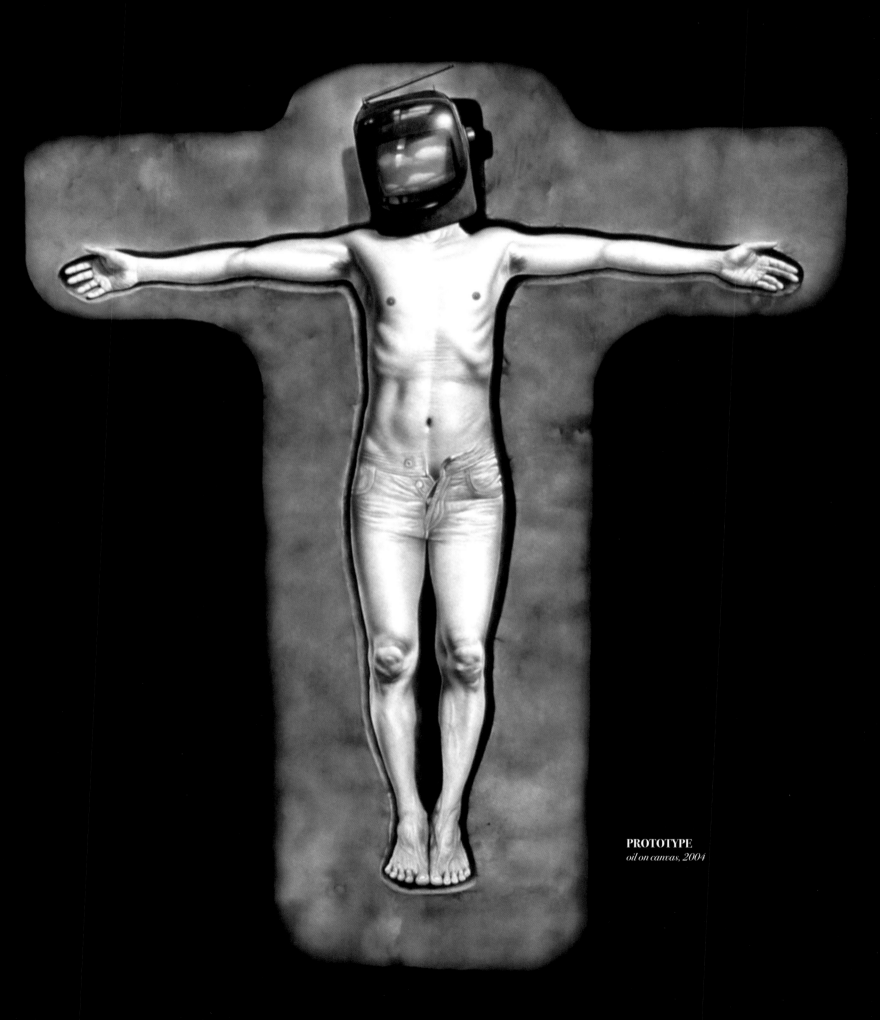

PROTOTYPE
oil on canvas, 2004

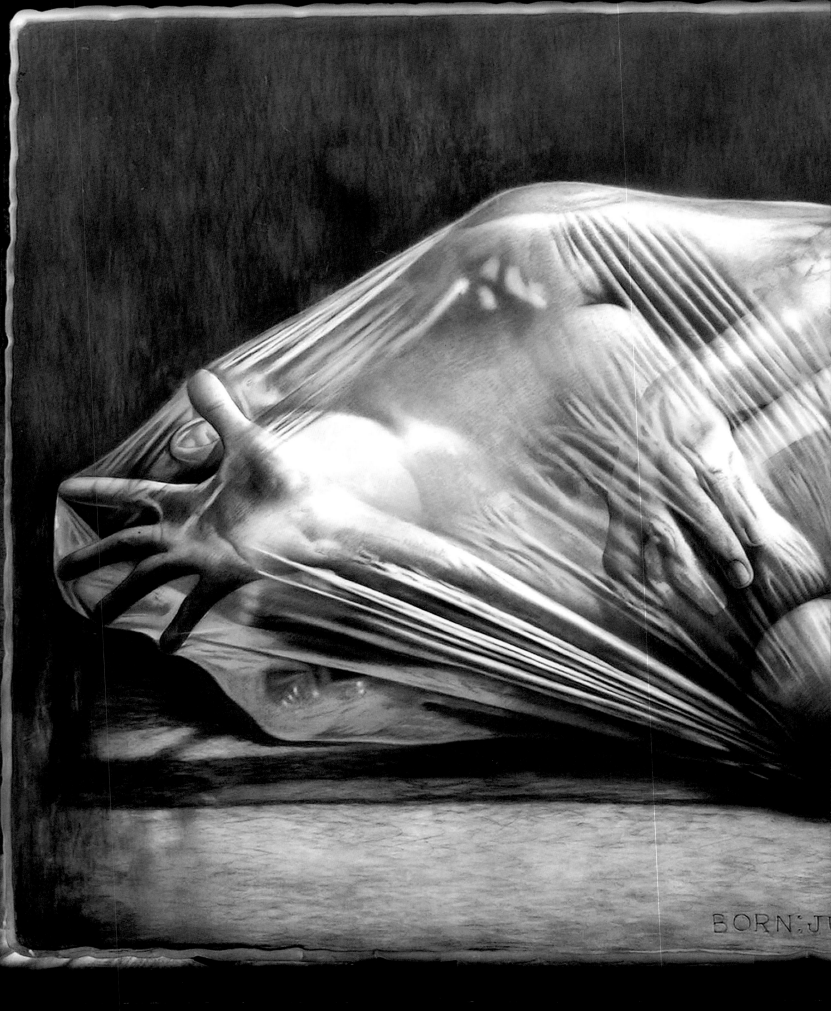

BORN: JU

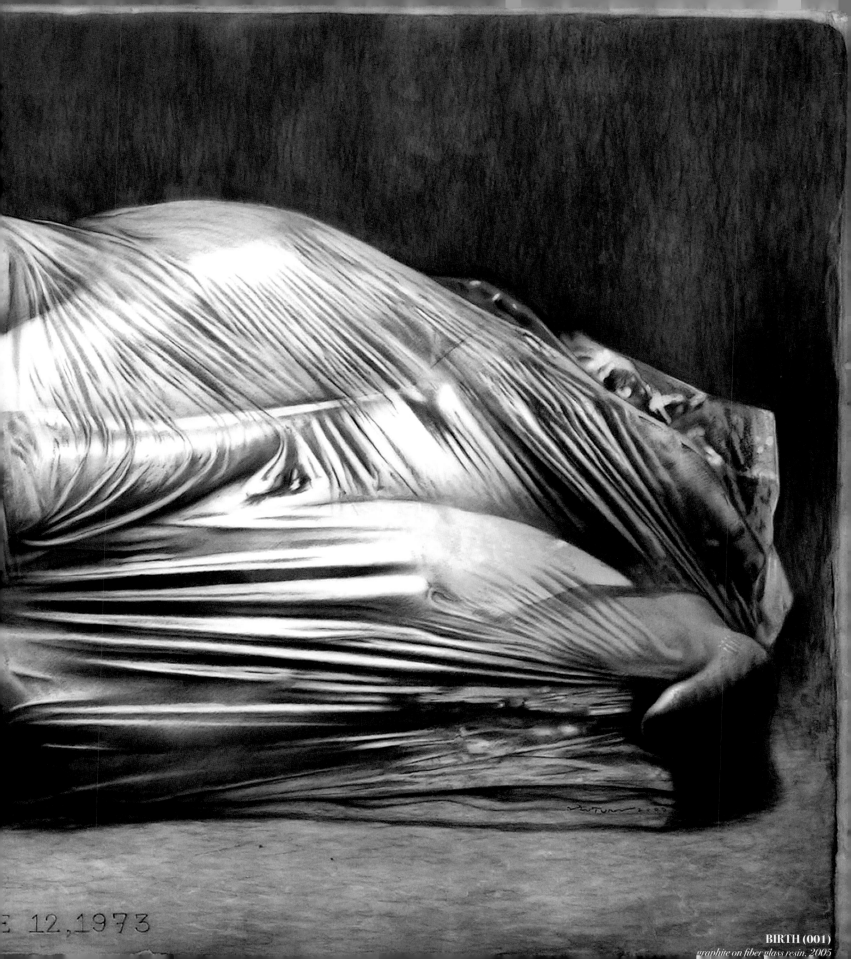

E 12, 1973

BIRTH (001)
graphite on fiber glass resin, 2005

This gave rise to a flurry of contemporary themes on the issue of gender

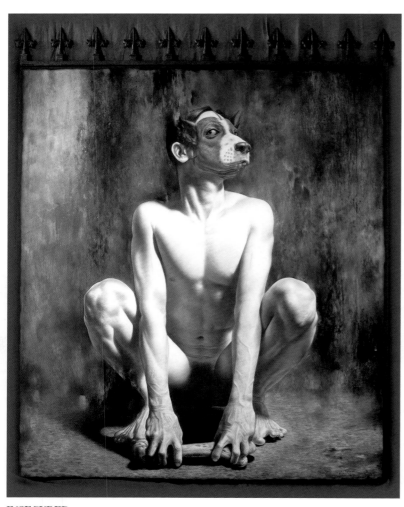

INSECURED
oil on canvas with steel on top, 2005

figure, more human however, hovers over a tower of human vanities and illusions in ascending tiers like the Hindu temples of interlinked mythical figures.

Also complementary to "Human Study" are the numerous drawings of the human body that accompany the main work. These demonstrate the virtuosity of the artist as he creates images in quick succession, taking the unclothed body, male and female, and turning it around, twisting it front and back in endless movements and positions. And human studies they are because they are based on the body's anatomy alone, muscular as well as structural, without placing it in the context of a situation or narrative. It is as though they waited to be contextualized in a larger whole, a reality in which they will find their living selves.

A major piece was a reworking of Leonardo da Vinci's Vitruvian man, a male nude done in classical proportions based on the geometry of the circle and the square. This gave rise to a flurry of contemporary themes on the issue of gender. At the beginning, the artist contextualized the thoughtful nude with a tinge of melancholy in a setting of urban squalor. More importantly, he raised the issue of gender as a construct, a complex of traditional and culture-bound ideas and affects to which the individual is introduced at birth.

Beyond this, in terms of the politics of gender, Ventura's personal aesthetic of the nude is engaged in breaking down the rigid binaries of male-female, even as the black-white components of "yang" and "yin" hold within them the kernel of their opposite. It follows from this that a number of his figures take on an androgynous cast as they foreground gender symmetry. Such is the ideal condition that he aspires for in art, for reality only too sharply underscores the power relations in gender relationships which are replicated in the larger political arena.

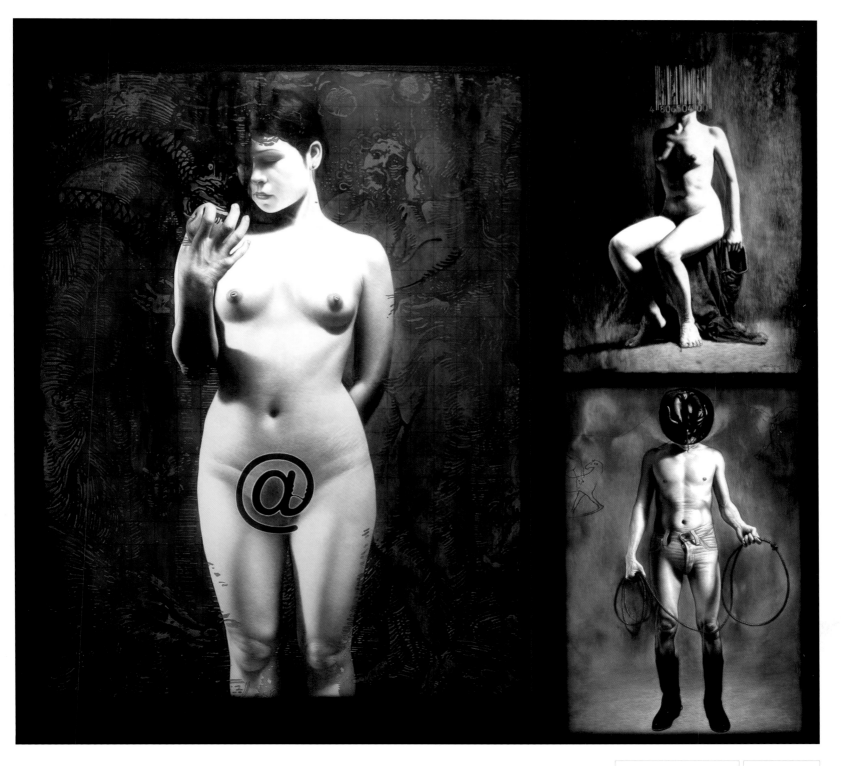

TEMPTATION
oil on canvas, 2005

COMMODITY
oil on fiber glass sheet, 2005

COWBOY
91 x 61 cm
oil on canvas,
2004

Much of the classical aspect of his figures derives from the artist's choice of a smooth marmoreal tone rather than a realistic brown cast. As such, they assume the appearance of bloodless lunar beings. The ivory pallor of their skin restates the aesthetic distance and restraint of classical art, as it removes them from facile accessibility, but instead presents them as iconic subjects for thoughtful contemplation. As highly individual figures, their gestures assume symbolic significations, though they sometimes suggest rhetorical stances.

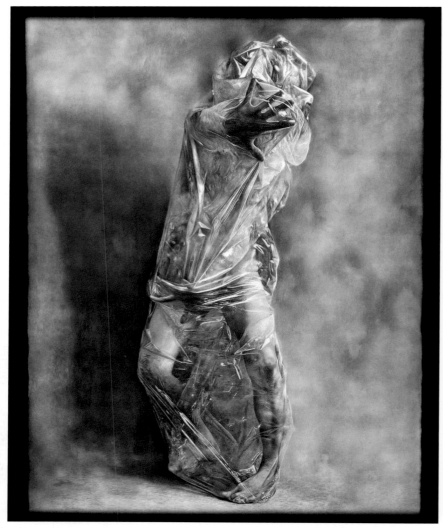

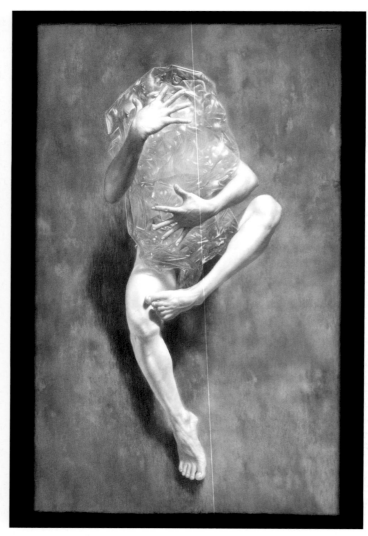

BIRTH (002)
graphite on canvas, 2005

EMBRACE
oil on canvas, 2006

Another principle of restraint is the overall monochromatic palette, limiting hues to sepia browns with reddish undertones. The sepia tonalities evoke memory and the passage of time, but in the intimate personal experience of the artist, they also suggest the color of rusting metal exposed to the elements, an allusion to the artist's growing up years in the depressed area of the fishing village of Navotas with the corroded galvanized iron roofing of the shanties.

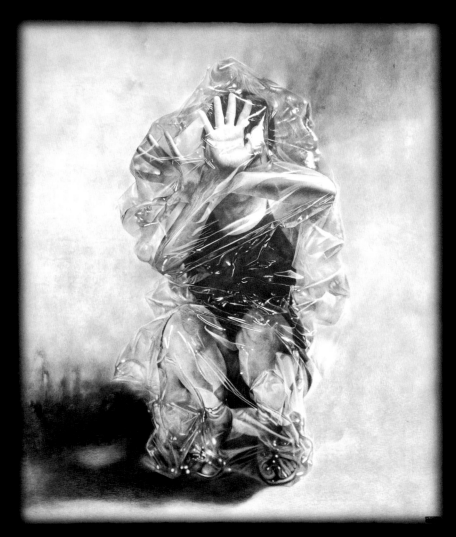

BORDER
oil on canvas, 2007

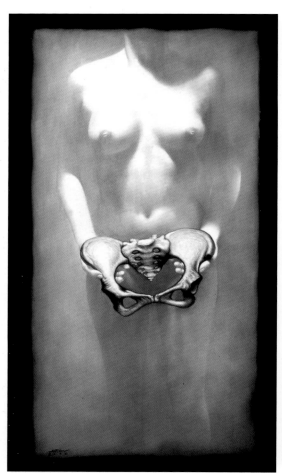

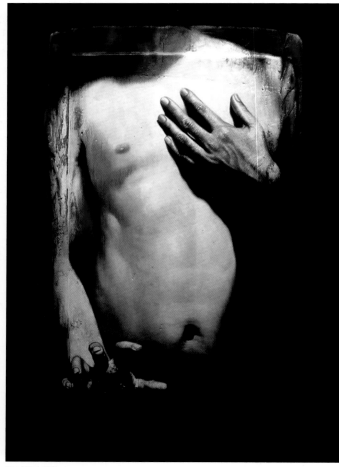

ANATOMICA
oil on canvas, 2002

PASSAGE
oil on wood, 2001

In an early painting, the "Morning Rust" (2001), a young man, just risen from sleep, shields his eyes from the raw light of day against a setting of fragile structures becoming an abstract blur, the pervasive reality of rust replicated in the brownish smear of the morning's expectoration caught in the bathroom drain and captured on a sheet of paper like a medical specimen. High tonal contrasts transgress the pellucid smoothness of the bodies, at the same time that they bring into sharp opposition the day's relentless Panopticon glare with the night's intimate sensuous shadows.

But into the flawless aspect of the male nudes, quiet but with measured articulate gestures recalling the stances of classical

He has assumed the capability of distorting the human body

statuary, Ventura introduces a troubled, as though garbled, passage as a reminder of finiteness and decay, an echo of the "memento mori" or the skull ensconced among objects of worldly pleasure. In a standing nude entitled Passage (2002), an arm seems to dissolve into strips of flayed flesh. The two hands, moreover, are at counter-purposes, though unconscious of each other's movements: the one touching the chest is gentle and protective, while the other is slyly extended forward in a predatory gesture. Through such devices, the artist deliberately shatters the mimetic illusion, even as he stresses the constructedness of the image at all times subject to the artist's manipulation and command.

This was particularly demonstrated in "Morph", an early show, which was based on his concern with anatomy, proving that the

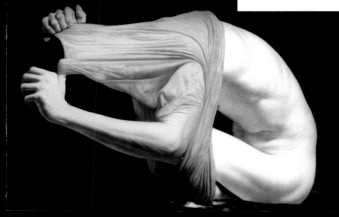

EPIDERMIS
oil on canvas, 2004

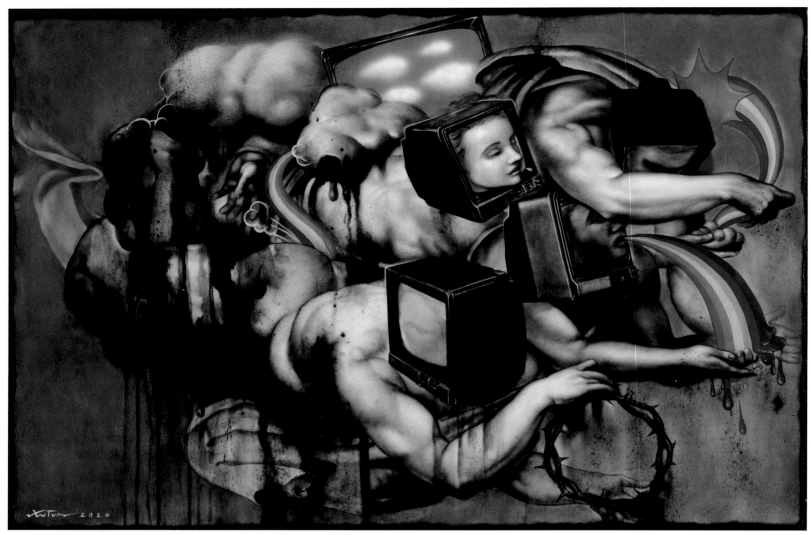

MESSENGER
62 x 92 cm
mixed media on board, 2010

basis of his art is his mastery of anatomy, so that having gone through the entire gamut of male and female nudes in all postures, stances, and attitudes, he has assumed the capability of distorting the human body, clothed or unclothed, or of morphing it in the most unexpected ways.

Plays with the body to create illusions

In "Basic", a large painting in square format, the artist plays with the body and its clothing to create illusions, interrogating the relationship between the real and the illusory, the exterior and the interior, an issue which is, to be sure, not entirely new in art, having been tackled by surrealist painters. However, while basing on realist premises, the artist proceeds to show that art is not pure mimesis, a copying, recording or a reflecting of the world of nature, but is first af all, a creation of the artist which is his to manipulate, organize, invent, etc.

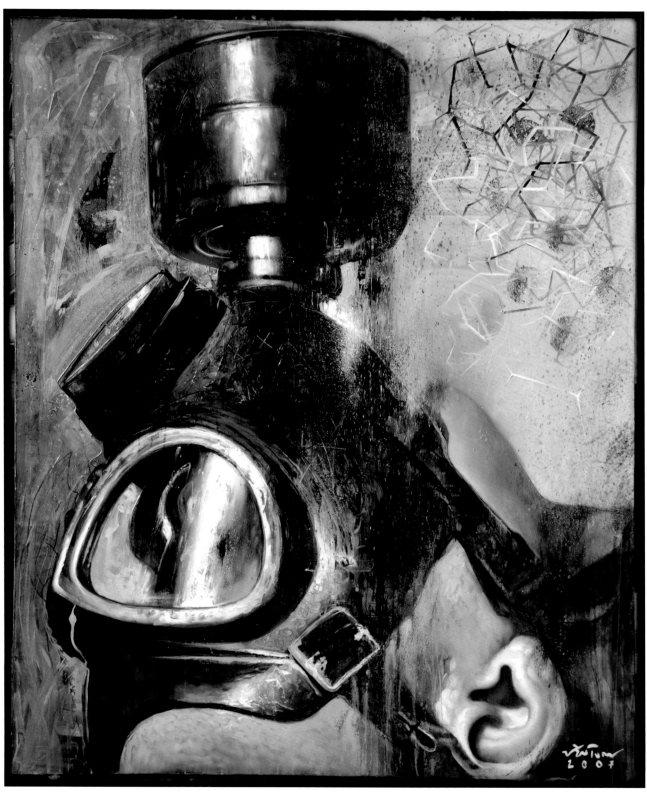

TOXIC (Under the Rainbow)
oil on canvas, 2007

50

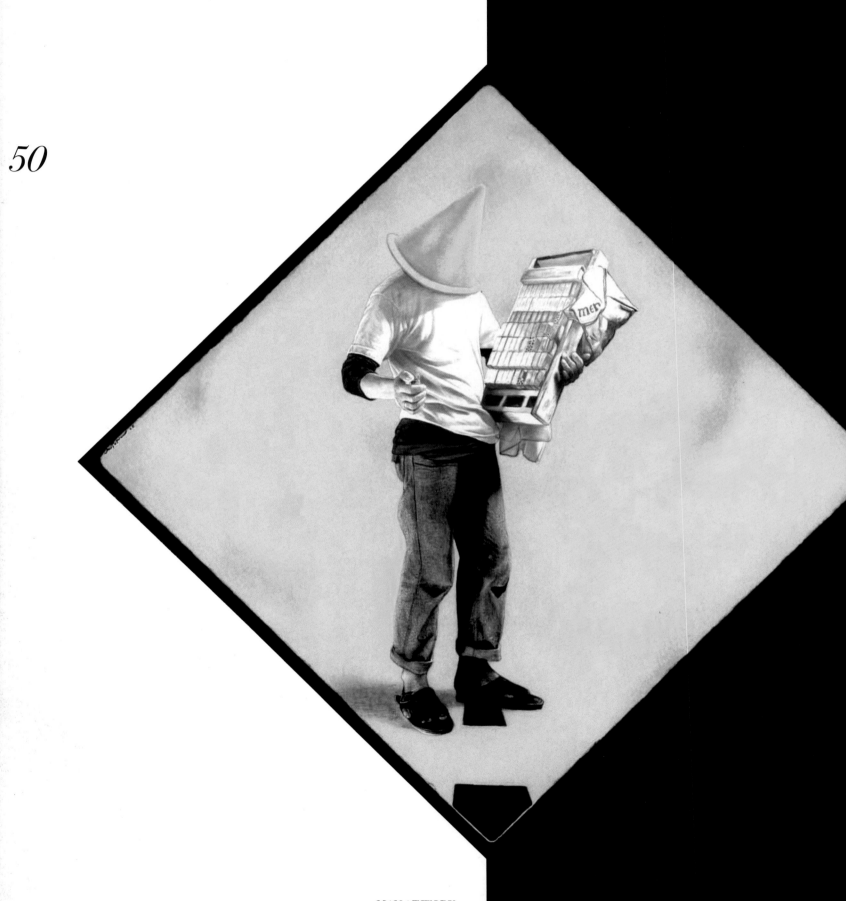

MAN AT WORK
oil on canvas, 2006

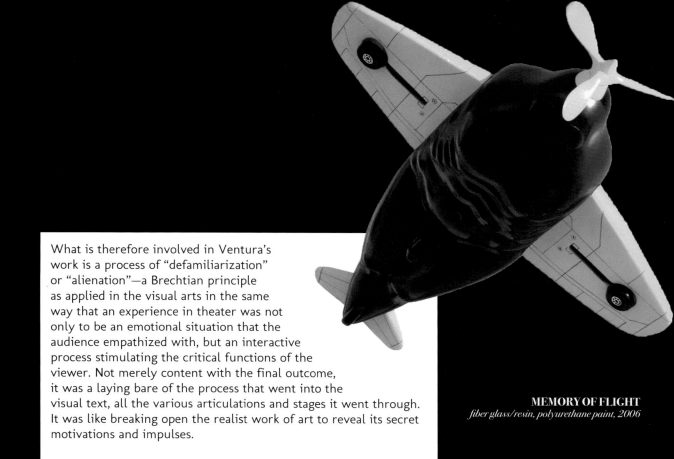

What is therefore involved in Ventura's work is a process of "defamiliarization" or "alienation"—a Brechtian principle as applied in the visual arts in the same way that an experience in theater was not only to be an emotional situation that the audience empathized with, but an interactive process stimulating the critical functions of the viewer. Not merely content with the final outcome, it was a laying bare of the process that went into the visual text, all the various articulations and stages it went through. It was like breaking open the realist work of art to reveal its secret motivations and impulses.

MEMORY OF FLIGHT
fiber glass/resin, polyurethane paint, 2006

Show that art is not pure mimesis

Thus the painting "Basic" begins with a familiar pair of white denim pants but which has been cut along the seam on one side and spread out to form a continuous two-dimensional form: the section from the waist to the crotch repeated twice and bifurcating into four legs, front and back. Now what happens is that this pattern, while basically flat, is superimposed on the three-dimensional legs of the wearer, knobby knees and all, down to the exquisitely drawn bare feet. The two panels on the right are in turn suspended on the back view with its buttocks and muscular calves. Moreover, the pants themselves undergo a morphing process in areas where they metamorphose into curling, moving draperies, like curtains that have come undone. There is likewise an observed discrepancy between the body position of the wearer and his attire, so that it may well have become several persons instead. Asymmetry is preferred to symmetry because it allows for greater invention.

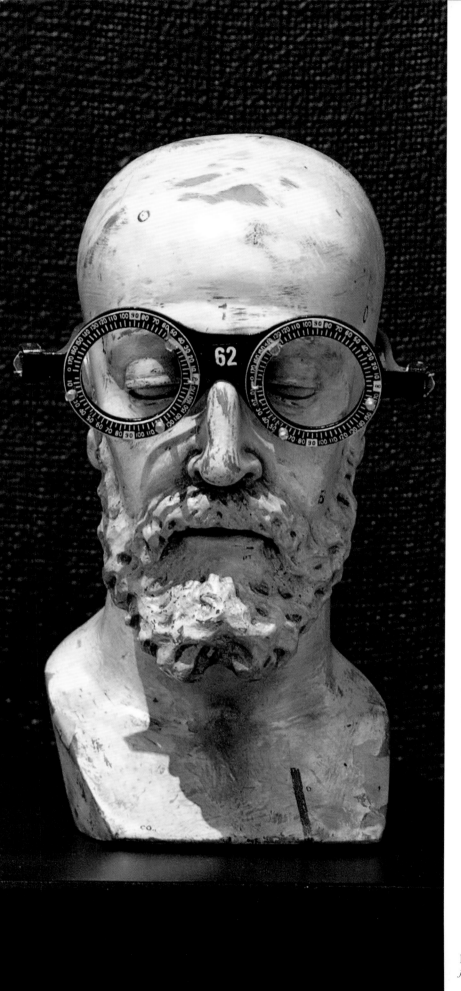

"Basic 2" and "Basic 3" show pairs of front and back torsos for man and woman. The first is quite classical, being a rendition of the "cuirasse esthetique" of the ancient Greek sculptors, the "kore", with their smooth pectoral muscles and their symmetrical rib cage. But the artist introduces an asymmetrical effect as he subverts realism by adding the fine, small collar at the neck. The woman's torso makes body and clothing coincide, and the highly realist torso with engorged breasts and pubis turns out to be the bodice bearing bands with attachments along the sides.

The intimacy between body and clothing is carried to exaggeration in the painting "Toy Story" in which a soldier in war fatigue and full combat gear trains his gun at a target, but he turns out to be just a toy model standing on a plastic base—just another spin-off of the deadly war in Iraq.

Nevertheless, Ronald Ventura's human figures are often lined in pain, thereby deviating from the classical canon and bringing in a darkly expressionistic cast. He reveals a sado-masochistic streak in the standing nude bearing bloody gashes on both sides of the back inflicted by an act of treachery. Another male nude confidently sets forth into the light of day but is abruptly interrupted in mid-voyage, his head and upper torso suddenly engulfed in a dark miasmic cloud which blots out his identity and being. In the drawings, the condition of angst may come out even more sharply as the artist uses red tonal

INSTRUMENT (3)
fiber glass/resin, found object, 2005

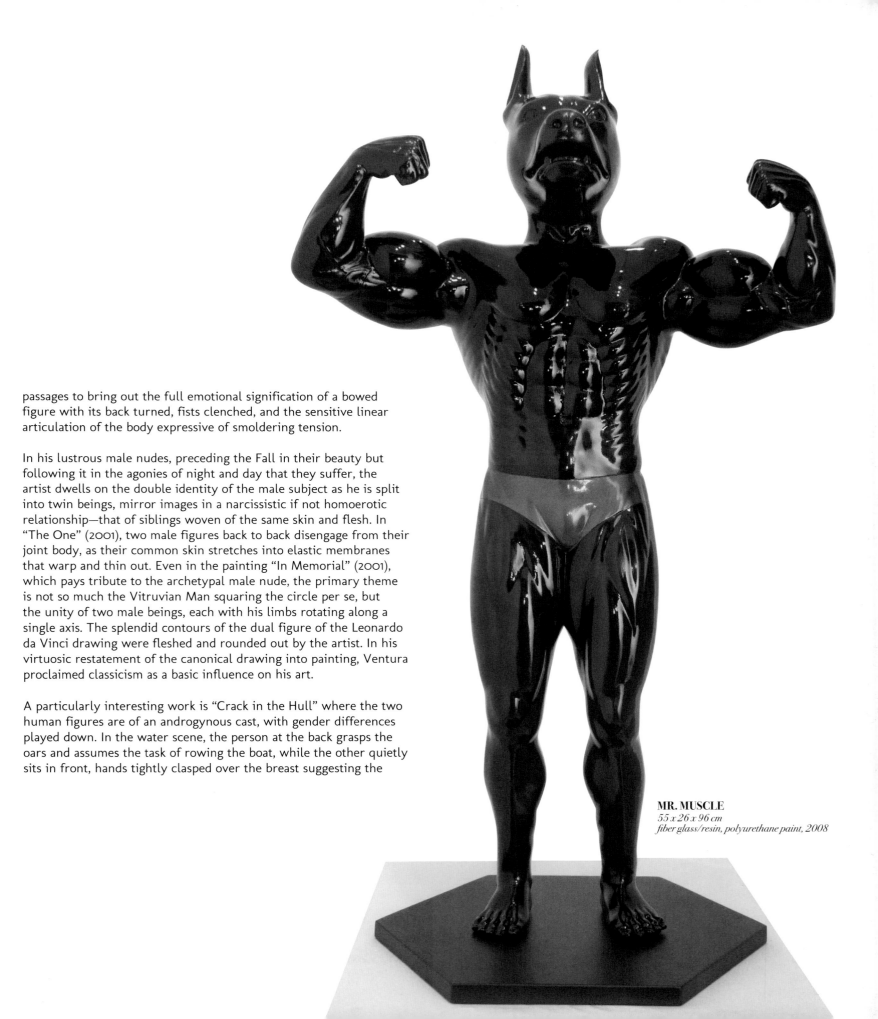

passages to bring out the full emotional signification of a bowed figure with its back turned, fists clenched, and the sensitive linear articulation of the body expressive of smoldering tension.

In his lustrous male nudes, preceding the Fall in their beauty but following it in the agonies of night and day that they suffer, the artist dwells on the double identity of the male subject as he is split into twin beings, mirror images in a narcissistic if not homoerotic relationship—that of siblings woven of the same skin and flesh. In "The One" (2001), two male figures back to back disengage from their joint body, as their common skin stretches into elastic membranes that warp and thin out. Even in the painting "In Memorial" (2001), which pays tribute to the archetypal male nude, the primary theme is not so much the Vitruvian Man squaring the circle per se, but the unity of two male beings, each with his limbs rotating along a single axis. The splendid contours of the dual figure of the Leonardo da Vinci drawing were fleshed and rounded out by the artist. In his virtuosic restatement of the canonical drawing into painting, Ventura proclaimed classicism as a basic influence on his art.

A particularly interesting work is "Crack in the Hull" where the two human figures are of an androgynous cast, with gender differences played down. In the water scene, the person at the back grasps the oars and assumes the task of rowing the boat, while the other quietly sits in front, hands tightly clasped over the breast suggesting the

MR. MUSCLE
55 x 26 x 96 cm
fiber glass/resin, polyurethane paint, 2008

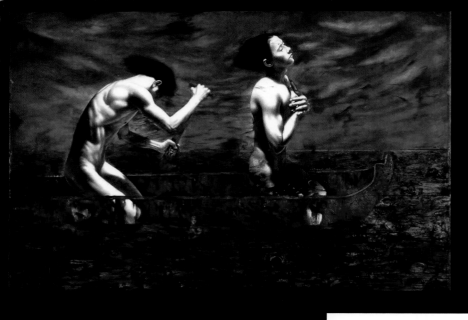

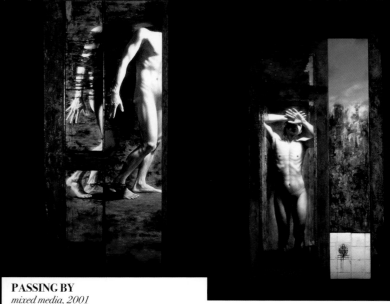

PASSING BY
mixed media, 2001

CRACK IN THE HULL
mixed media, 2001

MORNING RUST
mixed media, 2001

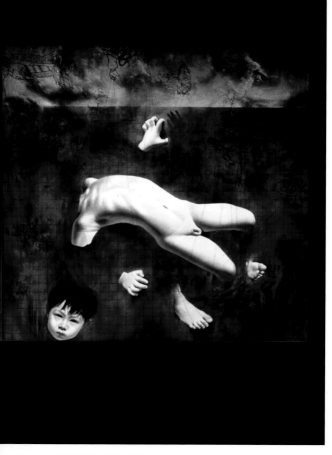

BLACK RAINBOW
oil on canvas, 2004

feminine gesture of modesty and concealment. Together they cross the sea in turbulent weather, the windy movements reflected in the chiaroscuro shadows flitting over their bodies. But in the waters float collaged units, icons of social institutions, religious and ecclesiastical. To the artist, these are powerful social forces that constantly impinge on the Filipino psyche to the extent that they threaten to breach the hull of the fragile boat, thus hinting at conflicts between the institutional and personal.

Without doubt, in Ventura's art, the male nude occupies a pivotal place. Unlike female nudes which have been painted by many artists in the long history of art, he perceives that the male nude subject bears a stronger residual taboo which he aims to break. This present conscious valorization of the male nude can be attributed to shifts in the social and intellectual climate, particularly in the field of gender awareness. For one, there has been a perceptible unloosening of the rigid molds towards a more liberal attitude in gender orientation. To an increasing degree, gender is becoming perceived as a cultural construct, rather than a purely natural one based on the binary categories of male and female.

To enrich his reflections on gender and history, Ronald Ventura made use of the device of windows and doors. According to him, "doors are temporary gateways between the past and the present. Closing doors signifies endings and beginnings, and capture our last word, our last emotion, as we trade one state of being for another." His device of using and juxtaposing door panels and sections defines as well as

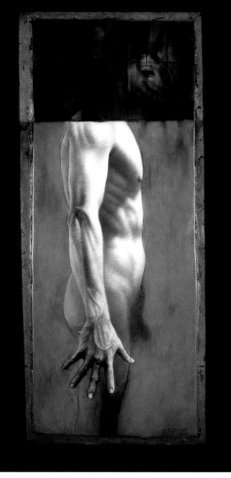

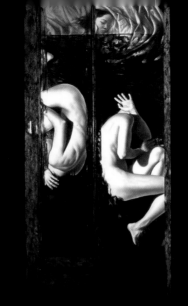

THE ONE
oil on canvas, 2001

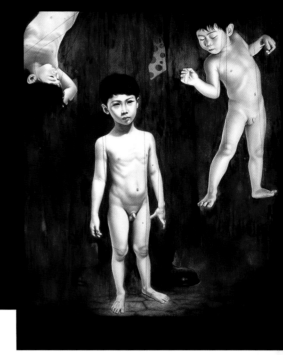

'TIL THE MORNING COMES
oil on door panel, 2001

MARIONETTES
oil on canvas, 2004

INITIATION
oil on wood panel

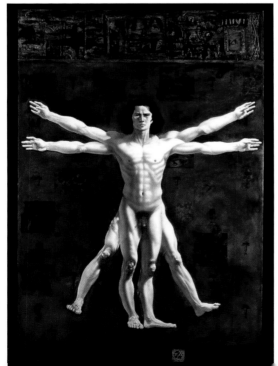

IN MEMORIAL
mixed media, 2001

constrains the format of the work, at the same time that it contributes to the production of meaning. "Dream in the Making" (2001) consists of two figures disposed in two sections. The standing male nude in full figure covers his sex with his hands, while above it is an apparition of a pair of feet against a dark, closet-like background, echoing those of the lower figure. As this incomplete figure moves upward into the light, it will reveal his full physical being with increasing assurance. In "Resurrection" (2001) , the dream is in the process of being fulfilled, as the standing nude, his arms in the gesture of self-revelation, sunders the webs that constrain him. These binding membranes bear imprints of religious and institutional icons which fall away with the figure coming into his own in the assertion of his true gender being. "Assimilation I" and "II" in the same year expresses tension in the continual threat of being assimilated into the system. In one, Saint Michael the Archangel, the symbol of traditional power structures, presses a foot on a young man's head. In the other, a standing dominant male tramples on a fallen one, signifying social persecution and prejudice.

Is the presence of woman found in these paintings? Only in "Till Morning Comes" (2001) where two male nudes sleep back to back, each confined within his narrow length of a door frame. Above them, in a horizontal section apart is a young woman, her sleeping face nestling within heavy folds of cloth. The painting is ambiguous in meaning. Does the woman's presence have a palpable effect? Does she visit their dreams? Their gestures even in sleep seem to convey refusal and denial of intimacy.

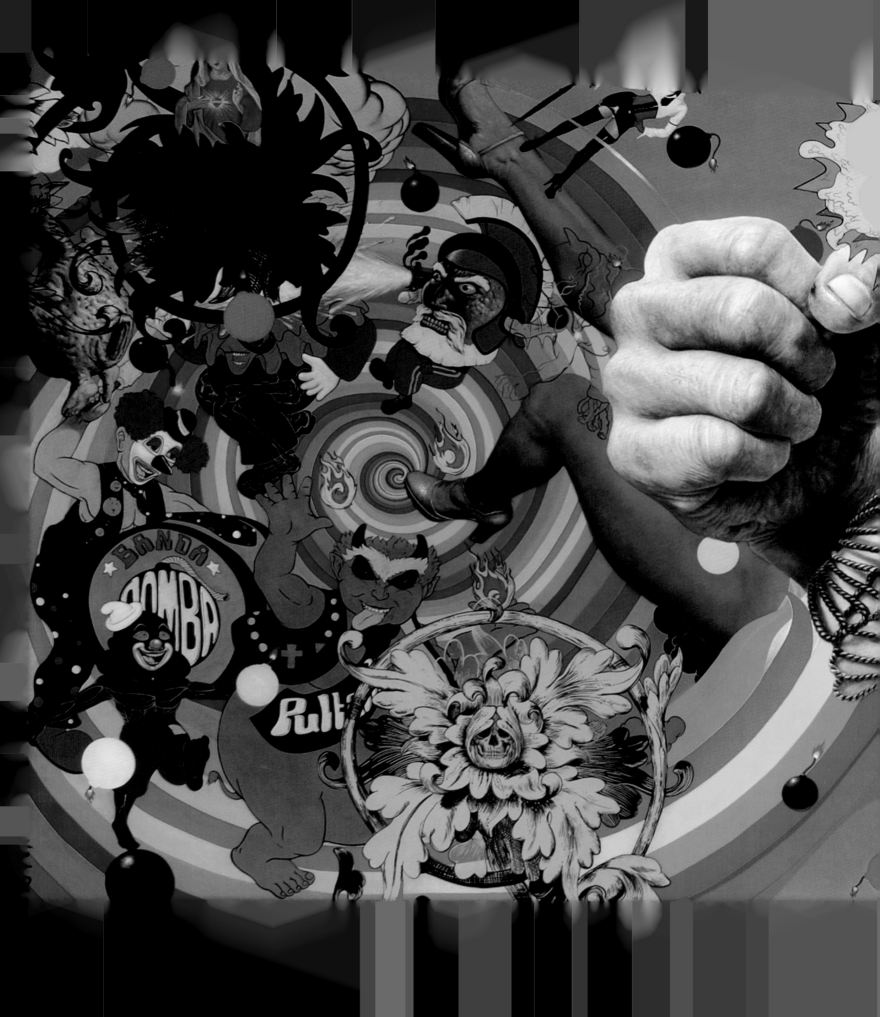

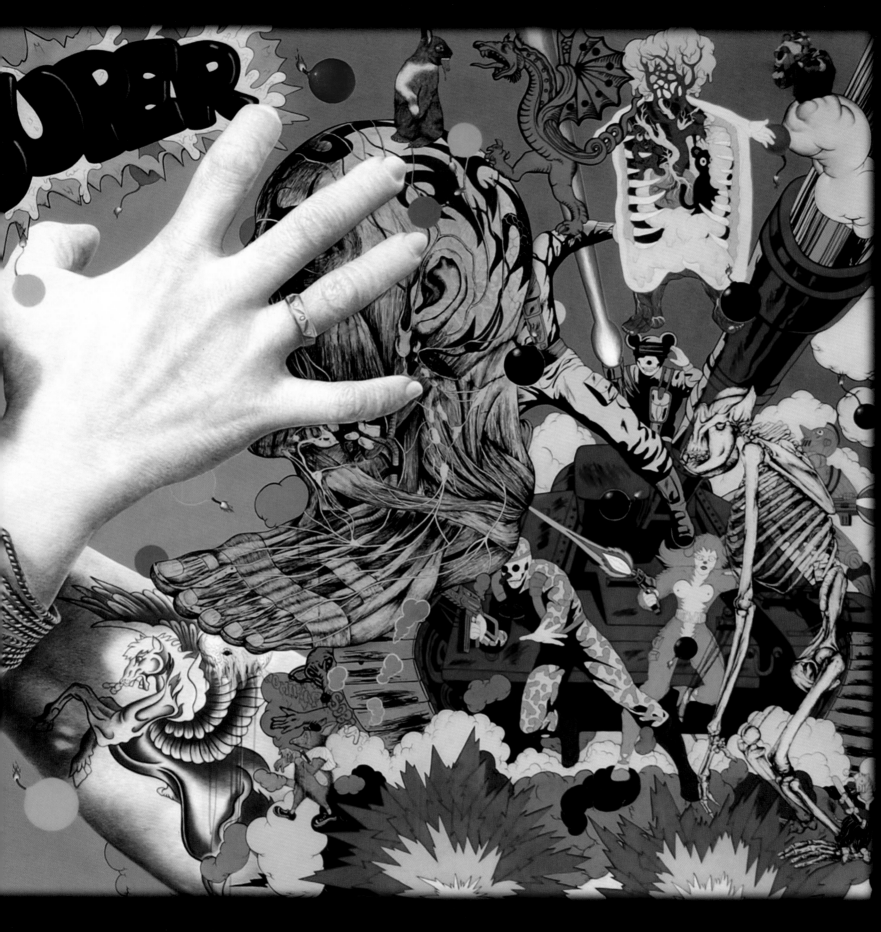

THE STRONG AND THE BEAUTIFUL
183 x 340 cm
oil on canvas, 2009

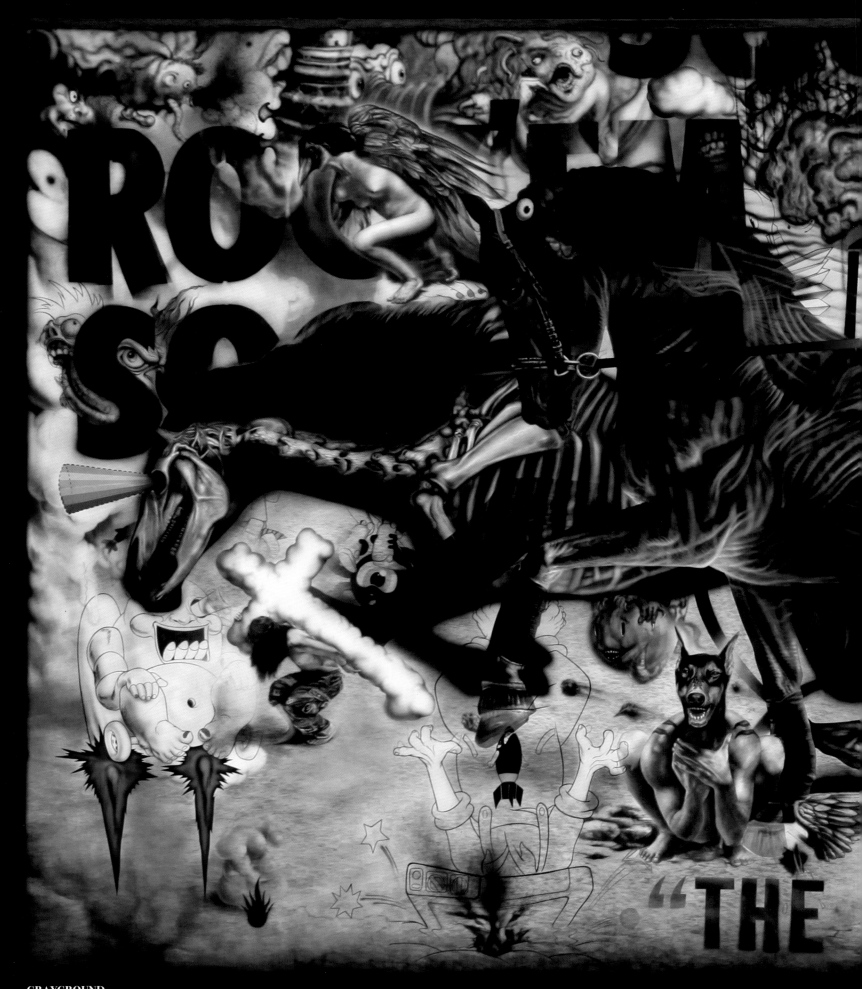

GRAYGROUND
152 x 396 cm, graphite, acrylic, oil on canvas, 2011

The old wooden doors in their weathered textures and carved designs can often only accommodate a single figure because of their narrow vertical space. In these juxtaposed doors or panels, a dialogue ensues between the elements or figures which occupy them. In the fertile imagination of the artist, the doors metamorphose into boats, beds, and even graves, as intimate spaces. Contrast is brought out between the luminosity of the nudes and the stained, distressed textures of the wood, sometimes collaged with ornamental units of woodcarving, in hues of ochre, dark brown, or even gilded tones, bringing suggestions of the sacred and the precious.

Within his thematic context, there are other binaries that Ventura consciously seeks to dissolve: figurative and abstract, two-dimensional and three-dimensional. In relation to the theme of self-realization, "Passing By" (2001) executed on a pair of adjacent panels, shows a progression from two-dimensionality to three-dimensionality in to identical male nudes moving in one direction, cropped vertically down their entire length. Upon the nude in the narrower and shorter panel on the left are superimposed cursory horizontal lines of various thicknesses, as well as passages of tone that have the effect of flattening the figure. The second figure, now released from these traces, assumes a supple roundedness of form and completeness of being. In another two-part painting, "Diptych" (2002) a figure dynamically breaks loose from the dense gestural and tonal field on the left even as he is in the midst of stripping his body bare in a spontaneous gesture of natural grace. In "Rest" (2001), where the format of the door is divided into

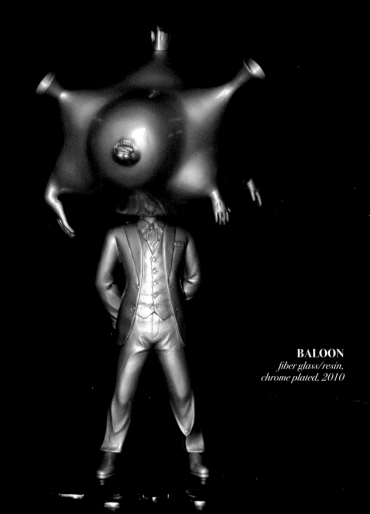

BALOON
fiber glass/resin,
chrome plated, 2010

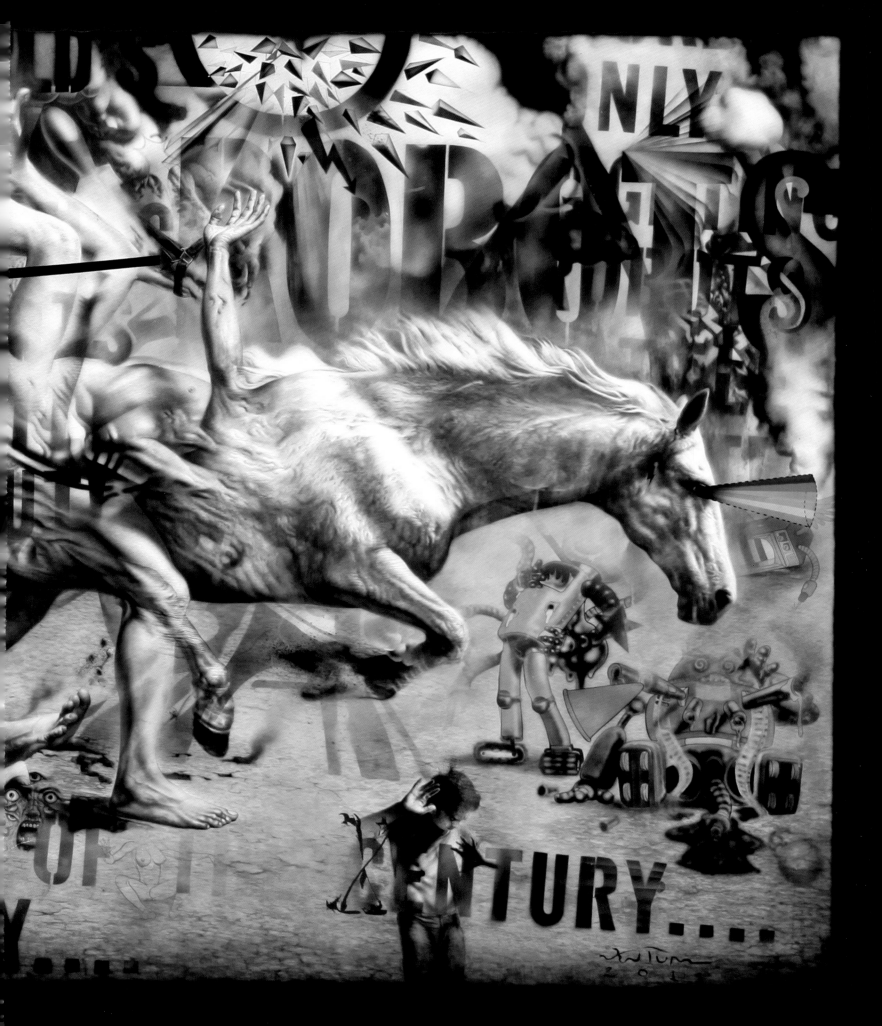

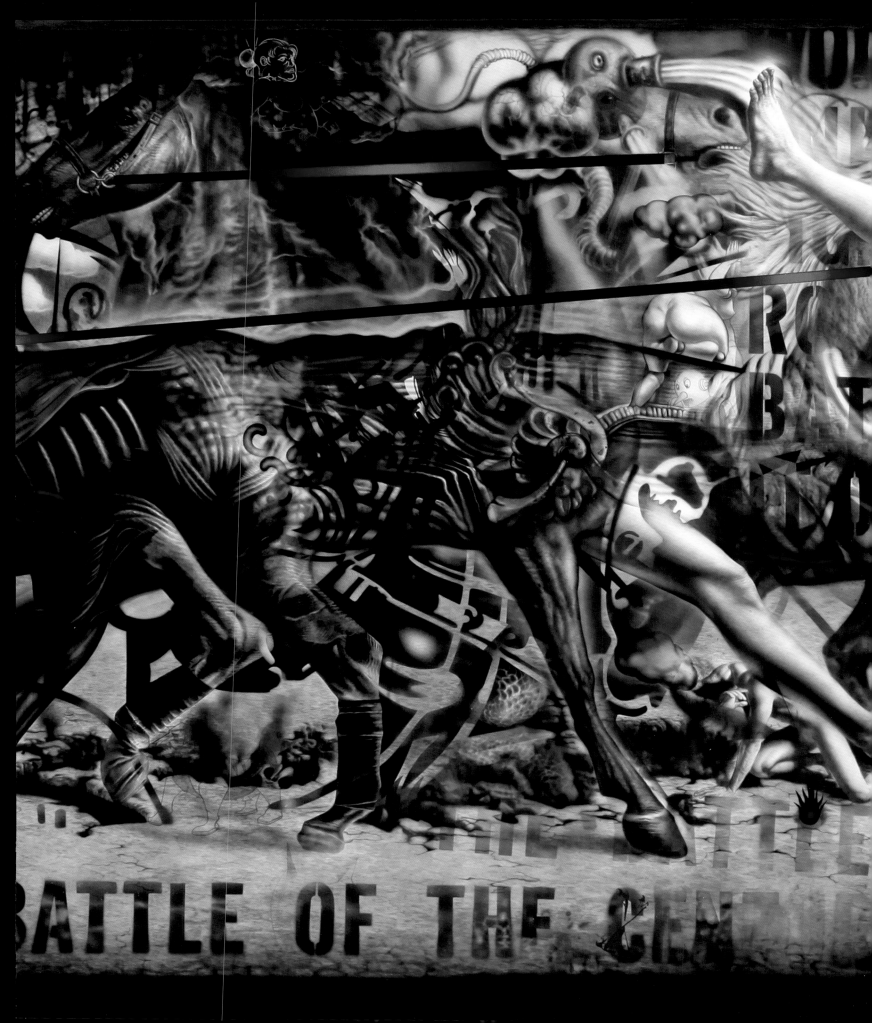

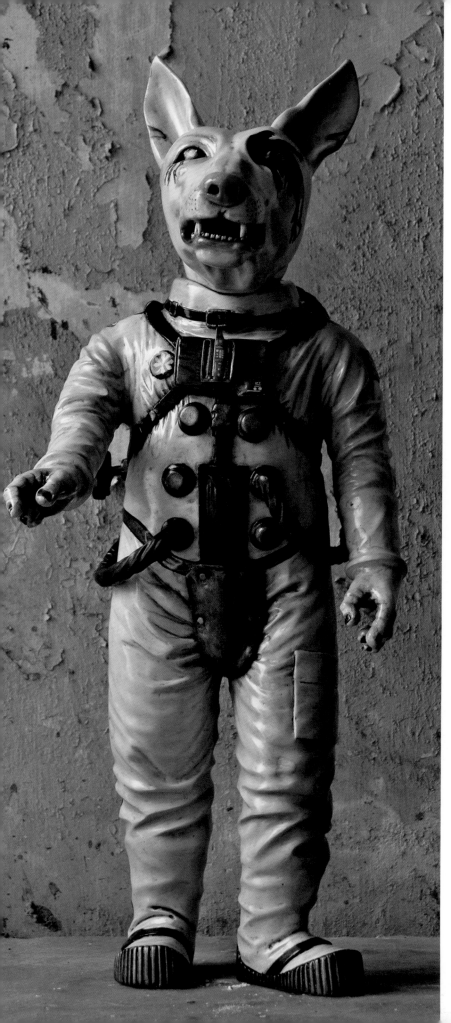

coffered panels, the upper space shows a horse galloping among the clouds while in the lower section a young man sleeps with his head resting on a table, the tension in his spread-out fingers hinting at a dream in progress.

Part of his work in the early years is the subtheme of exploited children as in his show "Dead-End Images", a grim title for the subject of children. While most of his subjects are boys, one shows a young girl, a sampaguita or flower vendor. The stark contrast between her pale flesh tones and the rest of the painting including her simple red dress and the shadowy landscape conjures a latent disquietude bordering on anxiety and alarm. She has a pleasant face, although bloodless, with the hint of a smile, and her upraised hand makes a gesture reassuring that all is well and at the same time staving off an implied presence from closer approach. There are, however, sinister indications of disaster: the strands of sampaguita that she holds have traces of blood. Furthermore, there are whispering presences that impinge on her consciousness. Superimposed on the image are sketchy figures of carnival clowns that mock her wholeness. In the sky above, a circus ringmaster wields a whip and a baton with a pendant of traffic lights that function to order her movements according to a mechanical and external rhythm. The title National Flower (the sampaguita is the Philippine's national flower) implies that she embodies Filipinas in her plight of being commodified and captive to external interests.

This theme is furthered pursued in "Marionettes" which shows three nude pre-teen boys. The one at the center stands straight, gazing directly at the viewer who becomes implicit in the scenario. The boy's puny frame is completely exposed and defenseless, passively expecting the machinations of powerful adults and vulnerable to their whims and vices like a human toy for sale. Upon closer look, one sees that the three hapless boys are marionettes manipulated by strings: the one on the right does a slow awkward dance, while the half-figure of the boy on the upper left is whirling in the wind and oblivious to his surroundings, perhaps beyond saving. The shadowy tall male figure

LUNATIC (Dog)
28 x 73 x 38 cm
fiber glass/resin, polyurethane paint, 2010

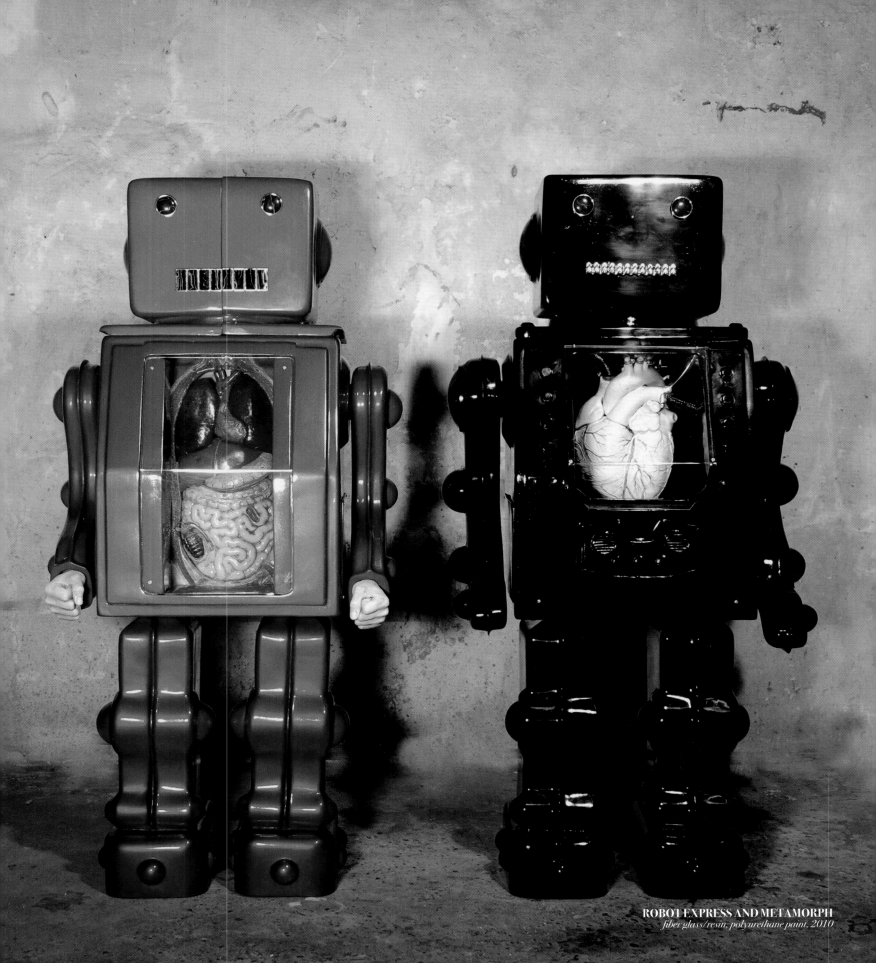

ROBOT EXPRESS AND METAMORPH
fiber glass/resin, polyurethane paint, 2010

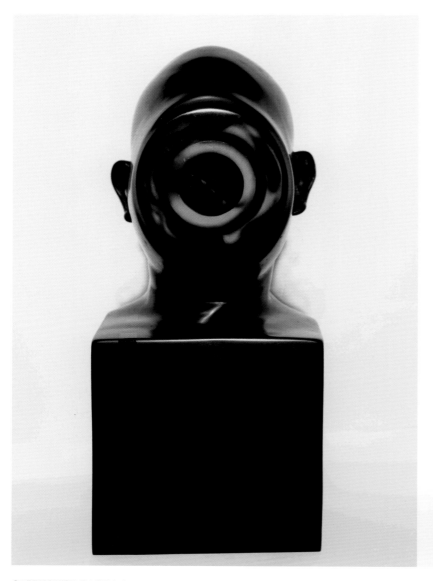

CAUTIONED FACE (1)
fiber glass/resin, polyurethane paint, 2010

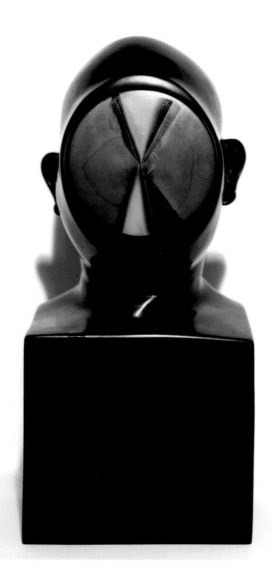

CAUTIONED FACE (2)
fiber glass/resin, polyurethane paint, 2010

in their midst with his shiny black boots and polka dotted tie is no other than Ronald MacDonald who is the prince of hamburgers but who is an ideological symbol as well. In general, the lurking figure is the sly adult who clandestinely lures children with sweets, if not spiked candies, to hold them captive and to make them soft as putty to their nefarious designs. But as the MacDonald icon in particular, he represents the wide reach of globalization in food chains that seek to replace indigenous tastes with fast food and bring children, through bright and colorful inducements, into the fold of the "American way of life" including, not only hamburgers with ketchup and mustard but also bloody wars as well.

Still along the theme of puppetry, Ventura does a brilliant appropriation of a painting by Caravaggio, a 16th century Italian baroque painter. The Caravaggio painting in the rich tonalities of the master shows a couple guiding their child in taking his first steps. But in Ventura's work, the child with his human face has a wooden puppet's figure with its clearly articulated ball-and-socket joints. In the artist's theme of the lack of freedom, the child, as soon as he learns to walk, enters a social structure which strips him early of his free will and capacity to explore, learn and make choices on his own.

Another particularly striking work is "Mystery of Blue Sky", executed as always in Ventura's flawless figurative style with its superb control of colors and tones, as well as its rich conceptualization. Here a boy comes upon a box, possibly a gift, which greatly intrigues him as he tries to scratch the paper wrapping apart. Completely absorbed, he himself is all wrapped up in an emotional experience which launches him to a high heaven of blue sky and clouds. His feet, however, still touch the ground which connects to a sweatshop filled with sundry mechanical parts and assorted tubings, possibly alluding to his environment as child laborer. This low everyday ground exudes a murky, reddish glow which contrasts with the cerulean blue of the sky and its softly floating clouds. But the blue sky turns out to be only an illusion like the scenographic tableau of a theater stage. For one soon discovers that this utopian image is punctured in places and from the holes, possibly caused by bullets, issue passages of dried blood. Another hole reveals the rusty net supports of the illusory image.

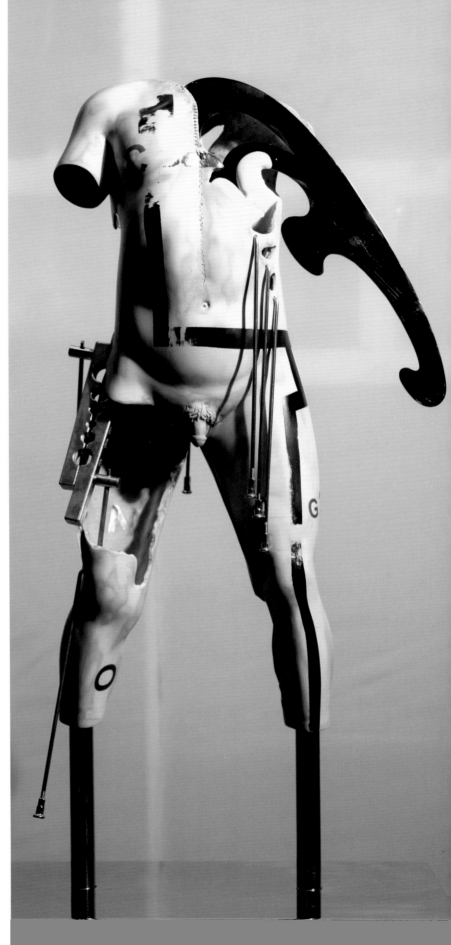

SCALED MAN FIGURE
*fiber glass/resin, stainless steel,
polyurethane paint, 2010*

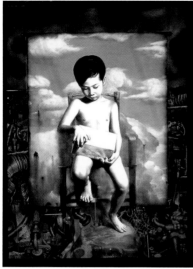
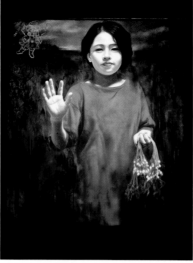
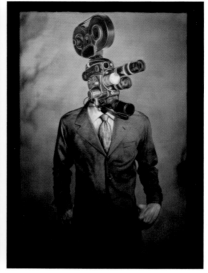

**MYSTERY
OF THE
BLUE SKY**
*oil on canvas,
2004*

**NATIONAL
FLOWER**
*oil on canvas,
2004*

MEDIATOR
*oil on canvas,
2004*

RELIEVER
oil on canvas, 2004

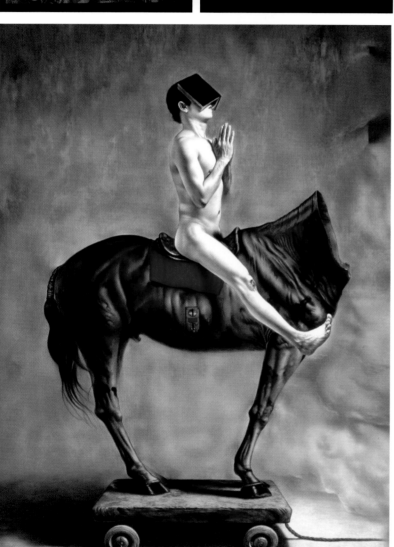

There is likewise a sense of the moment of the eruption of violence, as in the Pompeian figures

When he finally opens the box, the entire image will fall upon him, painted cardboard panel and all.

In "Black Rainbow", all is lost in the dismembered body of a young nude boy, all parts flung randomly onto the dark red field. His head hints of suffering in the puffy cheeks and eyelids. The arched torso indicates physical struggle, and so do the hands that clutch vainly for support. There is likewise a sense of the moment of the eruption of violence, as in the Pompeian figures caught in their last living gestures. The exquisite tonal treatment of the figure in which the rib cage and the muscles are foregrounded as the basic elements of the human form lend drama to this spare work. At the same time, the artist's figures acquire a sculptural quality because of their smooth execution and sensitive tonalities akin to the marble Apollos of classical art. Because of this, his ideal figures convey the sense of exquisite victims entrapped in structures of banality, poverty, and violence.

There were likewise in this particular show two supplementary series under the same theme of child exploitation. One is the series of children entrapped in cubes which are dices in a Snakes and Ladders game. Opaque or transparent, the cubes could be taken as a virtuoso device to display the artist's capacity in creating many variations of the form, standing, seated or striding, imprisoned in a cube. Again, these images suggest manipulation, of figures thrown willy-nilly

ZOOMANITIES (Series)
fiber glass/resin, polyurethane paint, 2008

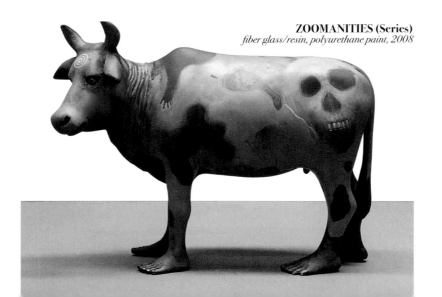

on a gameboard, where, deprived of their will, they are caught in
a fatalistic situation. Even more, the checkerboard in black and red
becomes a two-dimensional field where contending forces fight for
the child's soul. These forces take the form of cartoon characters,
clowns and carnival animals, lightly sketched in white on the
surface, while the children move about with slow, doleful faces, like
somnambulists in a dream.

The other secondary series is entitled "Mourning Cookies" consisting
of small biscuit molds of faces which, impliedly, are baked or made
to set or harden. In these paintings, the artist juxtaposes the face
removed from the mold and the mold itself which are positive and
negative images, asserted as visually equivalent in value, constituting a
significant whole. They seem to be made for ritualistic or ceremonial
purposes in honoring the dead and have been associated with fiestas,
such as the San Nicolas biscuits baked in molds. The faces themselves
have the quality of stone sculpture or of death masks whose only
claim to life is their infinite reproducibility. There is an elegiac tone
in the images of entombment, where the beautiful and seamless body
is laid among a debris of stone and bones, or when an eyeless face,
still bearing the sensitivity of living flesh, lies without sight or speech
among the ruins.

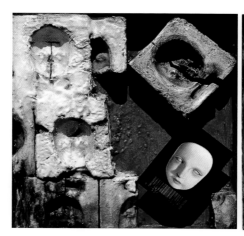

HEAD (3)
fiber glass/resin, polyurethane paint, 2004

MOURNING COOKIES (1)
fiber glass/resin, polyurethane paint, 2004

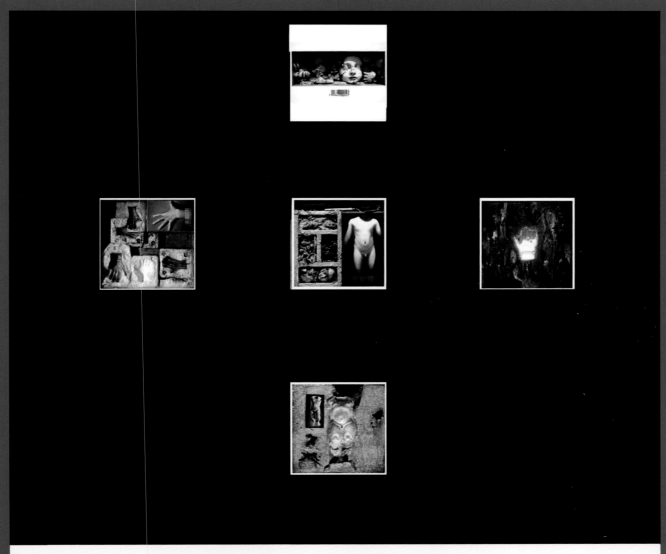

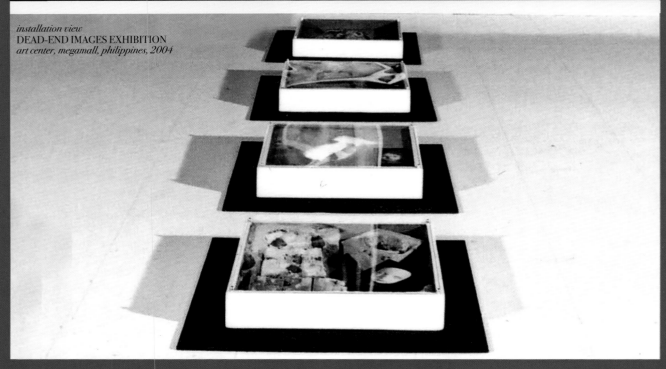

installation view
DEAD-END IMAGES EXHIBITION
art center, megamall, philippines, 2004

These works span Ronald Ventura's early career from 2000 to 2005, the year of "Human Study". Born 1973 in Manila, Philippines, the boy manifested his artistic talent early under the tutelage of well-known art teacher Fernando Sena who conducted many workshops for the youth in depressed areas in Manila. Upon graduation from high school, he took up fine arts major in painting at the University of Santo Tomas where he graduated in 1993. In a few years, he garnered a number of national and international awards, including the Juror's Choice Award in the Philip Morris Philippine Art Awards (1998) and Finalist in the same competition (2000), as well as the Juror's Choice Award in the Windsor and Newton Painting Competition (1999). In 2005, he won two major awards, the Cultural Center of the Philippines' 13 Artists Awards and the Ateneo Art Awards.

From "Human Study", the artist extended the parameters of his thematics to tackle a number of issues and directions in which he takes on a bolder engagement with the contemporary world.

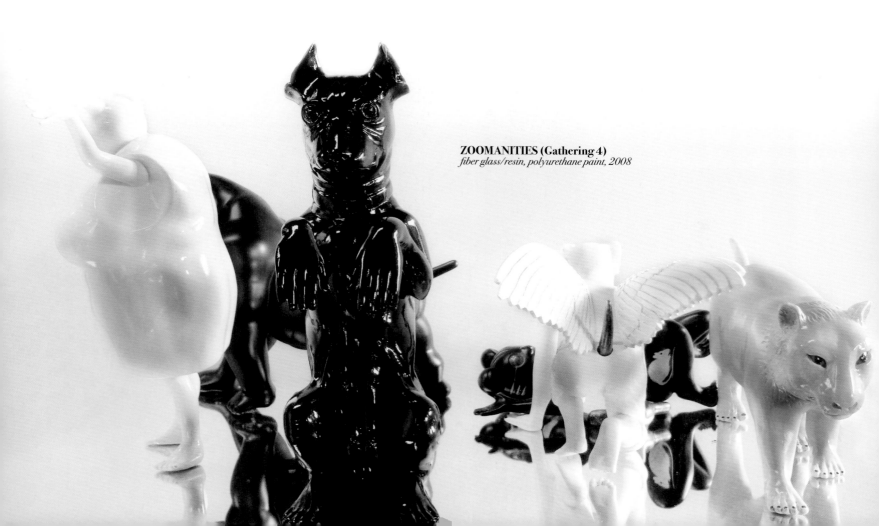

ZOOMANITIES (Gathering 4)
fiber glass/resin, polyurethane paint, 2008

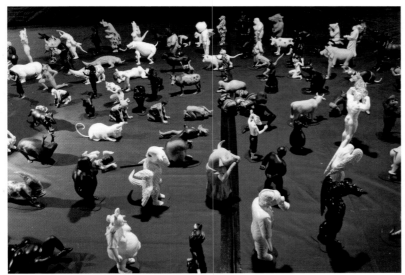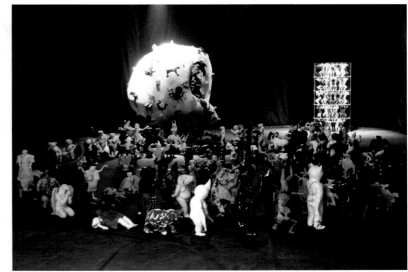

installation view
ZOOMANITIES EXHIBITION
art center, megamall, philippines, 2008

The first direction had to do with enlarging his living field to include forms of life other than the human, thus culminating in his work on animals, familiar and otherwise, and the osmotic exchanges between human and animal. He had been doing this previously, introducing striking portraits of animals with their own taut personality, and

Forms of life other than the human

culminating in the great congregation of beasts with their own power structures in "Zoomanities", shown in Manila and at Tyler Rollins Fine Art, New York, executed in mixed media, paintings and installations—a wild conglomeration of materials: fiberglass, resin, plastic, metal, silver, bronze, all hand-painted, done with or without found objects, religious and secular, but most of all, projecting an irresistible aura of their own.

Ventura carries his thematics further by taking a stand against speciesism which is the belief that the human race is superior to other species and that exploitation of animals for the advantage of humans is justified. Instead, he plays on the interchangeability of human and animal, rejecting specieist privileging. The standing figure "Initiation" (2002), caught by surprise, suddenly sprouts a donkey's head—possibly signifying the assertion of unconscious and non-rational forces over reason and logic. Horses, too, make their appearance in his latest paintings, as symbols of unconscious drives and impulses. They sometimes bear, however, a naïve, childlike quality like carousel ponies prancing and leaping although at times they can also sport a heroic air

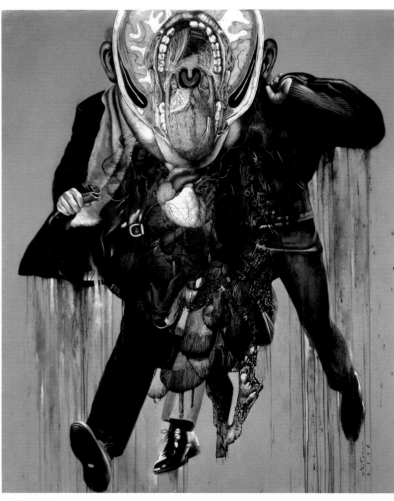

APPETITE
122 x 152.4 cm
oil on canvas, 2008

as in the handsome steeds of 19th century equine painters. Ventura will take this content further in his Singapore show with spoofs of exploitative glossy fashion ads where models display with impunity body parts of an exotic animal incorporated into a flashy designer bag.

With his 2008 National University of Singapore solo show, "Mapping the Corporeal", the artist seems to leave behind as an episode the idealized nudes coming into their own, and focuses on other hitherto untouched aspects of the human animal: his overwhelming carnal appetites that distort his human nature. This direction has led to grotesqueries and monstrous creatures with exposed viscera where the cravings take over the higher faculties, as in "Appetite" (2008), before which the gargoyles and succubi of the past must pale in shame.

Another direction the artist takes embraces the cyberculture of our times with its new language and icons that proliferate in computer technology—an exotic lexicon which settles into the belly of our present culture with avidity, spawning junk food, fast food chains, and social networks of no specific culture to fill our frenzied nights and days. Images from pop art and cartoons, color with black and white, arcane symbols, haute couture with history and philosophy, all these elements dizzily overlap and intermingle in Ventura's art. Yet, one notes that the artist asserts that they all finally redound to identity, "whether assimilated to a larger whole or lost totally." And this indeed is nothing to wonder about because the Philippines in particular is a severe case of cultural layering from colonial times past to the globalized present. It is only a wonder how one can extricate the corpus of identity from this "embarrass de richesses".

With all these diverse and conflicting elements, Armageddon is surely not far behind. Ventura shows how close it is in "Grayground" (2010), the large auction-busting mural 60 x 155 3/4 inches which holds a mind-boggling secular congregation of warriors and maddened beasts of all stripes all set to do war on all humanity and itself. But somewhere in the midst of this embattled whirligig is a gray zone, a no-man's land or vacuum but which in due time will be filled with the rushing apocalyptic wind.

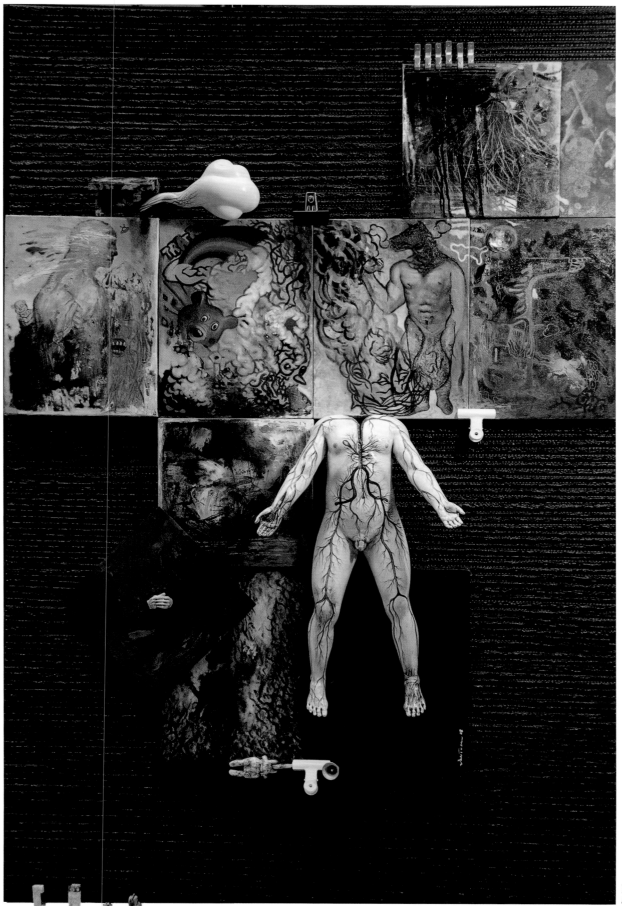

PROFILE
mixed media, 2010

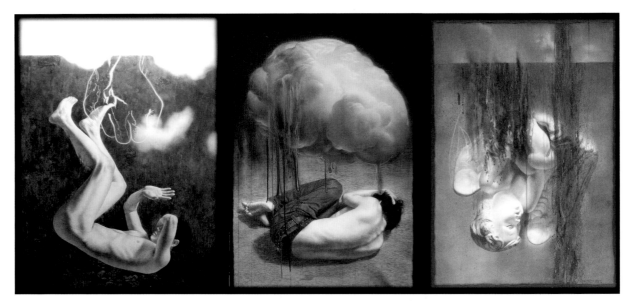

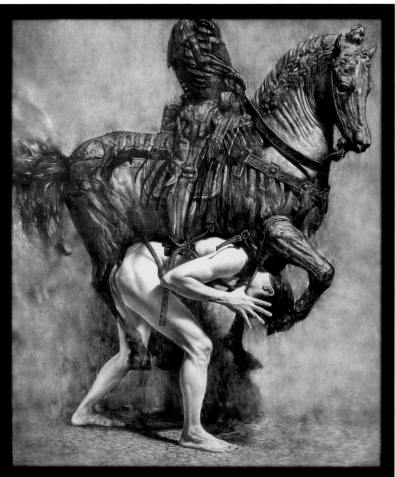

BIG BROTHER
oil on canvas, 2006

DARK CLOUD
oil on canvas, 2006

DETERIO-RATING DECO
oil on canvas, 2006

OVERSHADOW
graphite on canvas, 2005

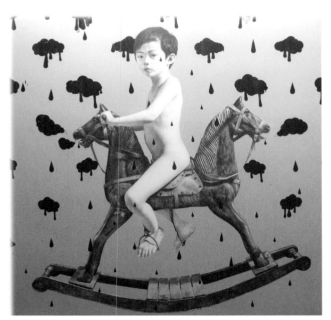

BLACK AND BLANCHE
oil on canvas, 2008

We are still used to pigeonholing artists on the basis of where they were born as well as their social and cultural background. Indeed, there are geographical and cultural factors which influence the definition of an artist's personality although it was with the advent of the industrial age that these influences began to weaken.

Does all this work on a practical level? Shall we try? Let's attempt to give a plain answer. What nationality was Pablo Picasso? French? Spanish? Or did he in the end opt – as he had threatened to do – for other nationalities, linked to one of his sudden ideological enthusiasms? "No idea really!", many of us guiltily reply! In short, when we are forced to say it plainly we discover we don't know the nationality of the most famous artist of the twentieth century: Pablo Picasso: French? Spanish? Or...?! However, let's console ourselves. There is no need to feel too guilty my friends. Indeed, if we go onto Google we discover that on that most reliable of search engines they have the same problems, to the extent that, in order to solve them, Google resorts to nothing less than a statistic [sic], based not on checking sources – as, nowadays, there is no need to

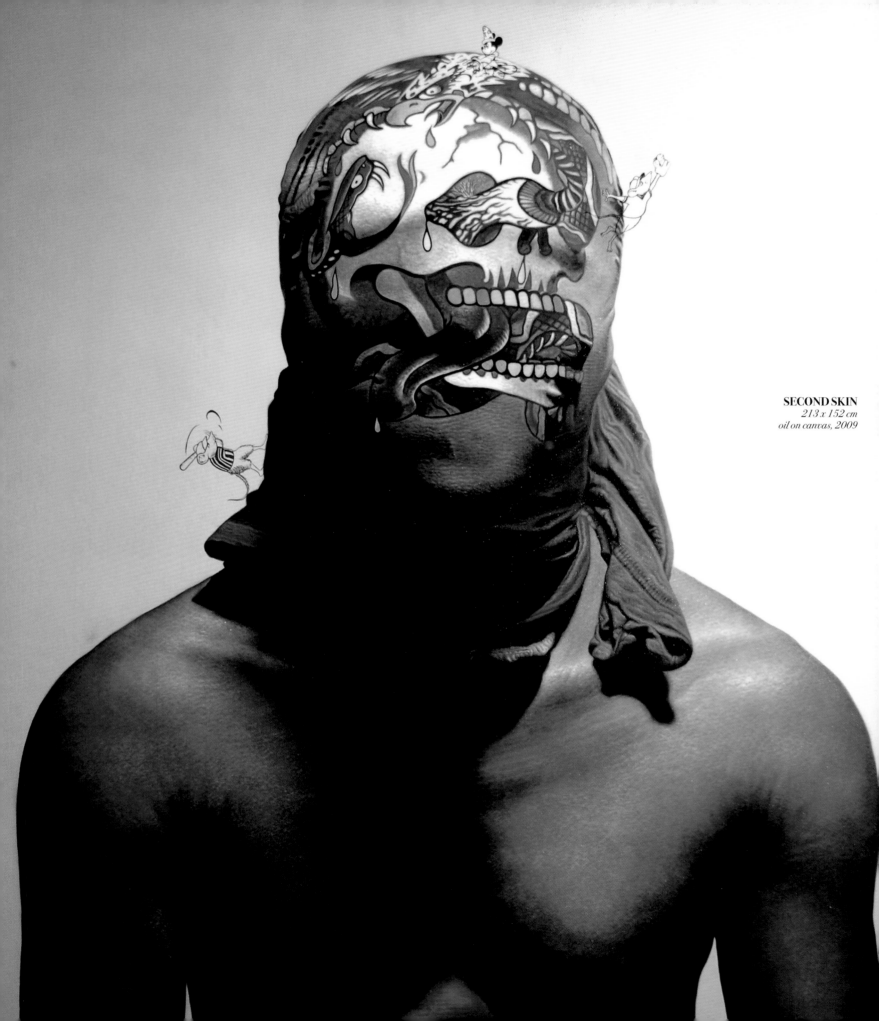

SECOND SKIN
213 x 152 cm
oil on canvas, 2009

stop at birth certificates – but on what they call other "credible" websites! He was, indeed, Spanish, they eventually declare, showing the list of these credible sites as proof. Now if this happens when speaking of a relatively stable and much less dynamic and migratory industrial agricultural Europe, dating back to before the two World Wars, how can we continue to define a person on the basis of a nation, a city or a geographical area to which this person is supposed to "belong" in that mishmash which characterises the global world? And yet not only does this happen but the pigeonholing of a person – and especially an artist– on the basis of nationality is still practically de rigueur and can help to both exclude him from and project him into the firmament of the stars of contemporary art. Let's take amongst others the great contemporary Chinese and Indian artists, whose works have rocketed in value in the last decade and who have taken part in exhibitions and events in many museums around the world, that were previously unimaginable for them, are there to remind us of it. All in all, the electronic and binary world has made it hard to positively and truly define the precise origin and nationality of many people, yet this does not prevent it from alluding to the context of an artist as though duty-bound to do so.

Some of these countries are beginning to develop an interest in artistic achievement thanks too to the presence of highly talented artists. This is seen, for

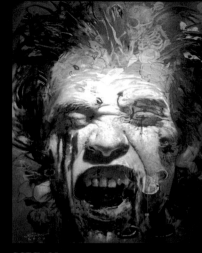

SCREAM
oil on canvas, 2007

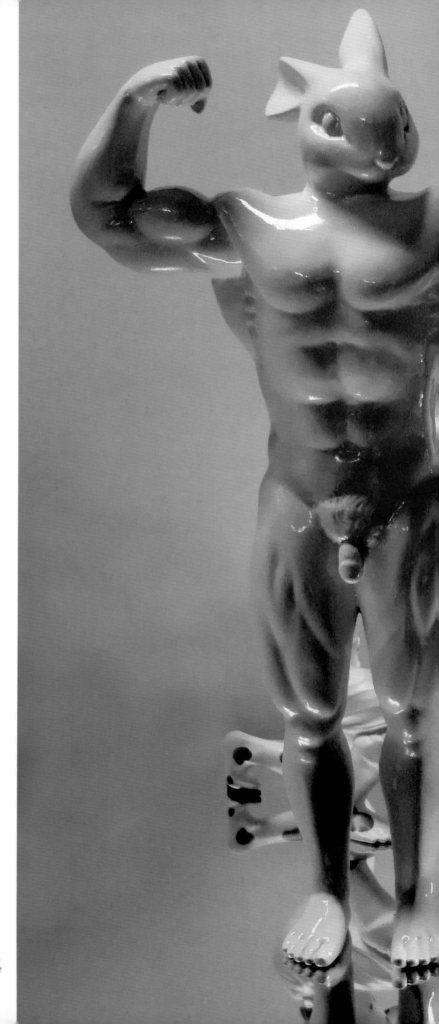

instance, with the protagonist of this volume, Philippine painter and sculptor Ronald Ventura, a sulphurous artist, whose gift is to transform his thoughts into powerful visual actions. He succeeds to transmit to us his feelings, thoughts and emotions, with regard to many situations which dominate today's reality and which affect our lives, in a kind of philosophical and artistic live broadcast. In his paintings and sculptures he does so in an urgent, incredibly varied way that is spectacularly rich in intuition, in ideas, in socio-anthropological and psychological studies, which he sprinkles with references to various linguistic genres depending on the case: from comics to graffiti and from chiaroscuro to sculpture, with the result that he touches a chord with and enmeshes people who belong to widely differing cultural and social dimensions. And all of this is done with an immediacy, a freshness and an authenticity which we are unaccustomed to.

With Warhol and subsequent generations of artists, such as Jeff Koons or Damien Hirst, who patterned their behaviour as artist managers and their idea of the current role of art on the basis of what happened with the advent of the mass media and its subsequent excess of power and the consolidation of mass society and the power structures which make it work, artists gave up on expressing their vision of the world. They yielded to and took advantage of the success of an increasingly aggressive consumer society dedicated to fame and profit, and accustomed to setting values and making decisions on a purely financial basis.

ZOOMANITIES (Gathering 5)
fiber glass/resin, polyurethane paint, 2008

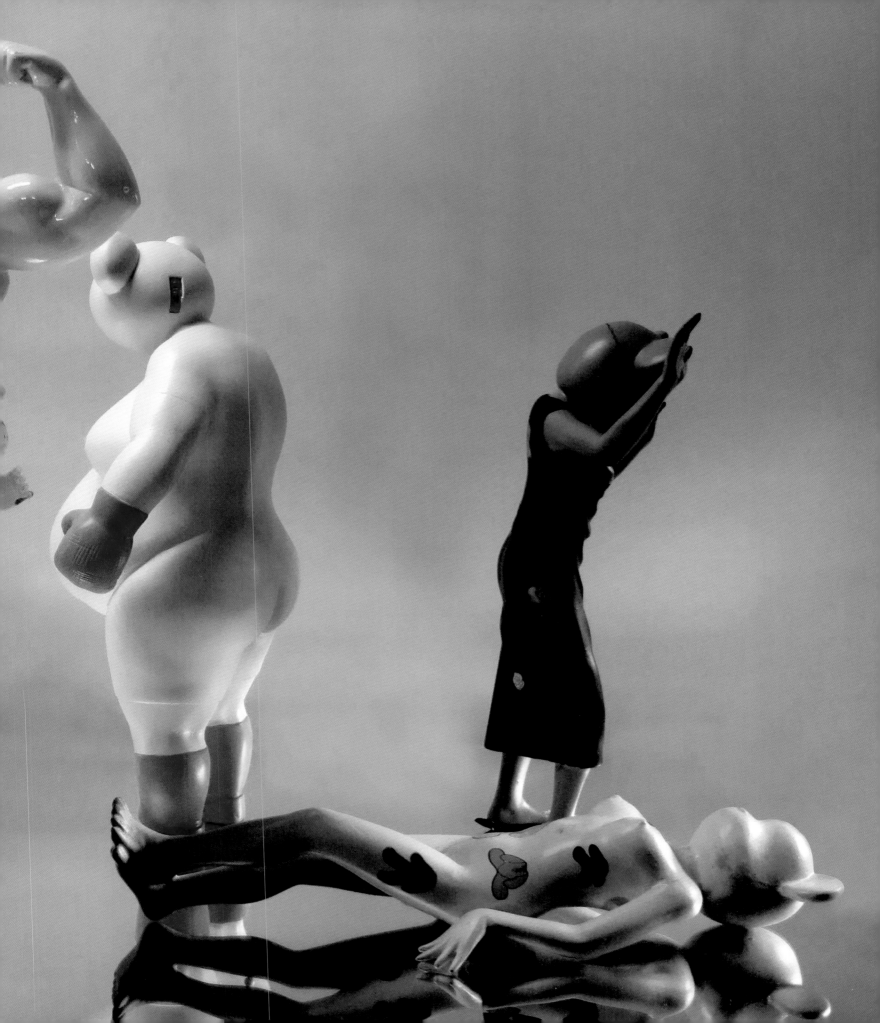

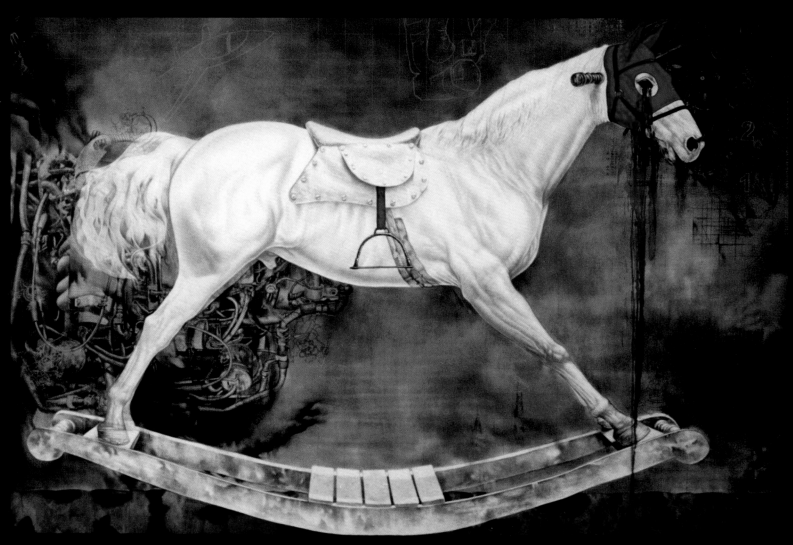

BLIND MECHANISM
oil on canvas, 2003

Now, with emerging markets gradually being encompassed by the global economy, parameters are shifting and these changes are reflected in the art world. Artists in emerging economies are assuming new physiognomies and taking on new roles, while enjoying a phase of freedom of expression. Therefore, while it is true that the countries which are now beginning to elaborate an independent, serious and pondered art scene have neither contributed to the development of the industrial and technological world of which they have come to enjoy a part of the fruits, nor elaborated as a nation their own avant-garde visions, today it is something else that counts. In order to operate efficiently and incisively in the contemporary world once more it is vital that each artist makes a basic choice regarding the attitude with which they deal with the powerful and ruthless competition from the forces which prevail in every field of communication and mass communication in particular, and that they are able to stand up to the extreme economic pressures which dictate most of the laws of the art world, such as economics, fame, success. They have to make this clear with their behaviours and choices, be they creative or critical towards the society in which they operate, through the relationships they have with the society of reference. This goes for everyone, both for those who find they are starting out in countries where both the consumer society and marketing have been establishing and consolidating themselves for a long time- having now covered a great deal of ground which has enabled them to settle in the most hidden nerve-centres of society- and for those who have only recently come to adopt a market mentality, coming from a society that is instead based on consolidated and conservative structures and institutions, and on stable and traditional values.

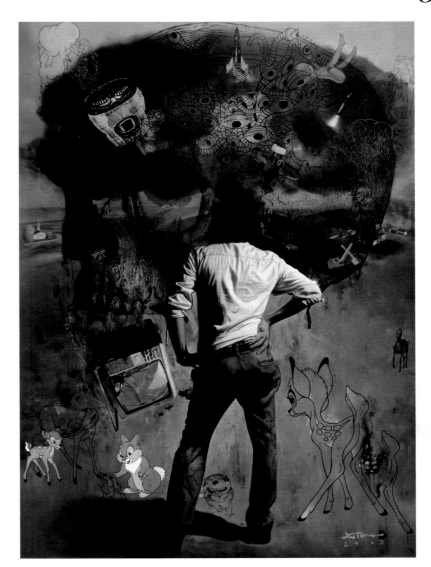

POP!
244 x 183 cm
oil on canvas, 2009

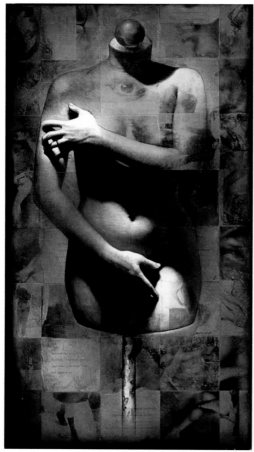

VENUS
mixed media, 2002

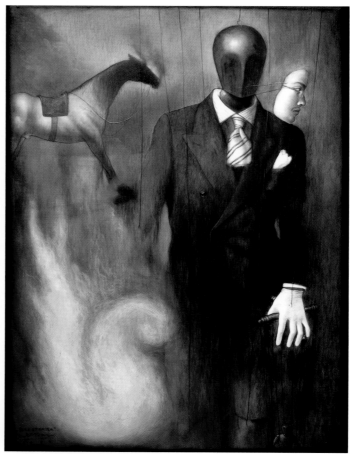

FIRE STARTER
oil on canvas, 2003

This book dedicated to Ronald Ventura- the first to gather together his works from his debut to today, with its vast but select anthology (partly chosen by the artist himself) – also allows us to explore both his artistic style and social and cultural commitment from many angles. We are therefore able to examine both the visual techniques and the basic themes with which an extraordinarily talented artist, who is originally from the Philippines, is maturing his artistic expression and his conscience and personality, by means of an entirely personal dialectics developed independently and autonomously – something that might not have been so easily possible under the constant pressure of the spotlights of a large and super-competitive metropolis like New York.

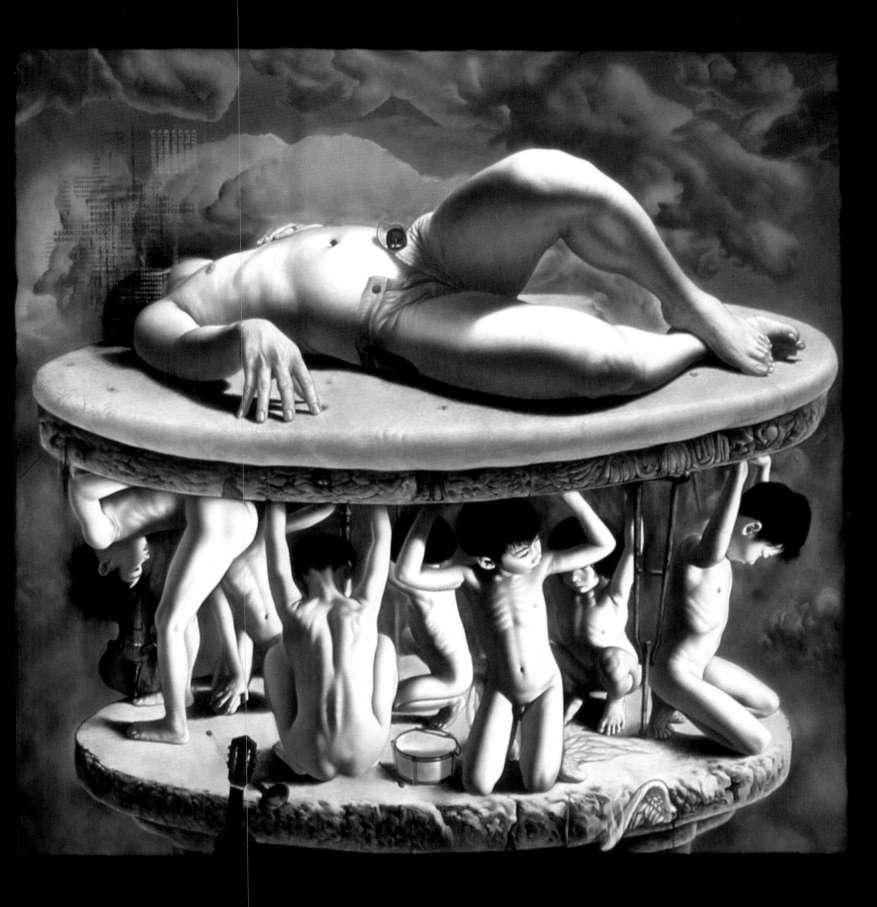

BEDROCK
oil on canvas, 2004

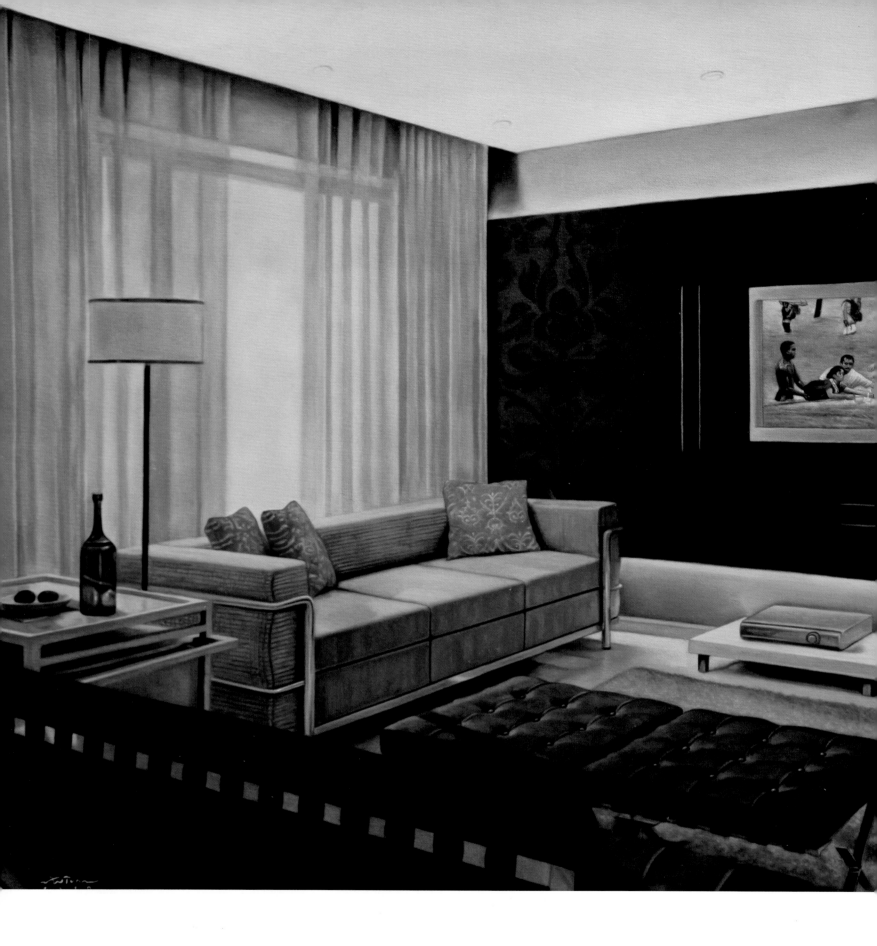

One aim of the artist and of the contents of the book is to reveal how the development of expression and the elaboration of an idea are interwoven. On one hand the artist aims to increase his knowledge of what is really happening in current society both from a human and from a political and economic point of view. On the other hand he moves from critically identifying pre-eminent trends in today's socio-cultural evolution to elaborating communicative strategies which prompt dialogue and awareness on the part of those of us who observe, without falling into the consumer trap of a chameleon-like adaptation to the styles and fashions of the day, exhibited in the most seductive, theatrical and narcissistic possible ways.

In the book we find two types of themes- those that are more strategic and general due to their ability to influence society as a whole, and those which are more circumscribed by specific themes and problems. Over time these alternate with one another, although often, observing them again at a distance on the pages of this anthology, we find affinities, differences, and also developments or portrayals of other points of view regarding the same theme. This reveals a continuity in terms of his focus and desire to enquire deeper, and also a belief in his

HOME THEATER (2)
91,5 x 150 cm
oil on canvas, 2010

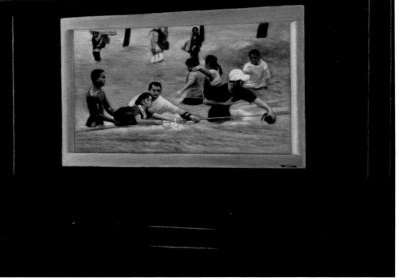

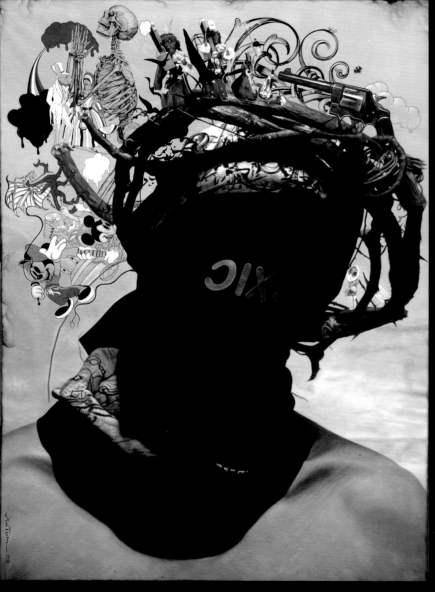

BLACK PARADE
213,5 x 152,5 cm
oil on canvas, 2009

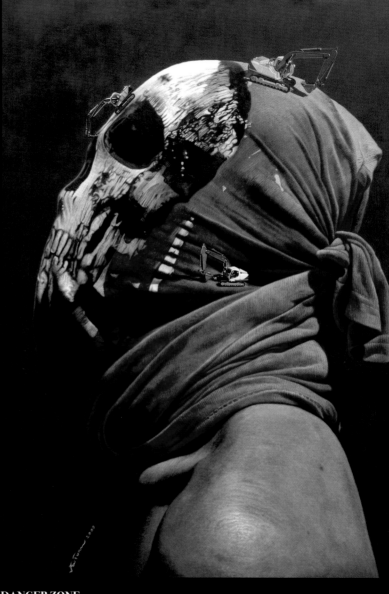

DANGER ZONE
244 x 152,5 cm
oil on canvas, 2009

interlocutors– that is we ourselves who observe and converse with him through his works – regarding key motifs, which influence his and our lives and our moral values. Some circumscribed themes and subjects, which are hugely topical but often, chosen because they are linked to the events of everyday life, are, for instance, the disharmonies and awkwardness which exist in the relationships between the sexes. Human Study, a work dating from 2005 which has contributed to drawing a great deal of attention to him with its skilful execution is an eloquent stage in his development. The link between the enigmatic marble white figures is guaranteed by the graphite execution and by their claustrophobic placement within a room with gleaming grey, sepia and greenish walls rather than by any clear references, while the space is dominated by the presence of a horse with two heads facing in opposite directions like Janus. Ventura will return to the theme of the male-female relationship at other times. For instance in 2009 within the sphere of the exhibition Metaphysics of Skin (Tyler Rollins, New York) he exhibited a painting dedicated to the story of Malakas and Maganda, which corresponds to the founding myth of the Philippines. It begins as a struggle between sea and sky, with the god of the sky furiously hurling large boulders into the sea – they will become the islands that form the archipelago of the Philippines. The two end up falling in love and producing a seed from which a giant bamboo is born which Sea and Sky are invited to split asunder.

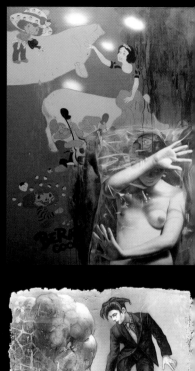

UNDER THE RAINBOW (2)
oil on canvas, 2007

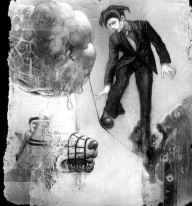

DIALOG BOX (1)
oil on fiberglass sheet, 2007

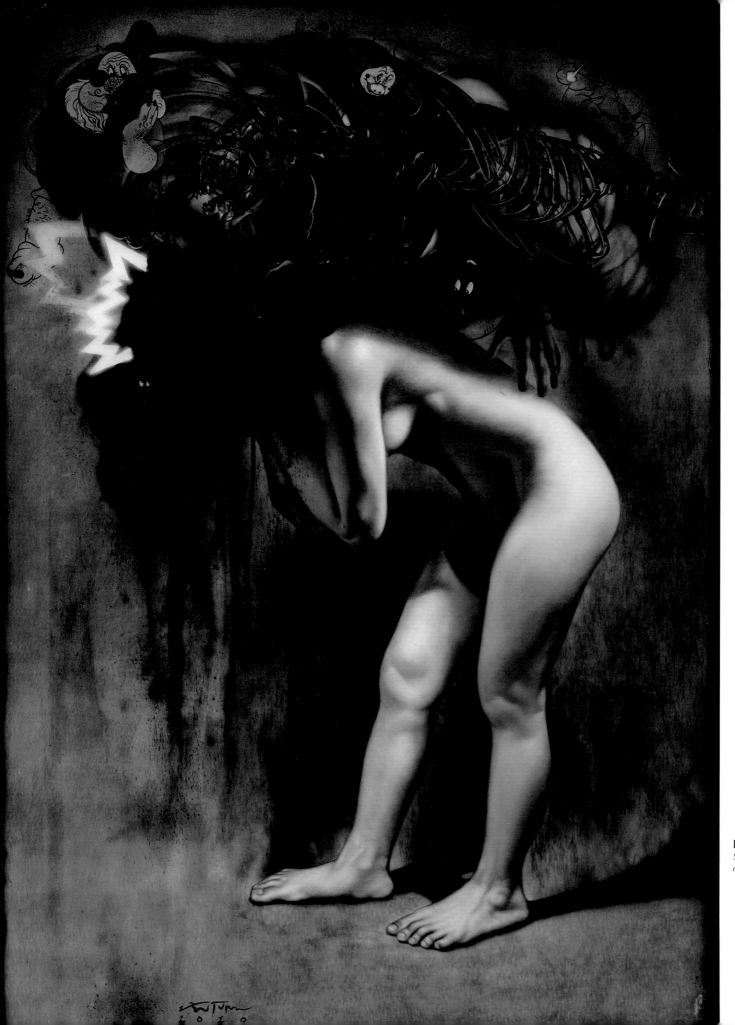

DRAMA PRINCESS
92 x 62 cm
oil on canvas, 2010

This produces Malakas (the strong) and Maganda (the beautiful), destined to populate the Philippines with their offspring. Like the other works in this exhibition the painting is covered in signs, symbols, graffiti, cartoon characters, tattoos in a non-stop overlapping of contrasting symbols, signs and meanings – yet choosing popular imagery, with the exception of the two hands intertwined in the centre of the canvas, his strong one and her beautiful and married one, rendered with hyper realistic accuracy. Here isolation and misunderstanding give way to the harmony that generates cheer and a future.

Along with Metaphysics of skin, Mapping the Corporeal –Ventura's first museum exhibition in 2008 at NUS Museum of Singapore – there is also an exhibition that deals with the general issues that concern society today. Mapping the Corporeal deals with the Warholian theme par excellence of art as a means of liberating oneself of any individual mark in order to become a mirror, a consumer object based on the ephemeral, on the seasonal changes, which depend on the vagaries of fashion and what is new. Nothing is important or has any worth: everything must be recycled in order to guarantee the cycle of meaningless but economically productive change. The body is marketing's main opportunity. The artist's model becomes the mass consumer society. The physical and natural is replaced by the artificial and sellable. Destination, 2008, shows us once again the ideal couple as defined by this consumer society, which re-elaborates every function and detail– transforming it into a gadget – with a view to financial profit.

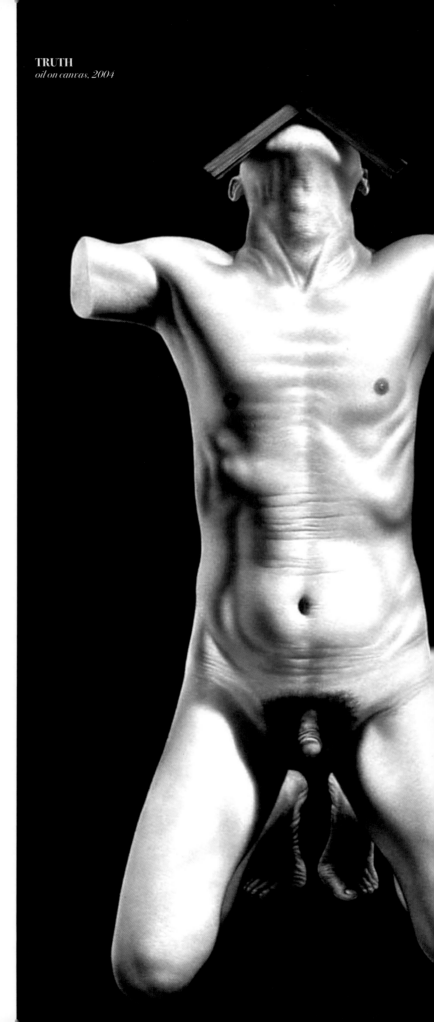

This circumnavigation around the ideal couple in a shopping mall does not relinquish - after exhibiting everything that has been elaborated for commercial purposes in the consumer society - a small touch of authenticity for which we thank Ventura. Alongside the man's hyper realistically presented model face we see his face in anatomical format that is to say in its natural, real form. The erotic instinct is still alive as he turns to the image of Eve.

An anatomical portrayal of bodies is often found in his paintings and sculptures. It is a mark of the hybridisation of rational and instinctive beings, men and animals; a theme which Ventura develops much further in sculpture, in the form of Zoomanities, which are not so much an expression of a physical contamination as of an affinity and base stratifications.

One theme, which has always been close to Ventura's heart, is that of religion- the Philippines are the third largest Catholic country in the world in terms of the number of worshippers. Over the years Ventura has dedicated works to challenging the excesses of religious fervour, sometimes practiced in a heartfelt way but also gratified in the form of flagellation, deprivation, and corporal punishment (Observation, 2011). At other times he denounces and derides the purely outward show of a sham piety as in Penitent Crossing, 2006, where the background to a penitent burdened with a theatrical cross is a street with modern features that is antithetical to that archaic custom.

PAINTER AS SUBJECT
oil on canvas, 2002

PRODUCT
oil on canvas, 2006

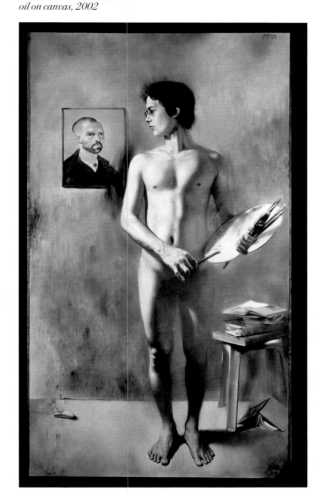

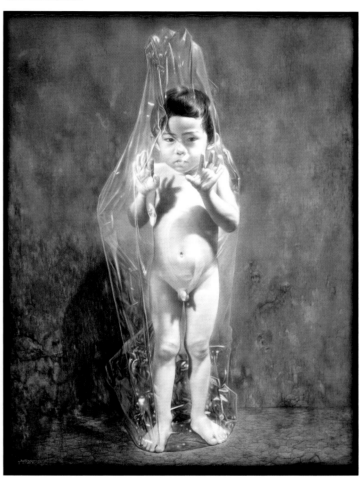

Those works that enable us to understand his relationship
with the media connected with the myths and realities
of the mass world, and particularly with television, are
especially interesting. Fragmented channels exhibition
(Primo Marella Gallery, Milan, 2010) turns the habitual
relationship that many artists have with television upside
down. The TV set – an original from the Fifties – with
its screen removed becomes the classic educational in
miniature window shop which, like the dioramas that
we see in museums, contains plastic scenes inspired by
the everyday lives of typical Philippine families. For him
this is another way of enriching his plastic and sculptural
language through image types which inhabit the average

OBSERVATION SERIES
(Penitents & Prostitutes)
30,5 x 23 cm (each)
oil on canvas mounted
on clipboard, 2011

series no. 10

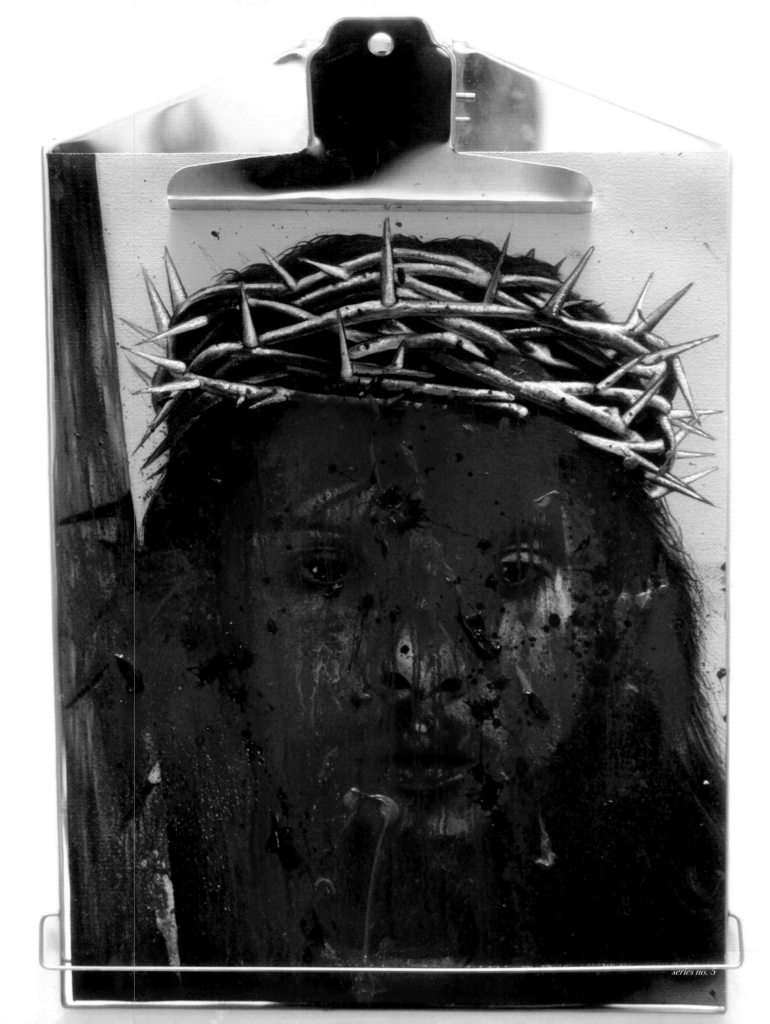

series no. 5

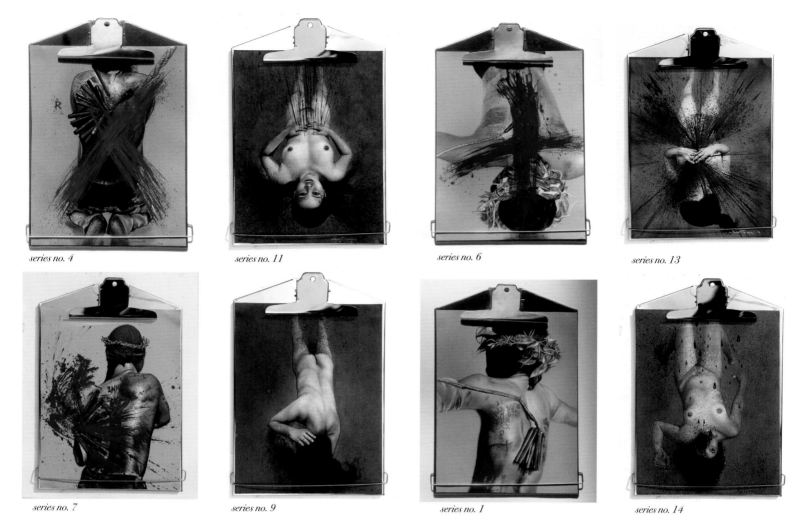

series no. 4

series no. 11

series no. 6

series no. 13

series no. 7

series no. 9

series no. 1

series no. 14

home of various social classes. Ventura is not competing with the world of the mass media. Instead, by displacing his visual, social and psychological observations, from the TV programs to the average Filipino people looking at them, we are invited to assess the relationship between these public lifestyles and TV marketing strategies represented here by the improvised stage of the TV box. In Hometheatre, 2010, he uses a contemporary plasma screen to introduce a broadcasts live feed of the city of Manila. It shows us a flood, a type of calamity, which unfortunately looms over the Philippines occasionally, causing damage and destruction. The scene takes place in an elegant, richly decorated and tidy apartment whose elegant order raises a question: what leads to this so extreme contradiction between public and private, quite chic style and dramatically chaotic, social and individual life? Once again we are personally implicated and invited

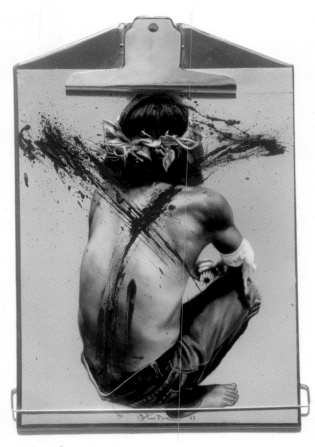

series no. 3

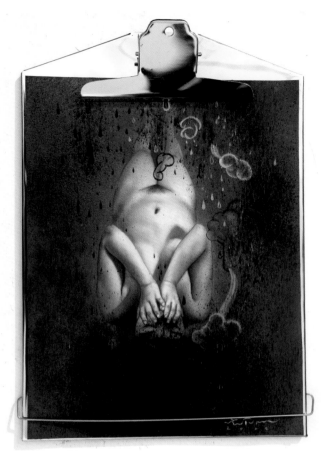

series no. 12

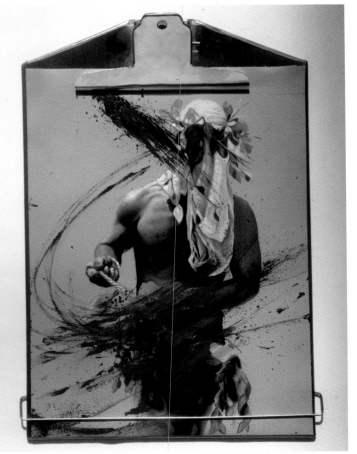

series no. 2

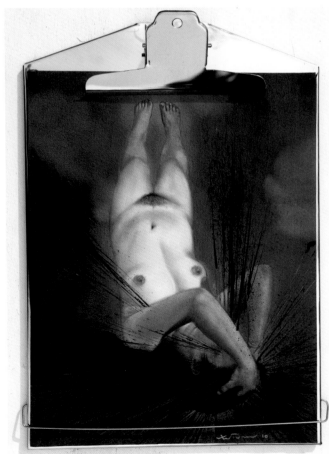

series no. 8

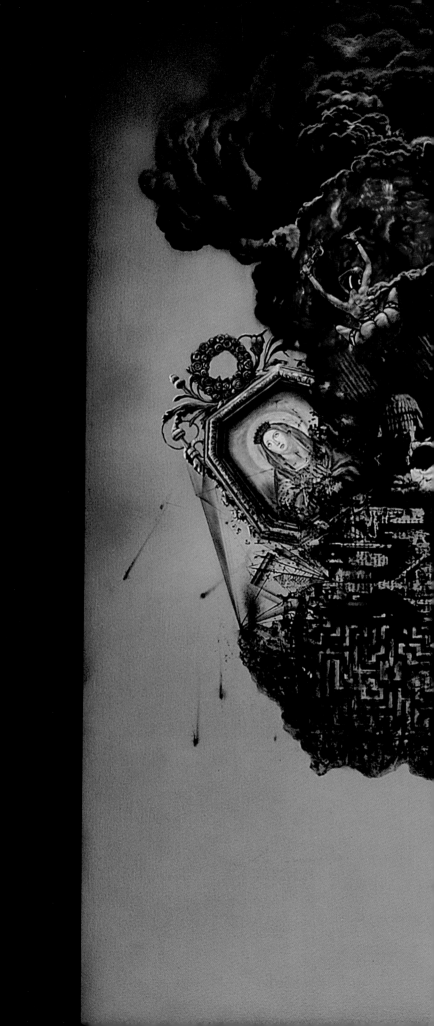

CUMULUS
150 x 305 cm
oil on canvas, 2011

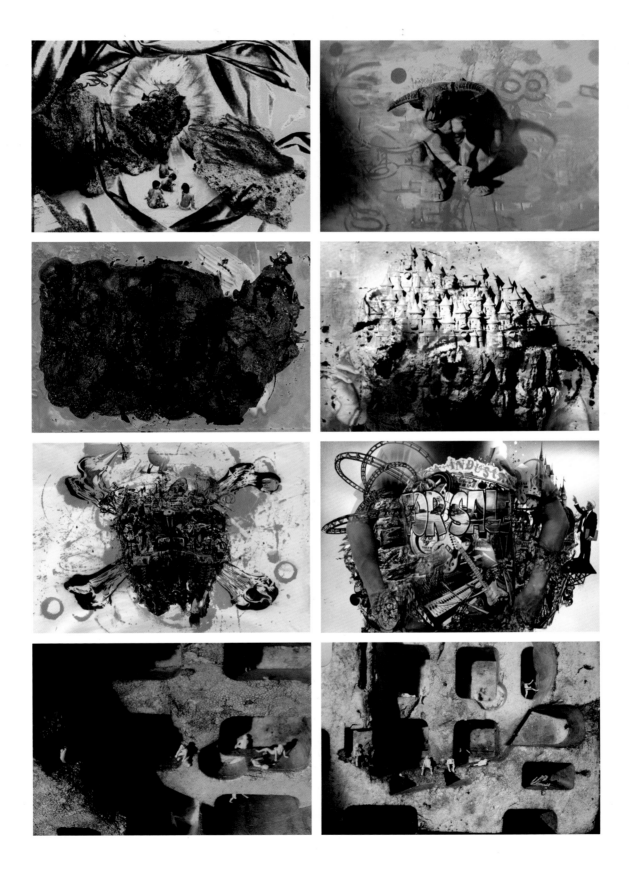

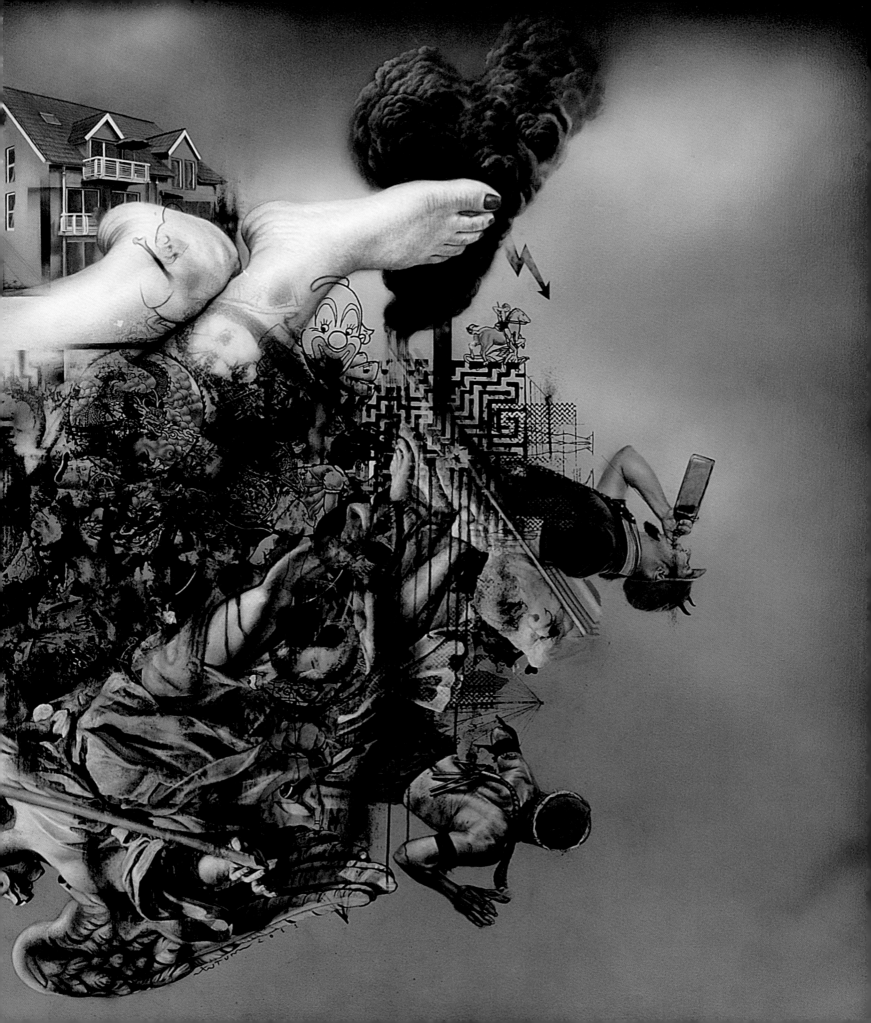

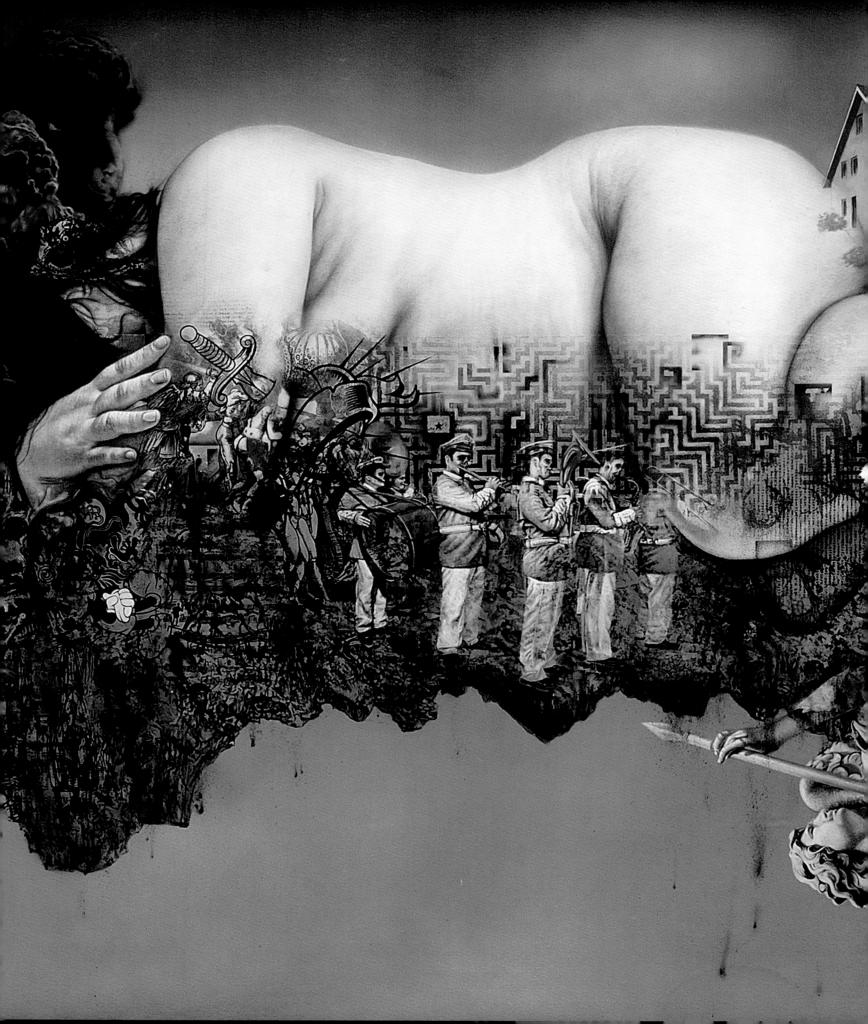

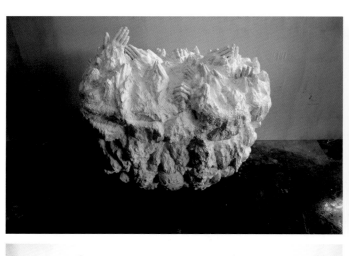

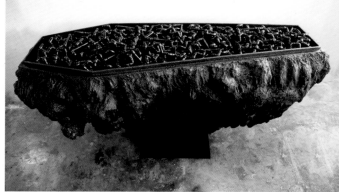

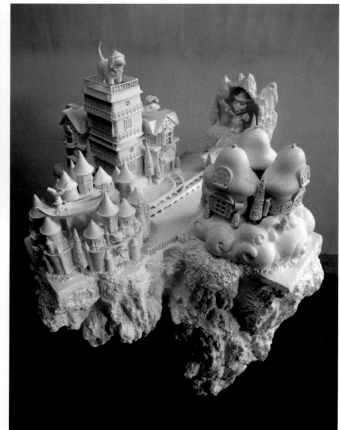

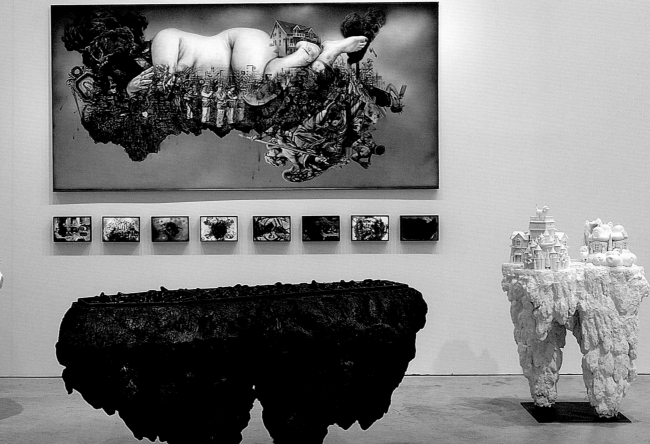

to intervene critically into a moment of life of today's world that Ventura proposes to us in an apparently detached but profoundly sympathetic way. The excessive power of the world of the mass media in itself is neither a competitor nor an ally for him. It has become such a pervasive presence in secretly moulding our lives to become a kind of social subconscious, unperceived and invisible in practical life. A TV set is just another window which is no more or less reliable than any other panorama. It is in the artist 's ability the power to capture the authentic and often hidden development of events. Ventura's works excel in the non-rhetoric ease with which his imagination transforms a subject in a strategic and apparently neutral moment of visual truth. On these occasions the relationship between an artist and his vision of the world find their path through, and get in touch with our mind and eyes, live from his paintings and sculptures.

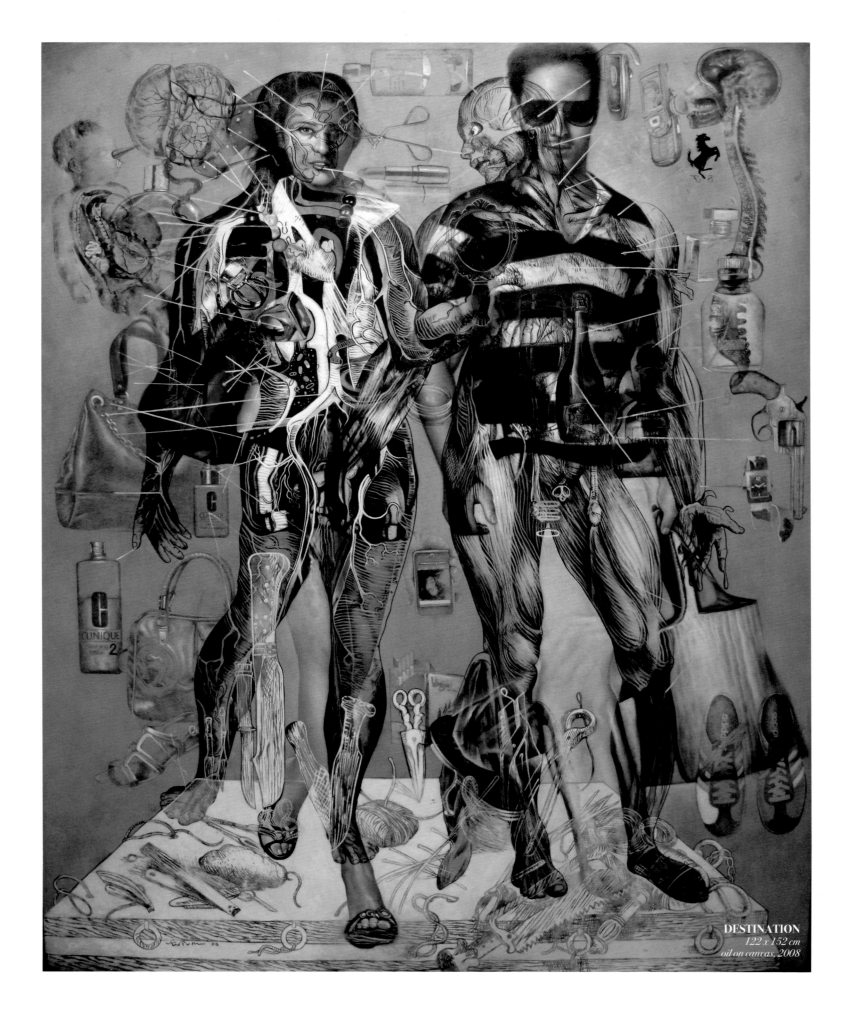

DESTINATION
122 x 152 cm
oil on canvas, 2008

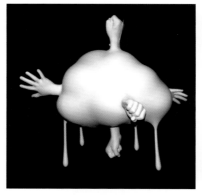

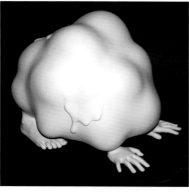

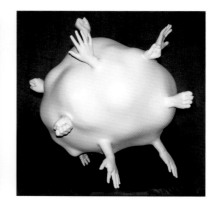

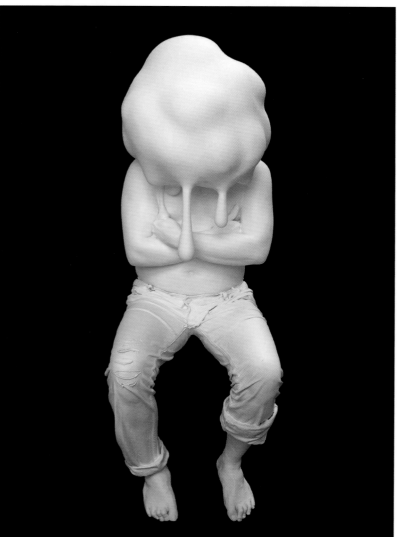

BALOON 1
fiber glass/ resin, polyurethane paint, 2007

BALOON 2
fiber glass/ resin, polyurethane paint, 2007

BALOON 3
fiber glass/ resin, polyurethane paint, 2007

CLOUDHEAD
fiber glass/resin, polyurethane paint, 2007

A TRIP DOWN
RONALD VENTURA'S
hyperrealist
highway
Igan D' Bayan
105

Memory can be a tricky bitch, but let me reconstruct events as they happened (or did not happen).

Ronald Ventura and I go way, way back. We went to the same secondary school in Malabon — Jose Rizal High School (JRHS), now defunct, its alumni holding pathetic ghost reunions from time to time.

Malabon is a city north of Manila. It is funnily called the "Venice of the Philippines," because with the yearlong floods caused by rains and/or high tide one needs a gondola to get around, no operatic arias emitting from one's mouth but only cursing and cussing as the city gradually sinks year after year.

A strange fish-smell is emanated by the entire city, due in part to patis or fish sauce being one of its "major-major" products. That's what Malabon is famous for: fish and floods. Hell, even the former mayor and congressman lived elsewhere. Filipino politicians are crafty species; them wise bastards, them crooked vultures. Those of us Malaboners (how we then youngsters jokingly call ourselves) who had no choice but to live in our own version of Waterworld and couldn't afford to fork up the high tuition for Saint James Academy — the plush Catholic school near the San Bartolome Church and the Malabon City Hall — gravitated toward the less-expensive JRHS with its saintly thugs and thuggish overachievers.

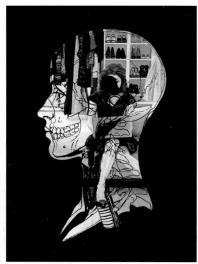

HER CASE
oil on cutout canvas, 2009

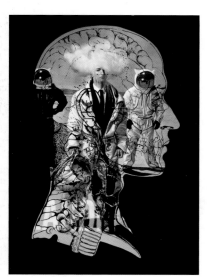

HIS CASE
oil on cutout canvas, 2009

school who drew really, really well. He said the name and pointed me in the general direction of the school bulletin board. I went there and saw two portraits in graphite (or maybe charcoal): one of Michael Jackson and another of Billy Idol. Both drawn by a senior student by the name of "Ronald Ventura." Even back then Ventura's technique was outstanding. I was drawing cartoon figures, and there was another student who was already brilliant in portraiture.

Suddenly things became like one of those Sergio Leone Spaghetti Westerns when you realize there exists a gunslinger better, faster and with more kills than you. Clint Eastwood on campus. Or a Star Wars episode where the young padawan studying the Force seeks out Master Yoda in the swamps. Or a kung-fu movie where Jacky Chan crosses paths with another warrior who can draw circles around him, and fight him till the bloody end. Maybe not to that extent: I just had to meet the guy.

We found ourselves campaigning for the same party during the student council elections (The Royal Party... what the hell were they thinking?), we talked and we clicked. The guy was easygoing, humble, intelligent, and we liked the same girl. Forgot her name but I can still picture the hair and — God, oh God — the teeth. During one of the parties in school, we both wanted to dance with her, I think When in Rome's The Promise or Poison's Every Rose Has Its Thorn or some other '80s shit was playing. We both chickened out. We spent the rest of the party drinking punch, more juice than gin. It seemed the other gunslinger was as gun-shy as me when it came to girls.

That was the start of our friendship.

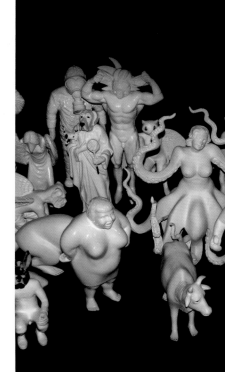

We both chickened out. We spent the rest of the party drinking punch, more juice than gin. It seemed the other gunslinger was as gun-shy as me when it came to girls.

That was the start of our friendship.

After high school, we went to the same college, the University of Santo Tomas (UST), with Ventura taking up Fine Arts, and I ending up in Literature. We weren't really religious persons, we found some of the dogmas of the Catholic Church tenuous and problematic, and yet we went to the royal and pontifical university in Manila. The World Youth Day assembly was held there, featuring The Pope and a cast of thousands of trembling lambs. For crying out loud, we had to endure twelve units of Theology. To think Ronald even became a UST professor after graduation.

Anyway, I would run into Ventura in the campus and he'd invite me to hang out in his parents' house in Tonsuya, Malabon. That I did, and I would be a common fixture in their home: drinking San Miguel Pale Pilsen with the Ronald and his brothers (Olan and Manok who would both become fine artists themselves), eating dinner with the family (the dad was an awesome cook), scouring the dead and empty Malabon streets during ungodly hours, eating sopas (soup) at Connie's, drinking coffee, drinking some more beer, smoking enough cigarettes to fill Damien Hirst's installation vats, and going home to sleep just as the corporate zombies made their way out of their domestic coffins to go to their respective offices. Like clockwork. Up till the small hours, Ronald and I would talk about Salvador Dali, Rene Magritte, Gustav Klimt, Jean-Michel Basquiat, Andy Warhol, Francis Bacon, Plato, Carl Jung, his old gallery Hiraya on United Nations Avenue, and Pinoy rock bands such as the Eraserheads and Yano.

ZOOMANITIES
EXHIBITION
2008

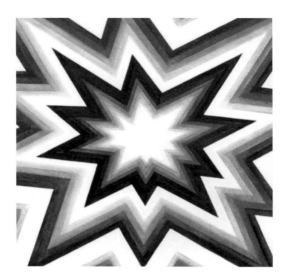 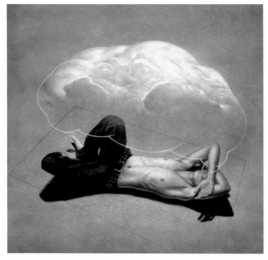 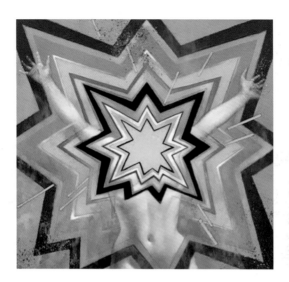

During those days in the early '90s, Ronald Ventura breathed art, art and more art. Everything was grist to the artist's mill. I was taking Philosophy at that time and I'd tell him stuff I read recently such as Plato's Theory of Forms or Jung's archetypes, the anima, the animus and such. Then he'd show me the paintings he was working on and I'd find the concepts there, transformed, tweaked into non-recognition, and transubstantiated into figures and shapes that were entirely his own. His painting style was so much different then: umbers and siennas, monochromatic browns dominated the canvases, the subjects were still flesh-toned, and thematically the works were diatribes against blind Catholic beliefs. Penitents (in Jesus Christ poses). Hypocrites (old women with black veils praying with exaggerated piousness). Flawed angels (playing guitars that usher in the end of the world). Sufferers of all kind, different afflictions.

We hung out: at the Ventura residence, in girly bars, at Templo where Ronald taught art to kids, in girly bars, in fast food joints (such as Wendy's) in Monumento at the center of Caloocan City, in girly bars, at Hiraya Gallery where I saw his huge paintings (along with Charlie Co's, Alfred Esquillo's and Jojo Legaspi's), and in girly bars (uh, as part of our study of the human anatomy).

 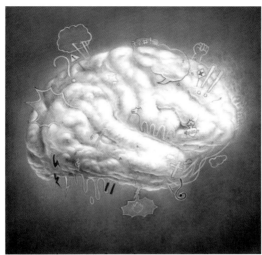 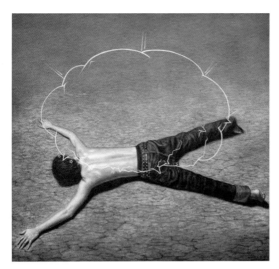

DIALOGUE BOX
all oil on canvas
2006

Three years later, Ronald rented a house in far-off Tansa, not sure if it is still in Malabon or already a part of Navotas. (The joke was: if you stand near the river you could almost see Borneo or the end of the world — whichever comes first.) He had a project for a Mandaluyong school: a big-ass mural. The Venturas and their band of merry men worked on those boards, while I (guitar in hand) played Cure and Stone Temple Pilot songs for them. It was like a caricature of a Fernando Amorsolo painting: the men harvested rice while a guitarist plucked his finest worksongs. More jokes: about the red dustpan, the guy who used to sell puto (sweet white bread), Diegong Bayong, and Pokwang the sexy siren of that village in Tansa — all legs and white as a turnip. (She would show up a decade later fat, bloated, in need of money, looking for the Venturas, but that's another story altogether.)

Ronald Ventura's art was in transition

Sure, the palette was still ruled by browns, but change was afoot — like Bob Dylan getting ready to go electric.

On the day of the delivery of the murals, we loaded the finished works onto a truck, clambered aboard, and made the long trip to the school, nearly getting electrocuted by low-strung electrical wires along the way.

I wrote one-paragraph explanations for each section of the mural; ugly language for beautiful art. As if images could be conveniently explained away by handy words. The mural's still there, I've been told.

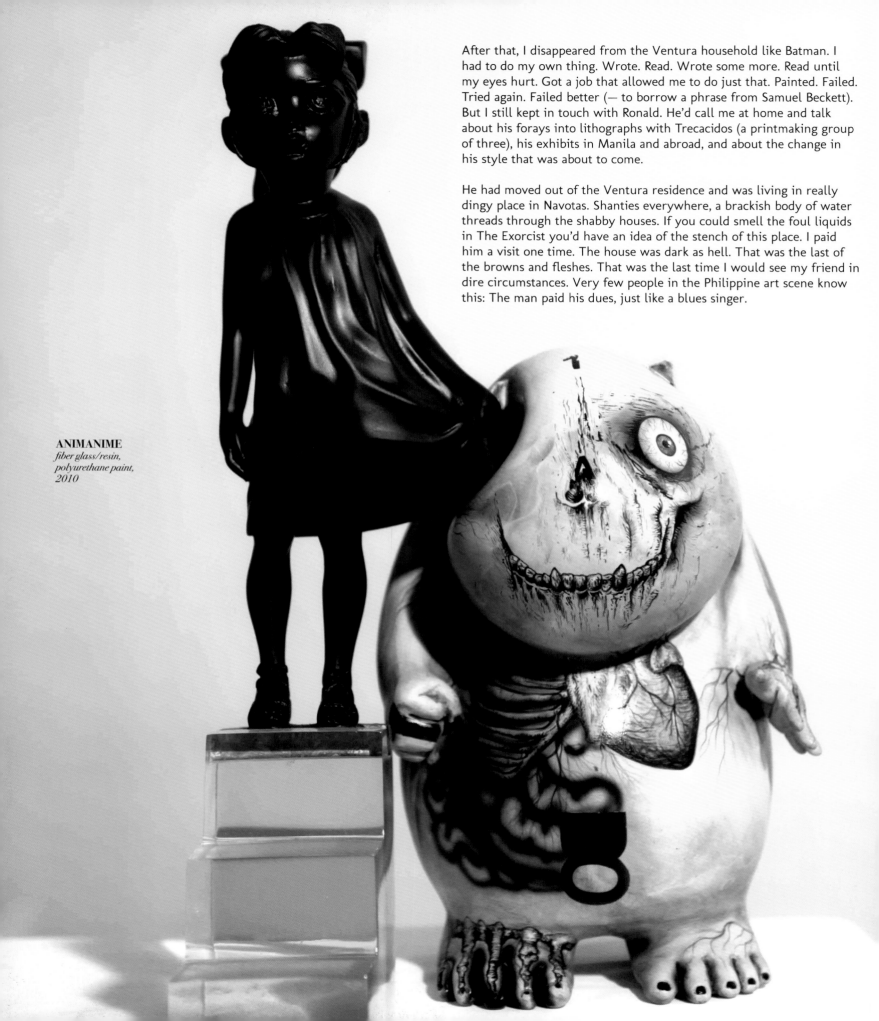

After that, I disappeared from the Ventura household like Batman. I had to do my own thing. Wrote. Read. Wrote some more. Read until my eyes hurt. Got a job that allowed me to do just that. Painted. Failed. Tried again. Failed better (— to borrow a phrase from Samuel Beckett). But I still kept in touch with Ronald. He'd call me at home and talk about his forays into lithographs with Trecacidos (a printmaking group of three), his exhibits in Manila and abroad, and about the change in his style that was about to come.

He had moved out of the Ventura residence and was living in really dingy place in Navotas. Shanties everywhere, a brackish body of water threads through the shabby houses. If you could smell the foul liquids in The Exorcist you'd have an idea of the stench of this place. I paid him a visit one time. The house was dark as hell. That was the last of the browns and fleshes. That was the last time I would see my friend in dire circumstances. Very few people in the Philippine art scene know this: The man paid his dues, just like a blues singer.

ANIMANIME
fiber glass/resin,
polyurethane paint,
2010

...in terms of technique, he was untouchable

He would eventually leave that place and crash at the mansion of a gallery owner (He Who Shall Not Be Named), a well-known doctor-lothario, dater of starlets, and the Philippine art world's Mephistopheles.

Ronald Ventura — surrounded by the white mod contemporary walls of the sprawling digs, seeing white all day, seeing nothing but whiteness and clean, clean lines — would dramatically change the way he painted his subjects.

Again, I disappeared like Batman and would only hear of Ventura's triumphs at the Philip Morris Asean Art Awards, his being chosen as one of the Cultural Center of the Philippines' Thirteen Artists awardees, and his mind-altering exhibitions: "Innerscapes" at West Gallery in SM Megamall, Mandaluyong City and "All Souls Day" at The Drawing Room, Makati City in 2000; "The Other Side" at The Drawing Room in 2001; "Visual Defects" at West Gallery and "Body" at The Drawing Room in 2002; "X-Squared" at West Gallery in 2003; and "Dead End Images" at the sprawling Art Center in SM Megamall in 2004.

When I got a job as a writer for The Philippine Star broadsheet in late 2000, I thought right away about doing a feature on Ronald Ventura. Been a long time coming. Though he was not the only artist at that time doing extraordinary work (so were Jojo Legaspi and Gabby Barredo; Manuel Ocampo in Europe and the States was another), in terms of technique he was untouchable.

WEIGHTS
*fiber glass/resin,
polyurethane paint, 2007*

In 2005, I got the nod of my editor Millet Mananquil to write about Ronald Ventura and I journeyed to the far ends of Earth Street along Mindanao Avenue in Quezon City to visit him. I got lost. Owing to villages with duplicate names. Roads that snaked to nowhere. Landmarks swallowed up by the liquid night. People — pale and huddled in the dark — giving confusing and opposing directions. It was weird searching and not finding Ventura's house in Quezon City. Quite unnerving. A feeling that would be replicated by the paintings that I would find later on in his house: those contorted figures with contorted stories to tell.

It takes a lot of patience, time and mad, mad skills, to capture that almost monochromatic horror

Ronald was set to mount a show at the SM Megamall Art Center titled "Human Study." And the paintings I saw at his house en-fleshed the new stylistic and technical approach: the alabaster-white figures were drawn with a graphite pencil and the background was glazed in gray, sepia or rigor mortis green. To be able to pull that off takes a lot of patience, time and mad, mad skills, to capture that almost monochromatic horror.

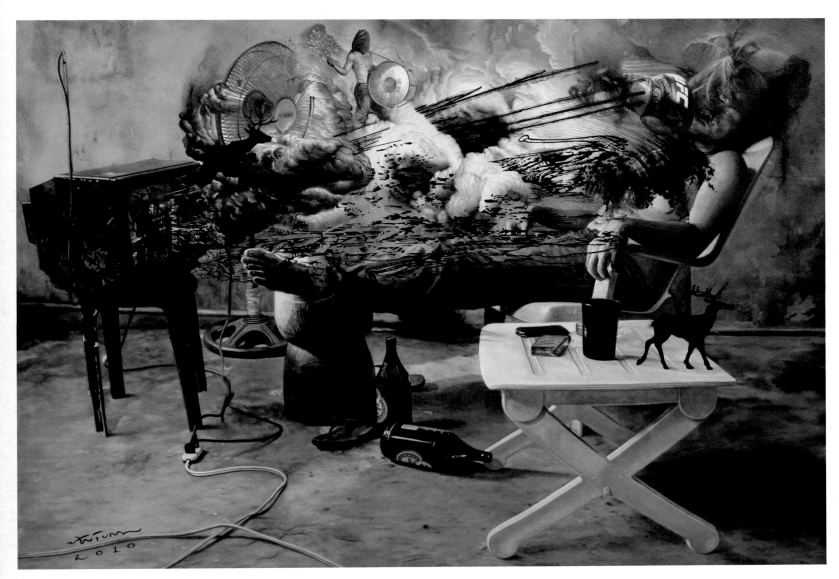

APOCALYPTIC CHANNEL
oil on canvas, 2010

There was a chalky-white figure of a man with a dog face ("Insecured), with its angry veins rivered by bad blood, resentment and paranoia. The attack on Christian mythos was still present with a painting of a penitent lovingly clutching a crucifix and modeling the stigmata wounds of St. Francis ("Francism"). Ronald explained, "Isn't it enough that Christ died for our sins? Must penitents do it, too — and make a mockery of His sacrifice?" New media was not spared from Ventura's brush as shown by a painting of a woman with the "@" symbol covering her crotch. The painting ("Temptation") showed this femme clutching a Biblical apple, a facsimile of an Albrecht Dürer print texturing the background. This was Eve at Midnight in the Garden of Downloadable Good and Evil.

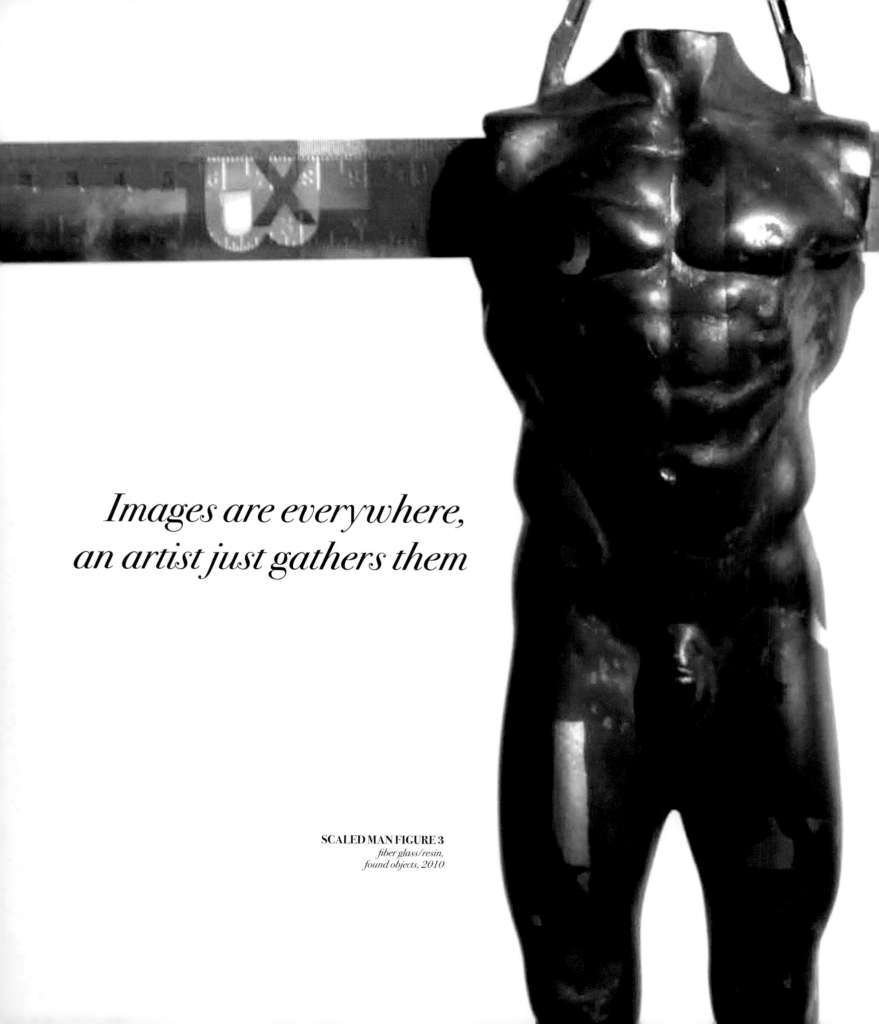

Images are everywhere,
an artist just gathers them

SCALED MAN FIGURE 3
fiber glass/resin,
found objects, 2010

This was also the first time I saw Ronald with assemblages and sculptures. One was the crossbow-man. The other was a resin assemblage with an octagonal base punctuated with tiny figures of saints and ready-mades of plastic soldiers and animals (a strategy Ronald would employ in future works). He said that this was his "monument to iconography," an ironic take on the Tower of Babel. He had a bit of problem when he approached an artisan who made saint statues. Ventura specified what he wanted made: a sculpture of a child with an adult's body. Seemed safe enough. Only Ventura wanted the statue (kind of like the child Jesus) to be sprouting wings. The artisan balked at the idea. Called it sacrilegious.

"That's a case of people confusing the image for the real thing," Ventura dismissed, adding more fodder for his attack on blind faith.

I also saw the work (in its initial stages) that would mark the transition of Ronald Ventura's stylistic change from his deep-brown phase to his marble-white phase and on to the next phase: "Human Study." The centerpiece of the painting: two horses in one body pulling each other in separate directions surrounded by a congregation of subjects. Probably a metaphor for what was going through in the mind of the artist at that time.

The imagery was so baffling that I asked Ronald where he got his inspiration.

His answer: "I think it was Basquiat who said that you don't ask a musician where his music comes from. Images are like a deck of cards that convey what emotions an artist is undergoing." And he added, "Images are everywhere; an artist just gathers them."

This was also the first time I saw Ronald with assemblages and sculptures. One was the crossbow-man. The other was a resin assemblage with an octagonal base punctuated with tiny figures of saints and ready-mades of plastic soldiers and animals (a strategy Ronald would employ in future works). He said that this was his "monument to iconography," an ironic take on the Tower of Babel. He had a bit of problem when he approached an artisan who made saint statues. Ventura specified what he wanted made: a sculpture of a child with an adult's body. Seemed safe enough. Only Ventura wanted the statue (kind of like the child Jesus) to be sprouting wings. The artisan balked at the idea. Called it sacrilegious.

That visit would renew the late-night talks. We hung out in bars in Manila and in Singapore. He visited my studio (I was already exhibiting as a visual artist by 2006) and he gave me pointers on what materials to use, how to improve my skills, and which artists to check out. He went to my shows and I went to his. I saw that he was on the cusp on another major stylistic shift, the most interesting one to date.

Colors came into the picture. Loud colors, screaming ones.

The genesis was in 2006 when Ventura went to Australia for a residency. Something Kafkaesque happened.

Upon arriving, he met a snag at the Kingsford-Smith Airport in Sydney. In Ronald's luggage were paintings on canvases with wooden frames — and since Australian customs officials are very strict when it comes to wooden articles being brought into the country — the artist had to stay in the quarantine area of the airport.

After a few anxious hours caught in bureaucratic limbo, he was finally sent on his way to Sydney carrying his bags slapped with yellow-and-black quarantine stickers. He rode the train and took a cab, looking for his hotel, a bit unnerved, relying mainly on road and street signs along the way. When Ronald came back to the Philippines, he created a suite of paintings as signposts, artworks that mark the existential traffic that flowed in his head while lost in a country that is strange and beautiful at the same time. The show, at the Ateneo University art gallery, was billed as "Cross Encounters," and it was a pivotal shift in Ventura oeuvre: the alabaster-white figures became impaled on jarring (cadmium) yellow background. There were even yellow-and-black fiberglass-resin dog-head sculptures with symbols that signified "caution" as well as canine soldiers collectively known as "Dog Club," suggesting a world that has gone to the dogs.

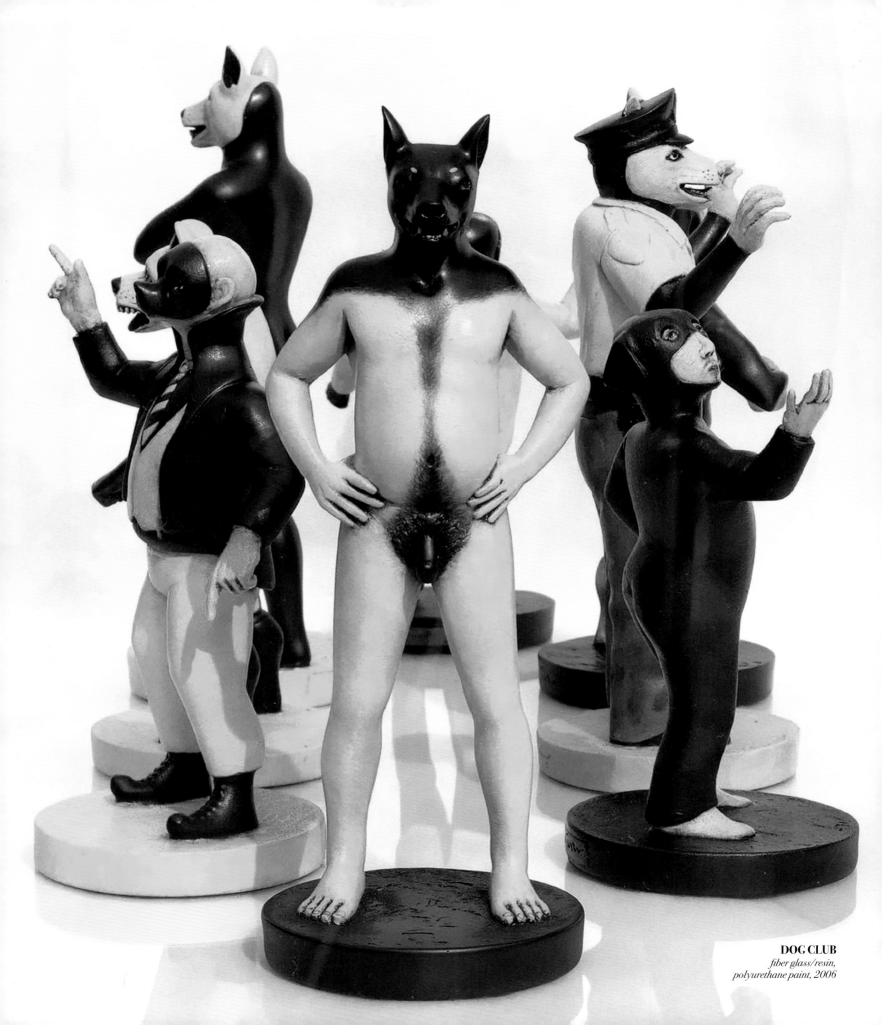

DOG CLUB
*fiber glass/resin,
polyurethane paint, 2006*

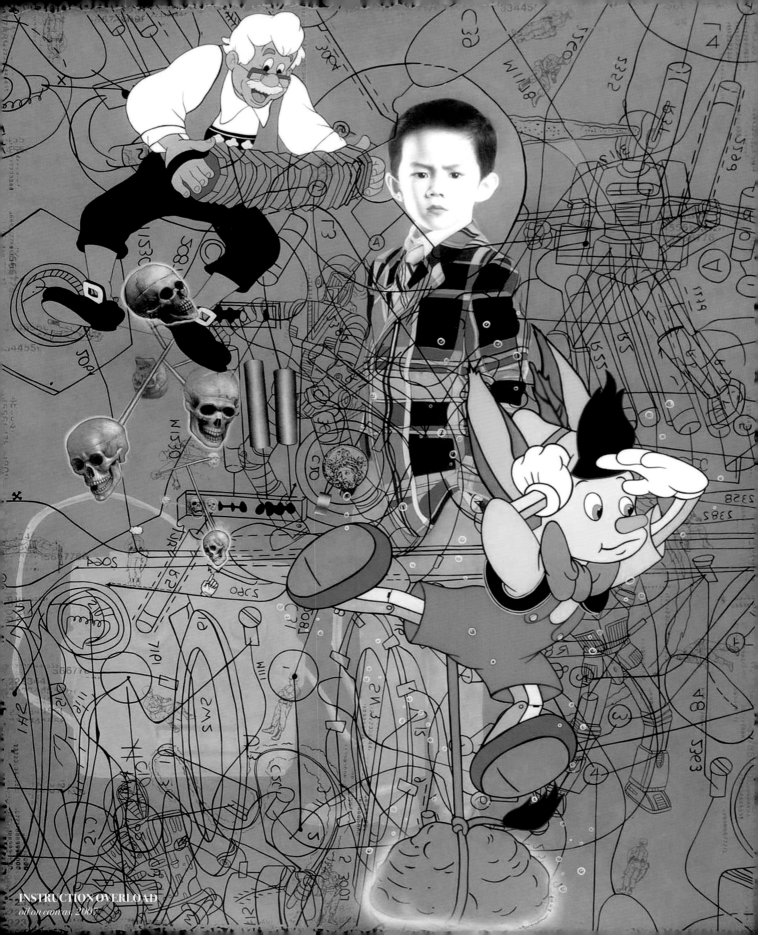

INSTRUCTION OVERLOAD
oil on canvas, 2007

The flirtations with color and pop culture continued.

In his "Illusions & Boundaries" show in 2007, the alabaster-white figures sprawled across backgrounds of various grays dominated as usual, but there was one painting (titled "Instruction Overload") that heralded Ventura's brave new artistic world. It showed a delicately detailed, hyperrealist portrait of a boy surrounded by lines, lines and more seemingly random lines, with a rendition of — surprise, surprise — Pinocchio in shiny, happy Disney colors taking the entire composition elsewhere: to the future.

There was a jolt in the juxtaposition

In his exhibition the following year, Ventura brought more colors and merrier cartoon characters to the fore. Exhibited were colorful Damien Hirst-like spots appearing in a grayscale artwork of a bodybuilding retro ape as well as dramatic Andy Warhol-like color bars defining space in a painting of a rhinoceros with human feet headed toward a skull suspended in its animation. Beautifully disturbing.

But it's the battalion of animal-men and assorted mutants that waged war on preconceived notions of "what sculpture is and what it is not."

When I visited Ronald at the SM Megamall Art Center where his "Zoomanities" was on view, I saw kids milling around the installation, wishing most likely that they had one of those toys-for-the-weird-boys to go with their Spawn, Transformer or anime action figures.

Who knows, maybe he would get restless again and embark on another stylistic shift

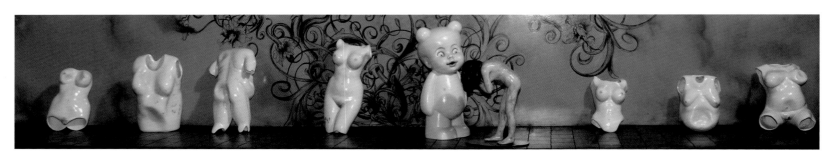

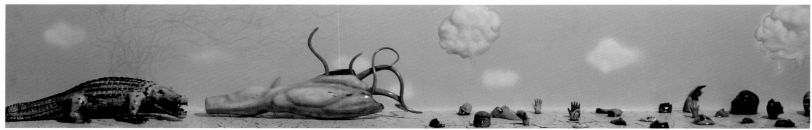

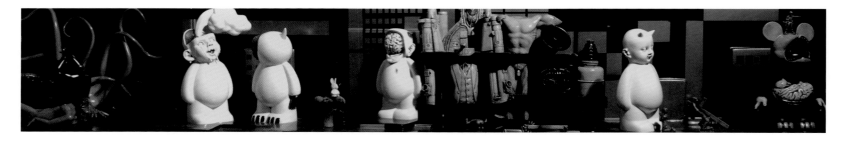

DIE OR DRAMA (1, 2, 3)
203 x 30.5 x 30.5 cm (3)
fiber glass/resin,
polyurethane paint, 2010

He informed me that the entire zoo took two years to finish. The "Zoomanities" sculptures (in fiberglass, fiberglass-resin, plastic, metal, silver, bronze, most of them hand-painted) depicted humans with animal heads, animals with human feet, pinup pigs, Playboy bunnies, monkey men, skeletons with wings, and fiberglass rhinos, among other beasts of burden — a combination of sculptures, casts of toys, dolls, saint figurines, whatever the artist could get his hands on to create "creatures of discomfort."

Ronald Ventura's strategy over the next three years (exemplified by shows in Manila, Singapore, Milan, New York; by landmark auction pieces for Christie's and Sotheby's) saw him go for less dour coloration and more of an existential mash-up of styles — hyperrealism and graffiti, the classical and the lowbrow, and everything in between. Nothing's real, everything's permitted.

But, who knows, maybe he would get restless again and embark on another stylistic shift.

The trip continues. This trip inside one hell of a strange trip. Mapping the corporeal, digging what's under the rainbow, taking a slice off the metaphysics of skin — my old artist-friend from Malabon is still at it. We ain't seen nothing yet.

Before Ronald Ventura set out for the road, he was the road.

Igan D'Bayan is a visual artist and an arts and culture columnist for The Philippine Star.

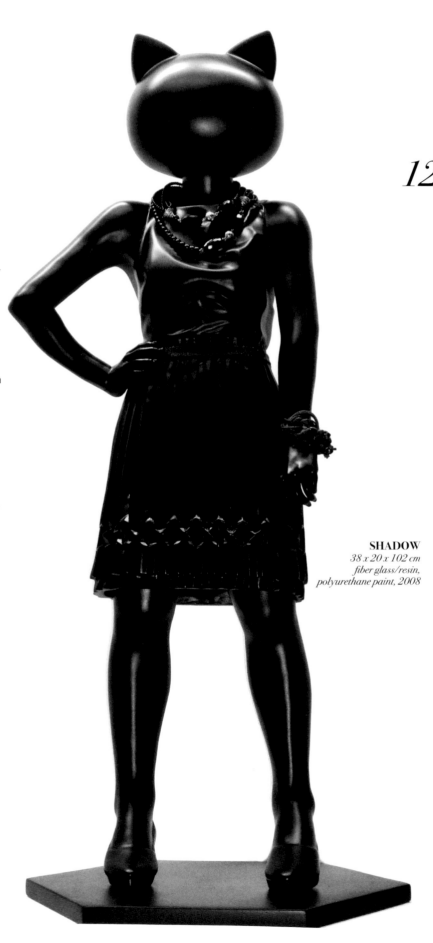

SHADOW
38 x 20 x 102 cm
fiber glass/resin,
polyurethane paint, 2008

GRAYNESS (Series)
*fiber glass/resin,
polyurethane paint, 2009*

series no. 15	*series no. 10*	*series no. 13*	*series no. 9*	*series no. 18*

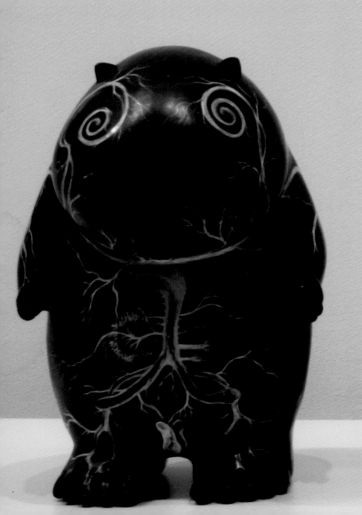
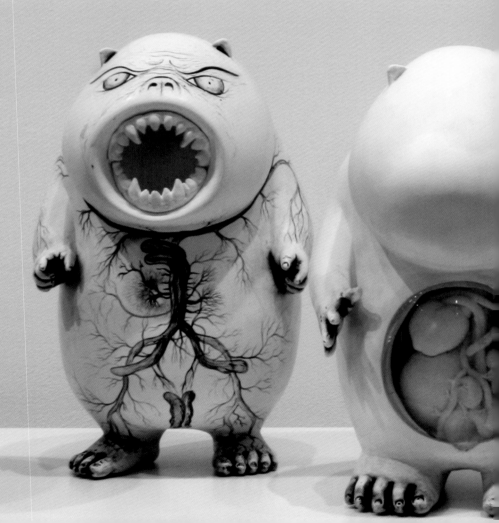

Grayness series

Adjani Arumpac

123

Ventura has been slowly letting loose nightmare fauna from his paintings. From sculptures of anthropomorphized monkeys to decapitated humans fused to foreign objects, he now wrenches off from his paintings another set of monsters.

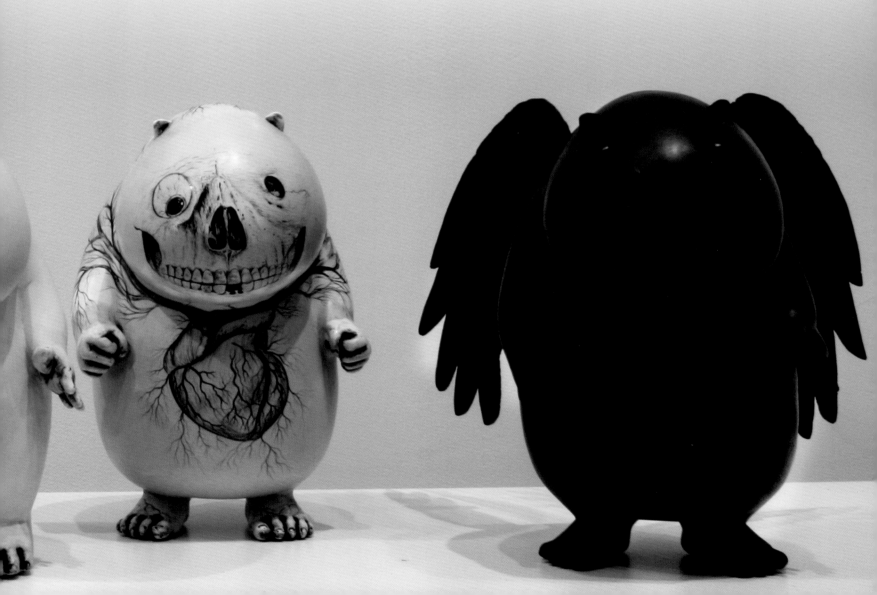

These creatures have recently been populating his canvasses, infusing his somber hyperrealist world with a charming sense of chaos. Suffice it to say, the advent of mixing pop icons with hyperrealism signaled the artist's coming of Modern age: from transgressing moral norms/boundaries by combining humans and animals; to incessantly eliminating distance by introducing the Japanese Superflat aesthetics of garish colors and graphic images; and finally, to turning his focus more and more on the medium itself, constantly going back and forth the two-dimensional and the sculptural, to arrive at a definition of the modern life.

This set of anthropomorphic pocket-sized monsters are as appealingly terrifying in three-dimensional as they are on canvass.

A charming sense of chaos

The plump round anthropomorphic bodies have been painted on with nerves and backbone, their protruding stomach hollowed out and stuffed with a skull or a grenade, their heads shaped like either that of a pig's or a nondescript face with jutting ears/budding horns. These are evil in piecemeal, metaphors for a slow decay and a general corruption of a society teetering between the seemingly clashing forces of capitalism (flamboyant flat icons) and culture (brooding hyperrealist humans). Now, they are aptly rendered as sculptures, as how Clement Greenberg argued that "the borderline between art and non-art had to be sought in three-dimensional, where sculpture was, and where everything material that was not art also was."

Absurd as they are, the fluidity of Ventura's images, their inherent ironies and their necessary transfer from medium to medium, smacks right of nonfiction.

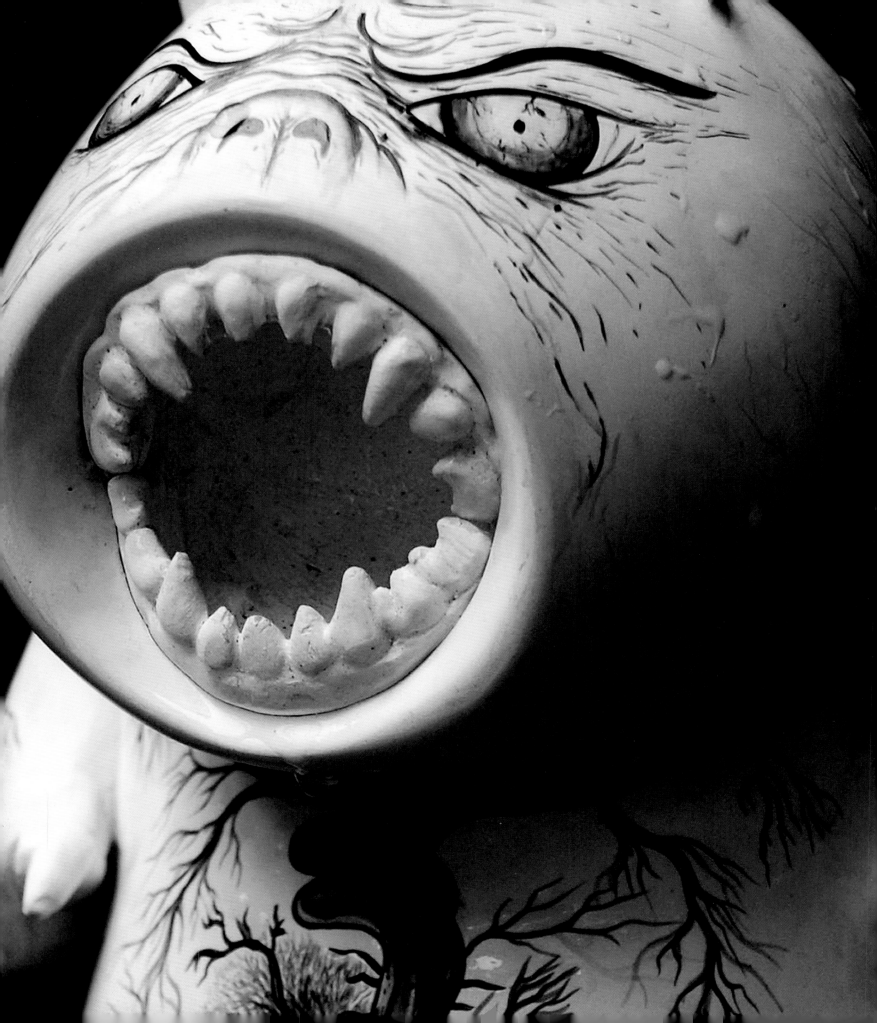

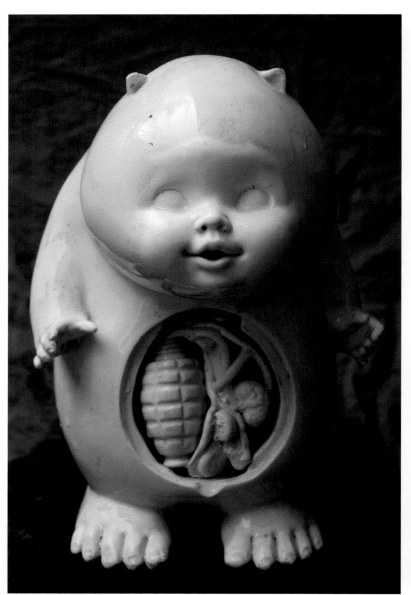

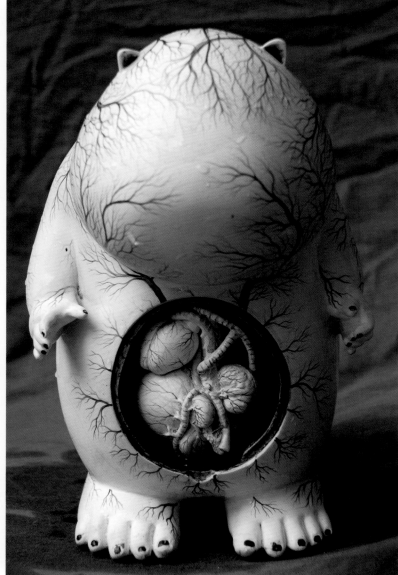

GRAYNESS (Series)
fiber glass/resin,
polyurethane paint, 2009

series no. 8	*series no. 4*	*series no. 14*	*series no. 11*

From transgressing moral norms/boundaries by combining humans and animals

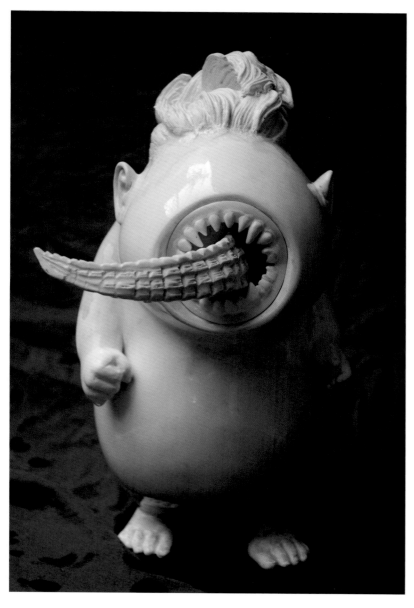 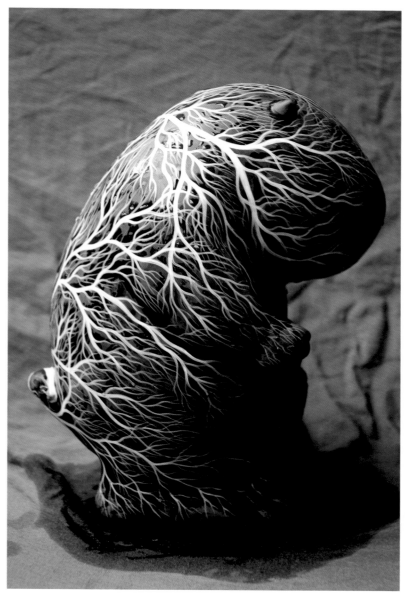

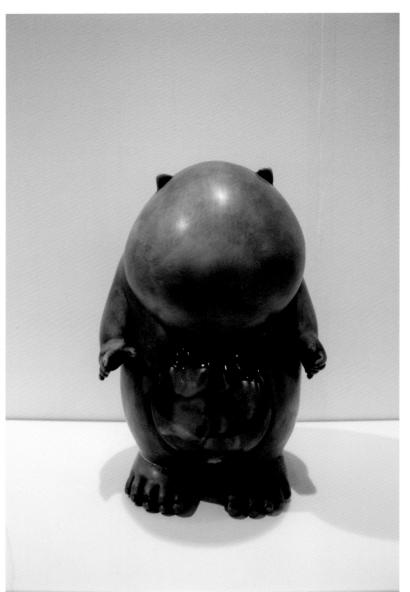 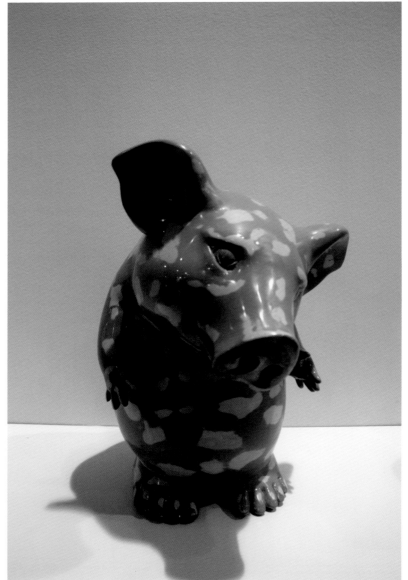

GRAYNESS (Series)
fiber glass/resin,
polyurethane paint, 2009

series no. 20	*series no. 19*	*series no. 3*	*series no. 6*

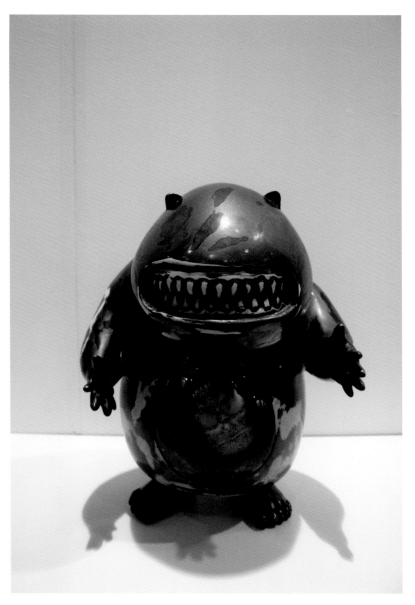 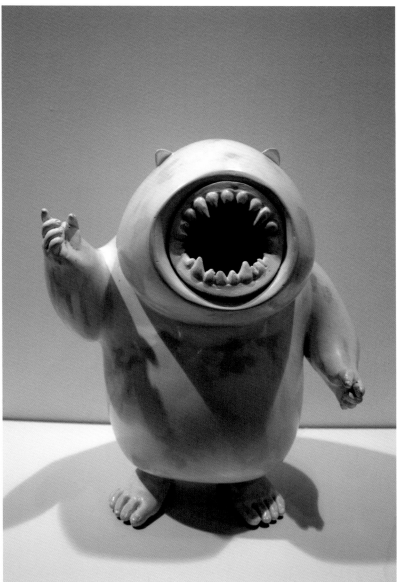

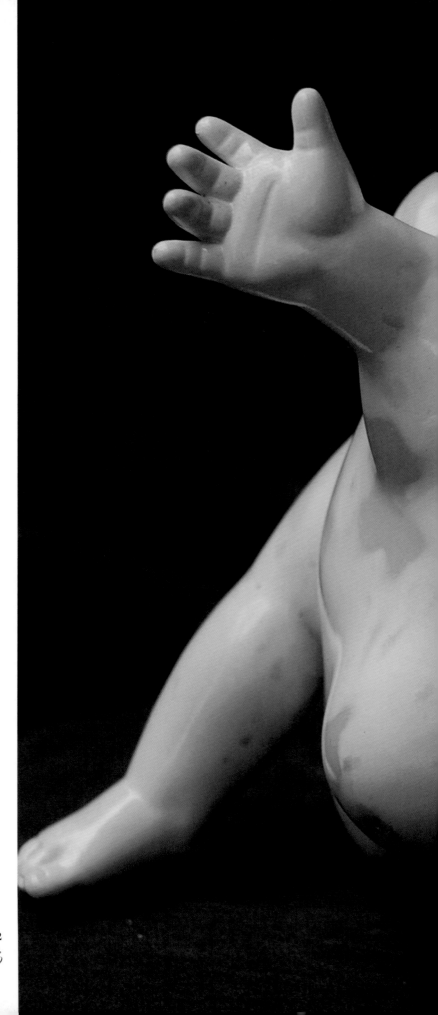

The fluidity of Ventura's images, their inherent ironies and their necessary transfer from medium to medium, smacks right of nonfiction

GRAYNESS (Series) NO.12
*fiber glass/resin,
polyurethane paint, 2009*

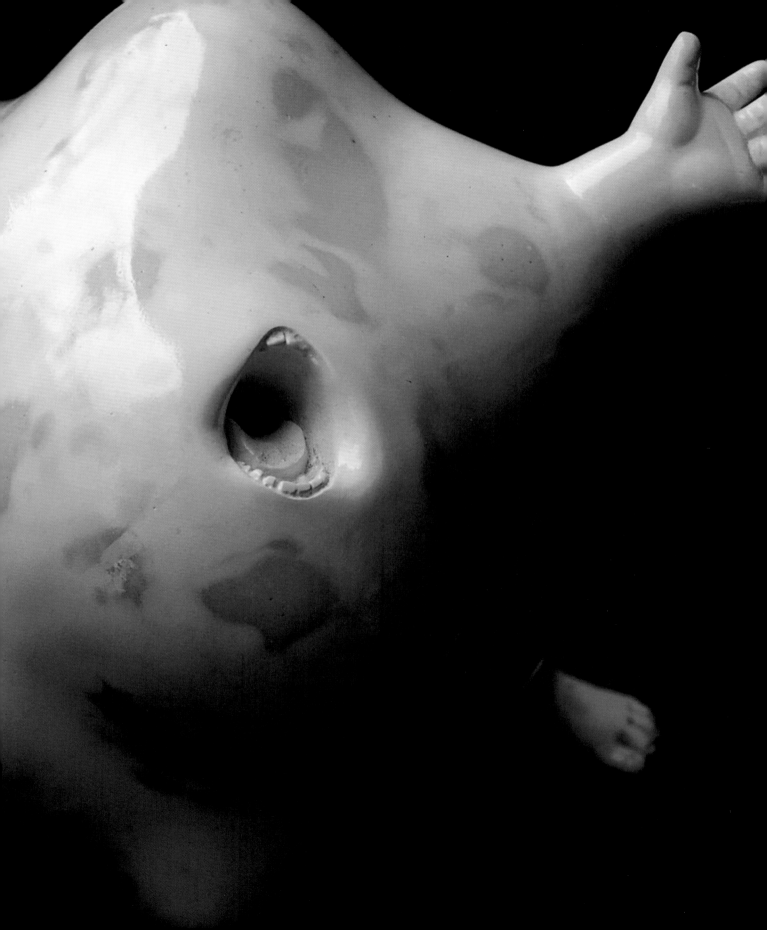

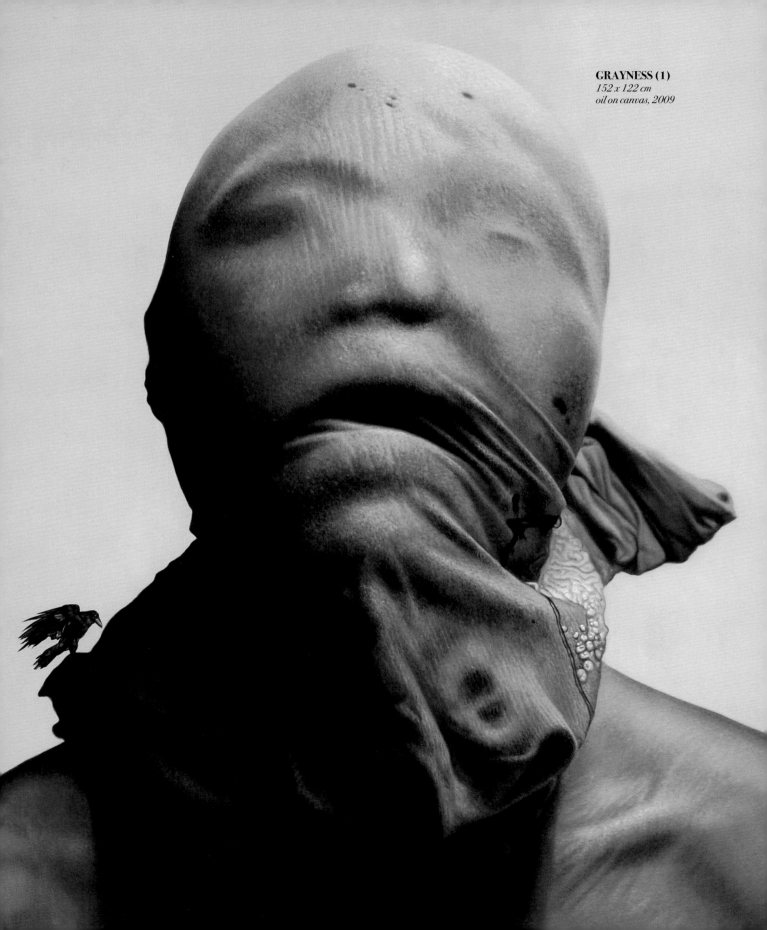

GRAYNESS (1)
152 x 122 cm
oil on canvas, 2009

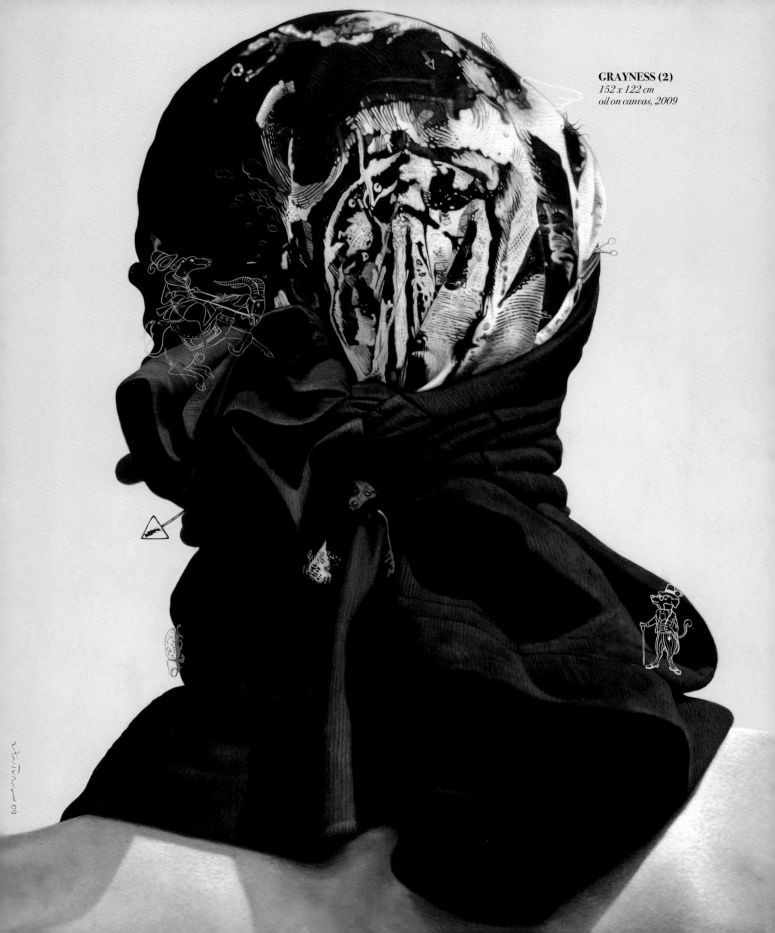

GRAYNESS (2)
152 x 122 cm
oil on canvas, 2009

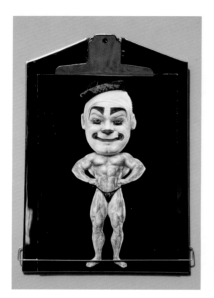 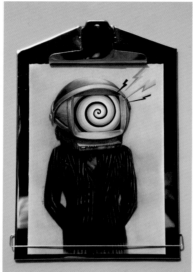 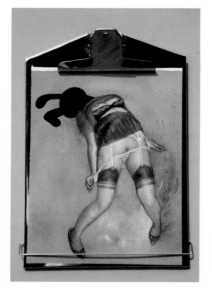 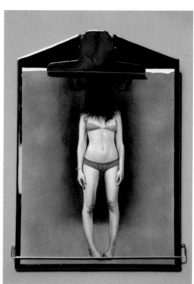

HUMAN STUDY (Series)
oil on canvas
mounted on a clipboard

series no. 7 *series no. 4* *series no. 8* *series no. 1*

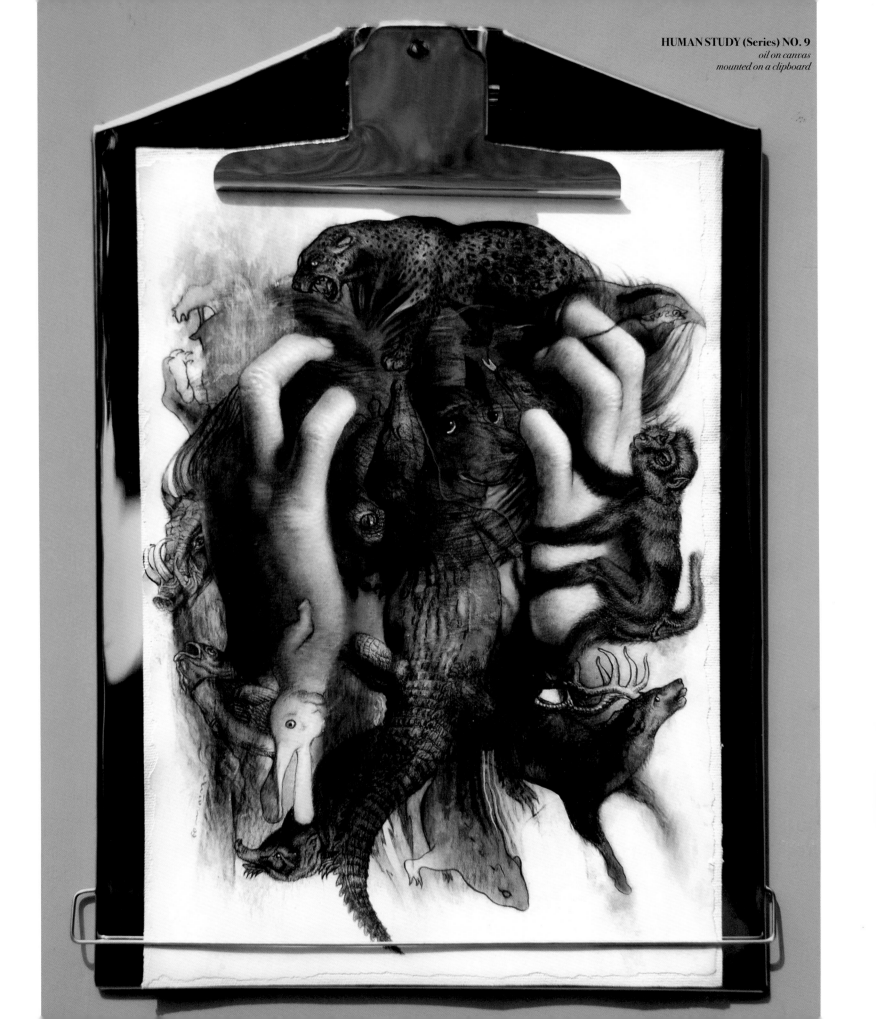

HUMAN STUDY (Series) NO. 9
oil on canvas
mounted on a clipboard

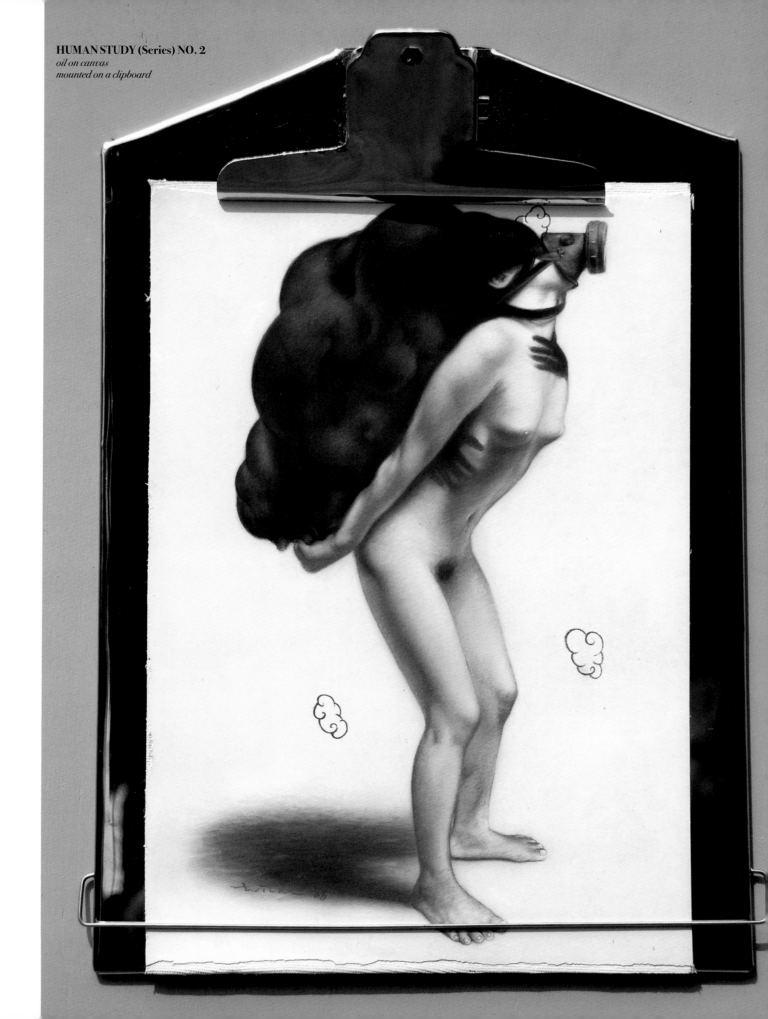

HUMAN STUDY (Series) NO. 2
*oil on canvas
mounted on a clipboard*

136

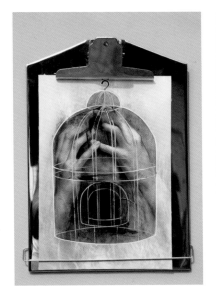 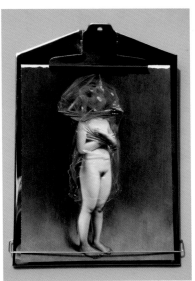 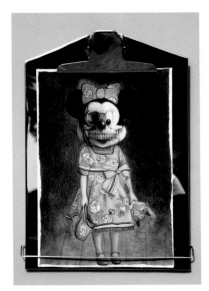 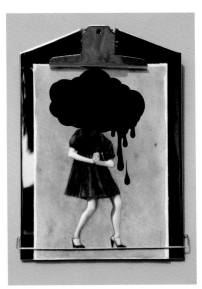

HUMAN STUDY (Series)
oil on canvas
mounted on a clipboard

series no. 10	series no. 5	series no. 6	series no. 3

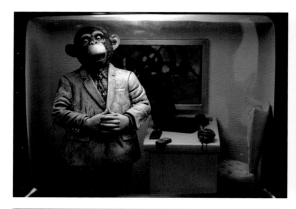

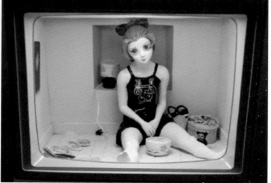

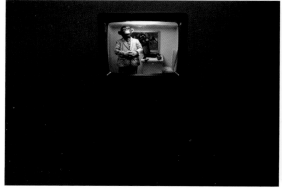

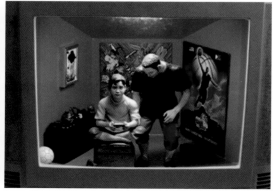

sponsor (detail)	**ANIMAE**
SPONSOR	**AMUSEMENT**

fiberglass/resin,
polyurethane paint, 2010

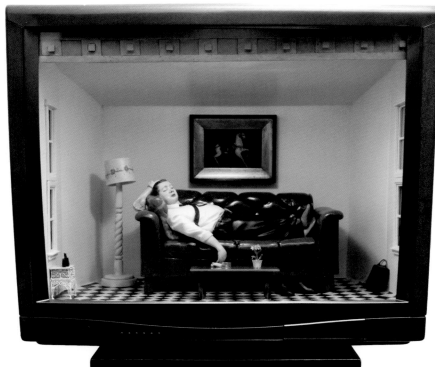

BREAKTIME
fiberglass/resin,
polyurethane paint, 2010

In the preface of his landmark book, "After the End of Art: Contemporary Art and the Pale of History", the philosopher and art critic Arthur Danto makes an interesting reference to an artwork by David Reed, whose installation appeared at Cologne's Kölnischer Kunstverein.

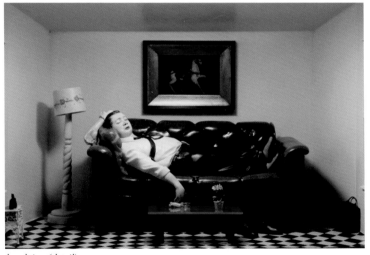

breaktime (detail)

The installation consisted of a bed set against a wall, a painting hanging above the bed, and a television set that played a looped video. The video was a clip from Alfred Hitchcock's 1958 film "Vertigo" where Judy, the character played by the actress Kim Novak, reveals her true identity to her lover in a hotel room. The setting in itself is unremarkable until the viewer realizes that Reed has replaced the nondescript painting in the video with one of his own – the same painting hanging over the bed in the installation. Here, it becomes clear that the installation is a recreation of the setting of the video clip, and that the painting has in fact taken on two modes of existence – what Danto refers to as "formal and objective reality, existing...as image and reality....occup[ying] the space of the viewer and the fictive space of a character in the movie."

This reference is significant in light of how it elucidates the disjuncture between modernism, which seeks to present the object as the epicenter of the aesthetic experience – "the purity of the medium being its defining agenda" – and contemporary art, which asks viewers to believe that anything goes and everything is possible.

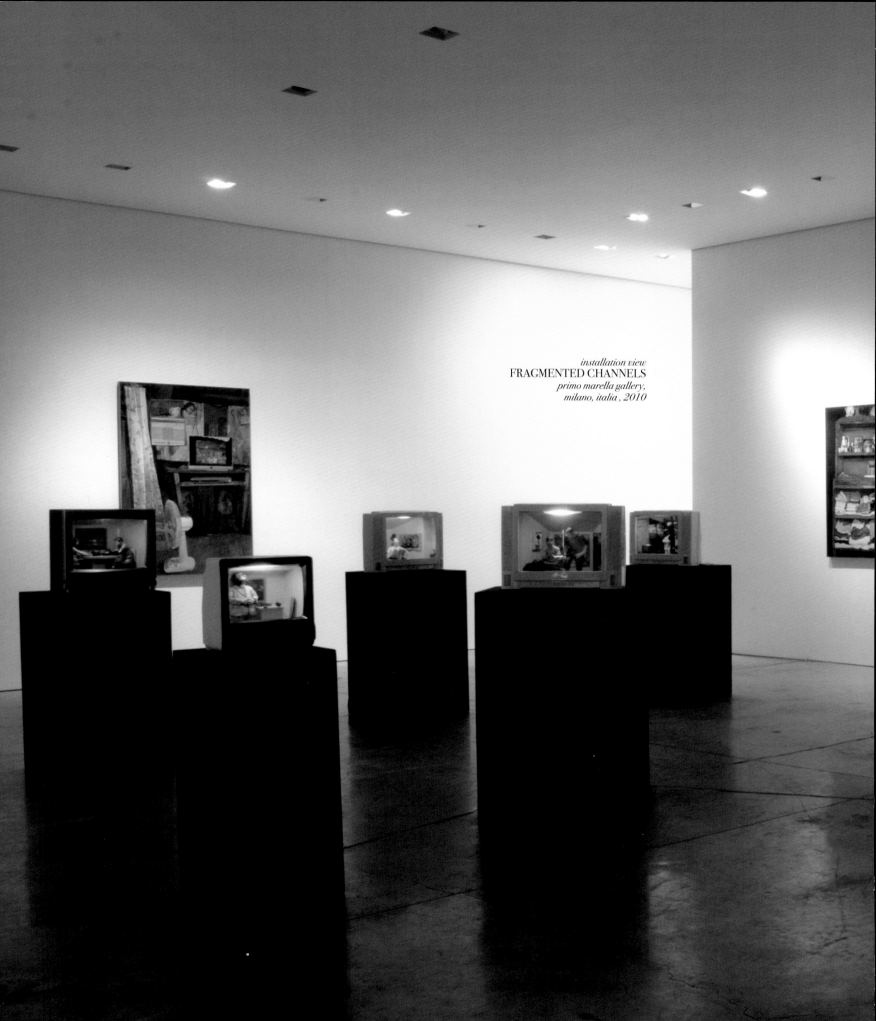

installation view
FRAGMENTED CHANNELS
primo marella gallery,
milano, italia , 2010

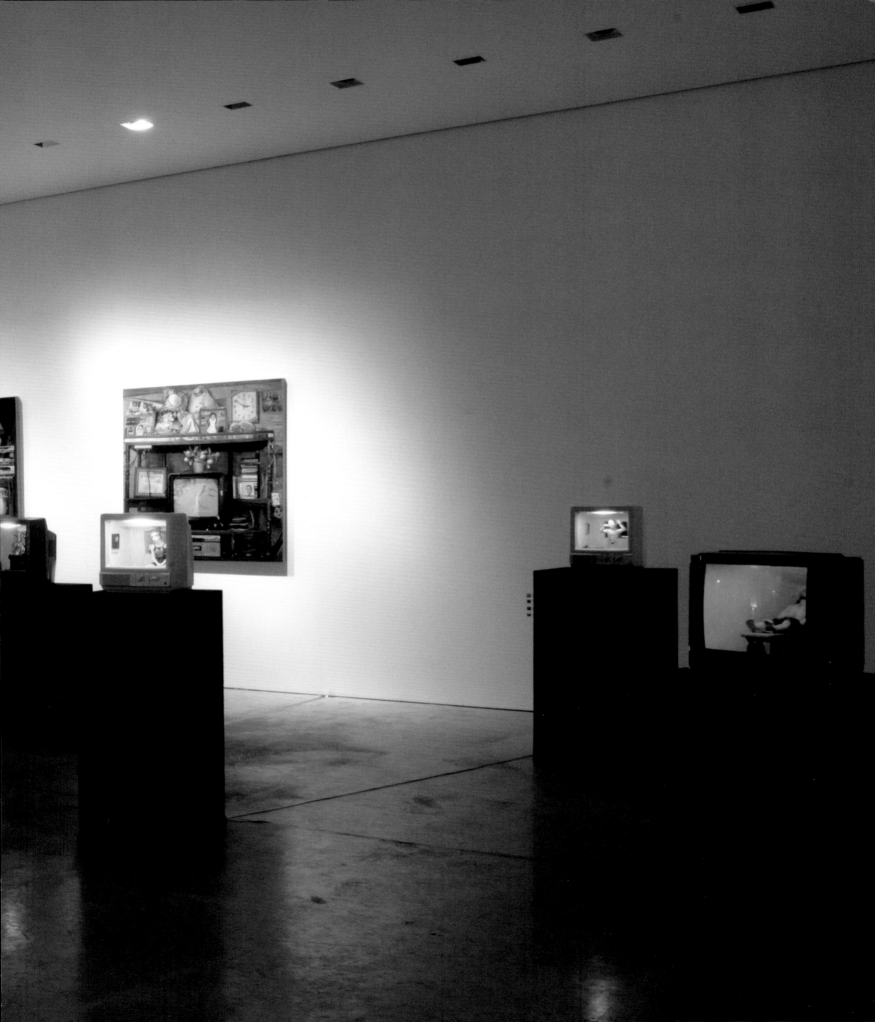

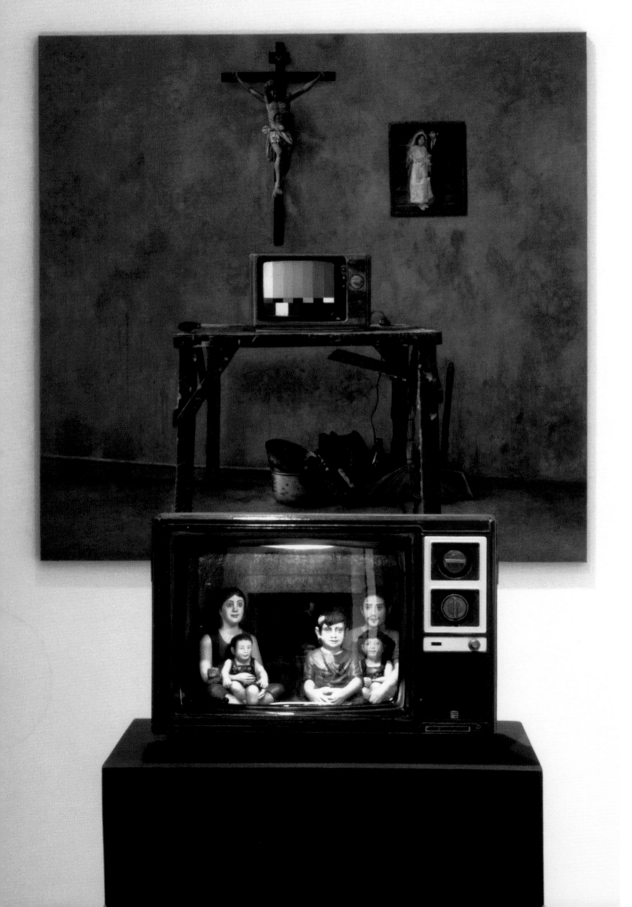

"Fragmented Channels" is the crystallization of the open-ended branching-out

3 O'CLOCK HABIT
polyurethane pant, 2010

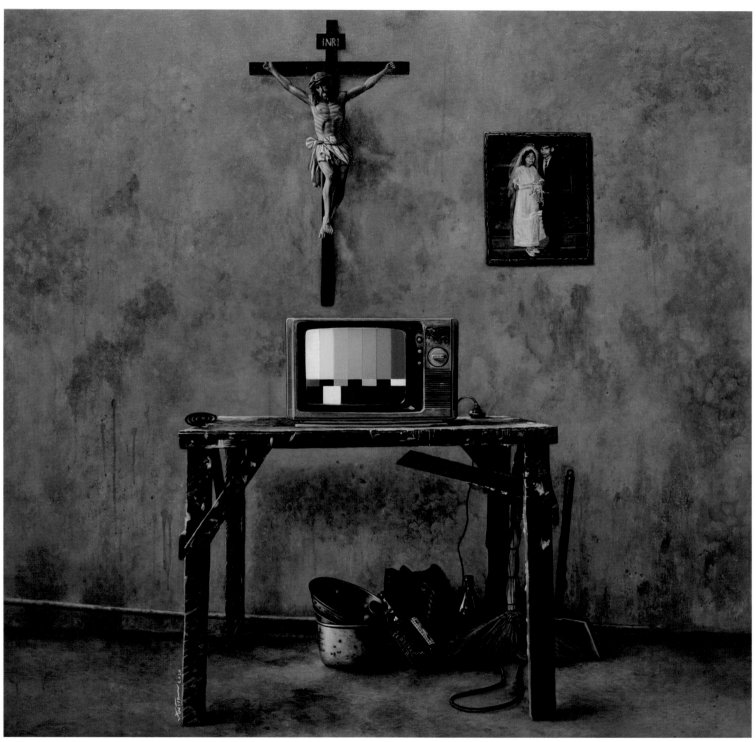

ALTAR
152 x 152 cm
oil on canvas, 2010

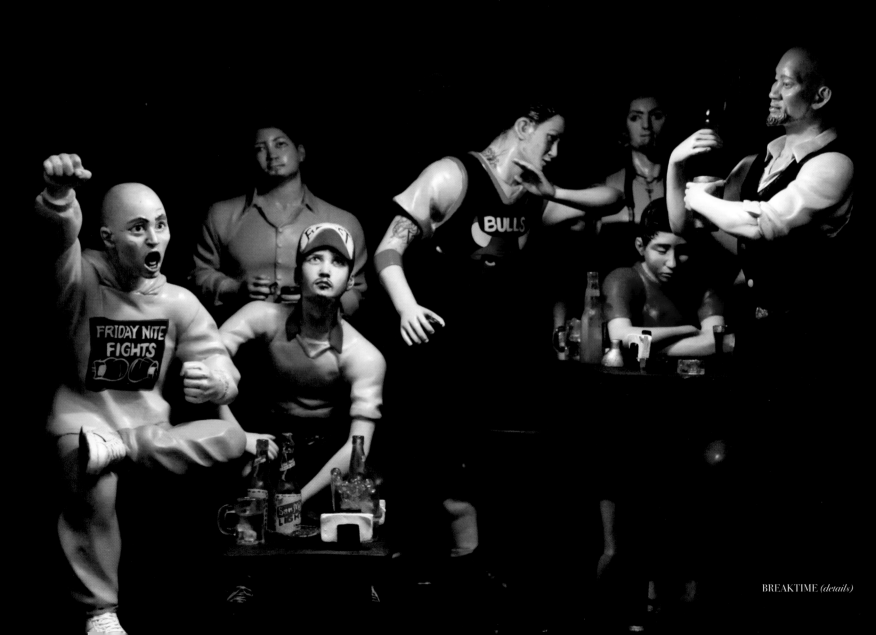

BREAKTIME *(details)*

Here, Danto sees Reed taking the position of the artist who has moved away from relying solely on one medium to bring his message across, "situat[ing] [his] paintings by means of devices which belong to altogether different media - sculpture, video, film, installation."

In many ways, Reed's work is analogous to that of the Filipino visual artist Ronald Ventura, whose creative trajectory shows the influence of multifarious sources that form complex thematic interstices. In the span of a decade, Ventura has employed various channels to reveal his fetishistic preoccupation with disfigurement, the macabre and the undead; Platonic notions of beauty, embodied by his anatomically precise alabaster renderings of the human figure and his madly neo-classical conceits of elasticity, light and material; and much later, the eye-boggling amalgam of body parts, toys, droids, pop icon figures, and graffiti for which he has come to be known in auction sale rooms throughout the region.

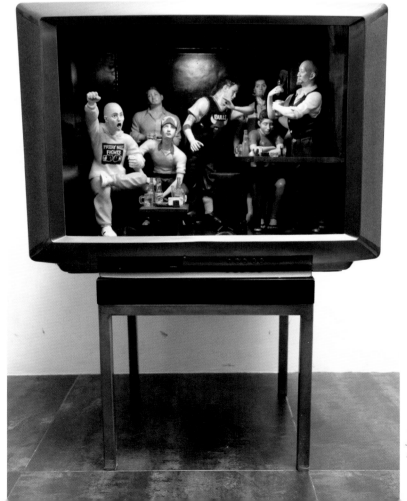

FIGHT CLUB
*fiber glass/resin,
polyurethane paint, 2010*

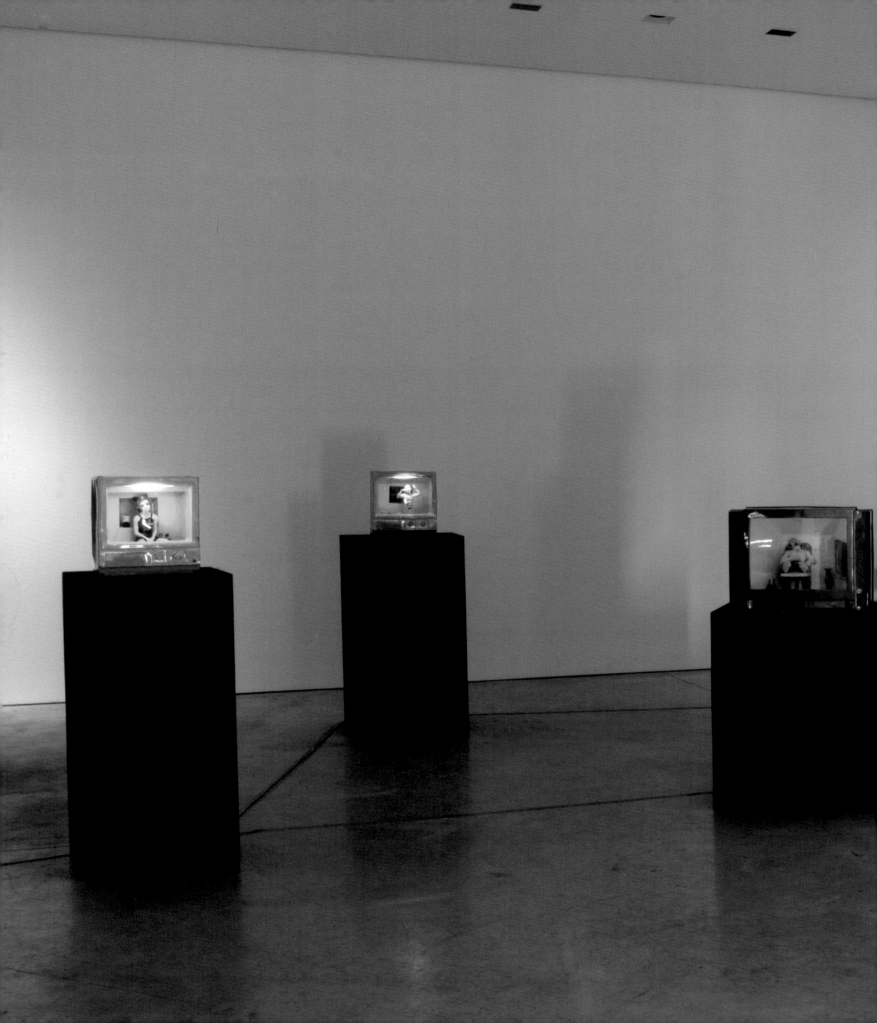

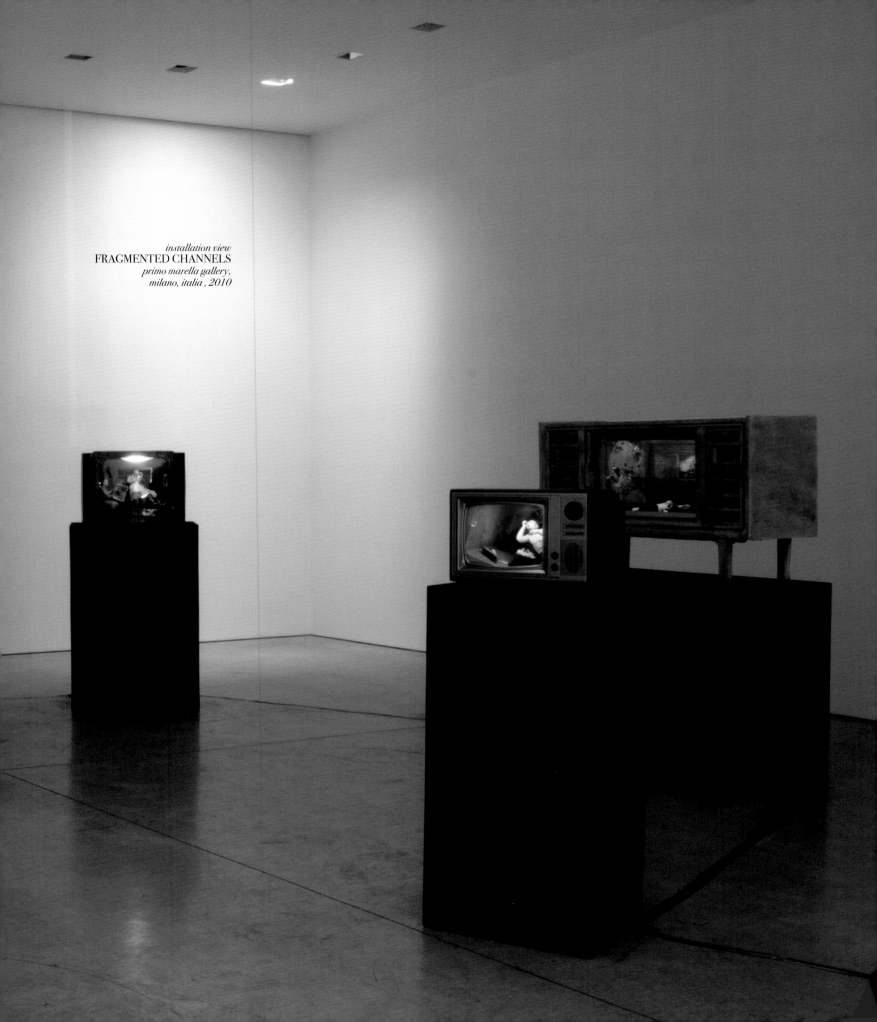

installation view
FRAGMENTED CHANNELS
primo marella gallery,
milano, italia , 2010

Ventura's aesthetic devices have trail blazed the collective consciousness

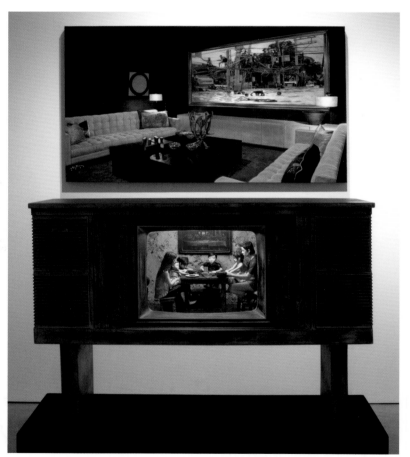

Clearly, Ventura's aesthetic devices have trail blazed the collective consciousness, moving from the explicitness and instantaneous response required by the hedonism and sexuality of his earlier work to the more implicit yet still seething restlessness that he manifests today. His current output is, therefore, startling in the sense that it marks what I consider to be a turning point in the professional life of the artist, a truly positive development in a career that has thus far been defined not so much by an overriding thematic thread, but rather by "bursts of energy" - perhaps the best way to describe magnum opuses such as "Blancher Pink" (2003) in the Paulino and Hetty Que collection; the monumental "Human Study" (2005), the Ateneo Art Award winning piece that cemented Ventura's reputation; and his more recent "Appetite" (2008) from the National University of Singapore show "Mapping the Corporeal" and "Framed" (2009).

"Fragmented Channels" is, in my opinion, the crystallization of the open-ended branching-out that has informed Ventura's work thus far, seeing that it brings together the qualities for which he is best known: technical skill and critical insight. More importantly, this exhibition situates the artist at the crux of the contemporary art movement through the sense of ease that he displays in presenting his ideas via multiple platforms. Unhampered by convention, a freedom that also clearly comes from attaining his level of success, Ventura brings together his paintings (and in them, the images that have become his leitmotifs) and resin sculptures to create assemblages: a series of television sets where scenes of solitude - recreations of life episodes - are hermetically enclosed.

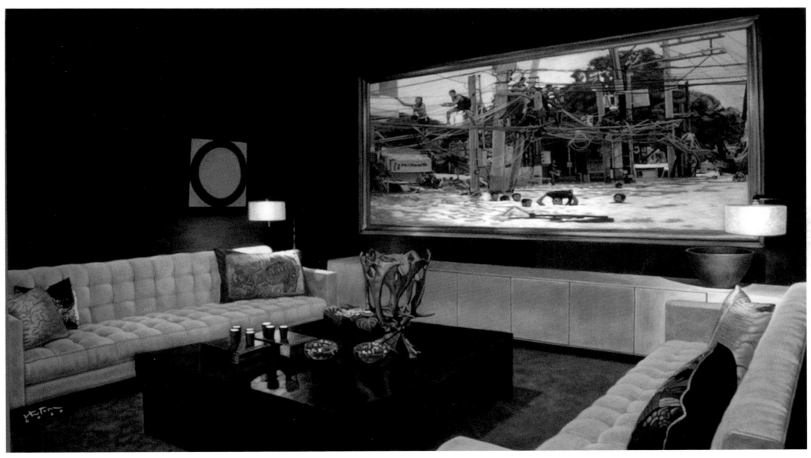

HOME THEATHER (1)
106,5 x 152 cm
oil on canvas, 2010

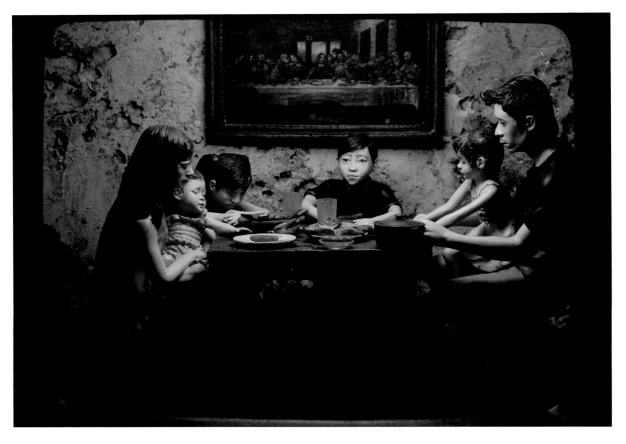

SUPPER (Details)
fiber glass/resin,
polyurethane paint, 2010

SOLITUDE (2)
*fiber glass/resin,
polyurethane paint, 2010*

BREAKING NEWS
*fiber glass/resin,
polyurethane paint, 2010*

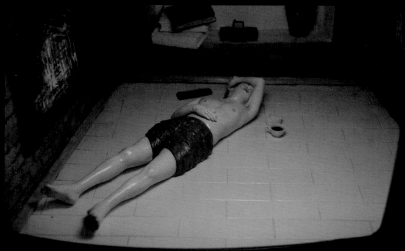

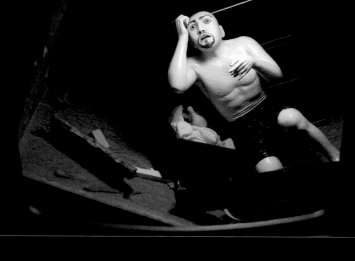

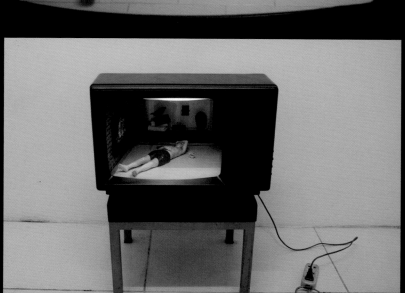

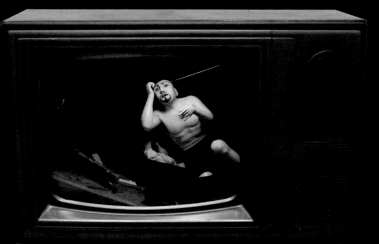

The works hearken to historical dioramas (such as those exhibited at the Ayala Museum in Makati City) but by their very presentation in reconfigured or molded outmoded casings negate the intrinsic power of their usual conveyance. In place of figures or events of import, the artist has instead populated the medium with quotidian characters, many of them taken from photographs of family members of workers in his studio, in situations at times comical enough to elicit a guffaw as in the case of the damsel desperately pursuing pulchritude in "Beauty Remedy" and the tattooed toughie and fellow macho types in "Kwentong Barbero" (Barber's Tale) girdled by walls plastered with girlie magazines. Other works such as "Sponsor" and "Animae" are more symbol than vivification, metaphors of greed and despair. For the most part, one observes a palpable mapping of the bleakness of the human condition, as in the girl who nauseatingly enucleates herself in a wretched attempt for attention in "Parental Guidance", the poignant unraveling of a relationship in "Sunset Drama" and, by extension, a sad reckoning of Third World living conditions such as the six members of a family forced to partake of a meager repast in a flooded dining room graced by Da Vinci's "Last Supper".

Three pieces in particular reflect back to the viewer the question of the gaze, and the existential conundrum of the familial and economic parameters by which society operates. In "Amusement", a young boy flanked by another figure sits transfixed in front of what one assumes to be a television playing a video game, the walls around him cheekily featuring what could be readily identify as Ventura paintings. Another assemblage shows a maidservant taking a break from her chores, furtively getting her daily soap opera fix, the romantic nature of the program symbolized by the black and white painting of Cupid and Psyche. Perhaps most disturbing are the zombie-like family members in "3 O'Clock Habit" who sit cross-legged in front of their idiot box, the title of the work a reference to a novena, but in this case an

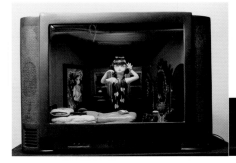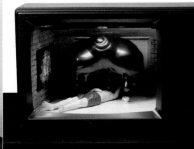

ANIME FEVER
fiber glass/resin, polyurethane paint, 2010

SOLITUDE (3)

A series of television sets where scenes of solitude

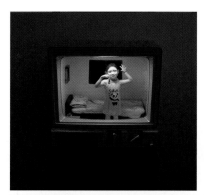

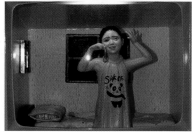

PARENTAL GUIDANCE (RATED PG)
fiber glass/resin,
polyurethane paint, 2010

evocative display of the worshipful reverence accorded to media and technology.

The set of paintings which form part of this exhibition are not to be seen simply as backdrops, but rather serve as counterpoints to the artist's sculptural exegeses. All are monochrome, save for one work, a rendering of a sumptuously appointed lounge done in full color. What is most surprising about these works is that they are, unique among Ventura's body of work, bereft of human figures. This is not to say that the spaces are unlived - for from it, one could sense that the images go beyond depiction and bear the hallmarks of trace. The domestic set-ups vary, yet all contain televisions that have been left switched on. Again, one spots the difference: the television sets shown are all old, cathode-ray models, save for the fashionable wide screen LCD television hanging on one wall of the posh interior. Closer inspection reveals that the pictures being shown in the aging televisions are innocuous: TV color bars, cloying commercials, felicitous news features. The post-cathode screen, on the other hand, contains a harrowing image of the desperation of people caught in the midst of the great flood that devastated the Philippine capital Manila last year.

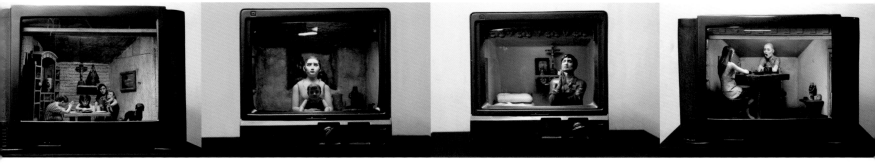

HABITUAL HOUR **3 MOTHER OF DRAMA** **WIN OR LOSE** **DRAMA KING**

recreations of life episodes – are hermetically enclosed

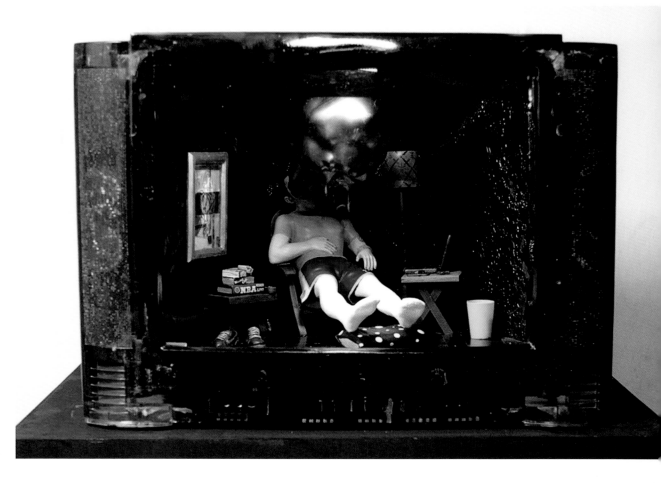

SOLITUDE (1)
*fiber glass/resin,
polyurethane paint, 2010*

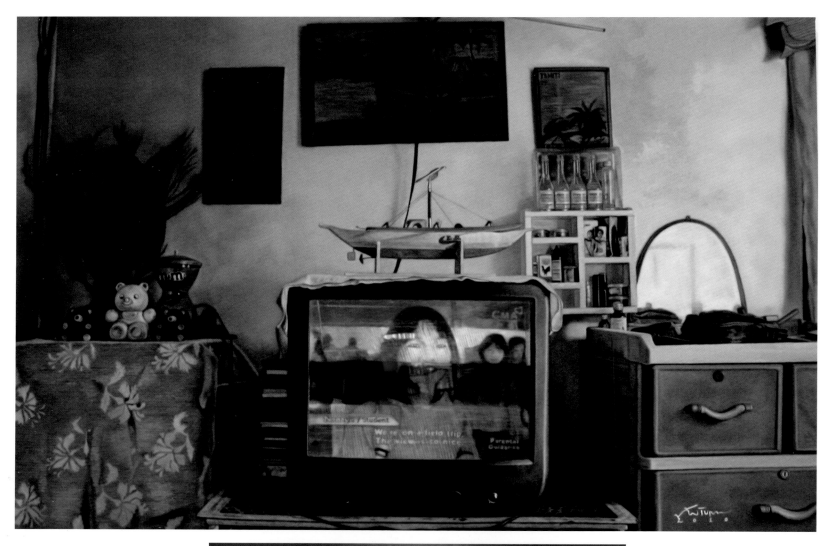

WAVES
122 x 182 cm
oil on canvas, 2010

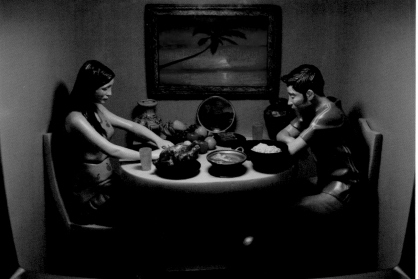

SUNSET DRAMA *(details)*

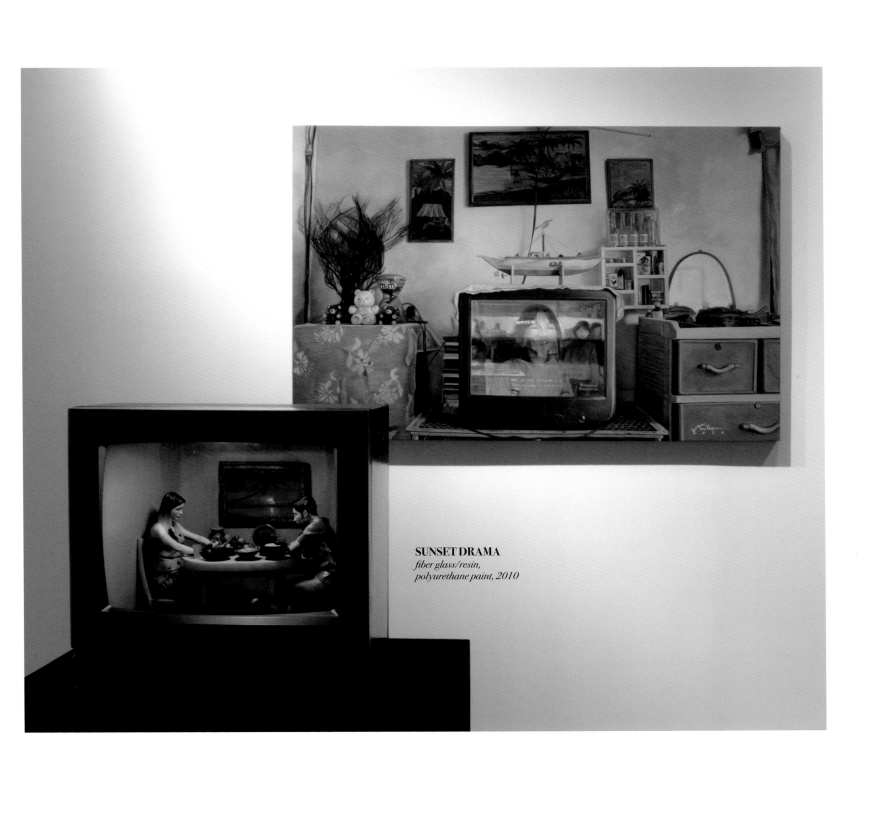

SUNSET DRAMA
fiber glass/resin,
polyurethane paint, 2010

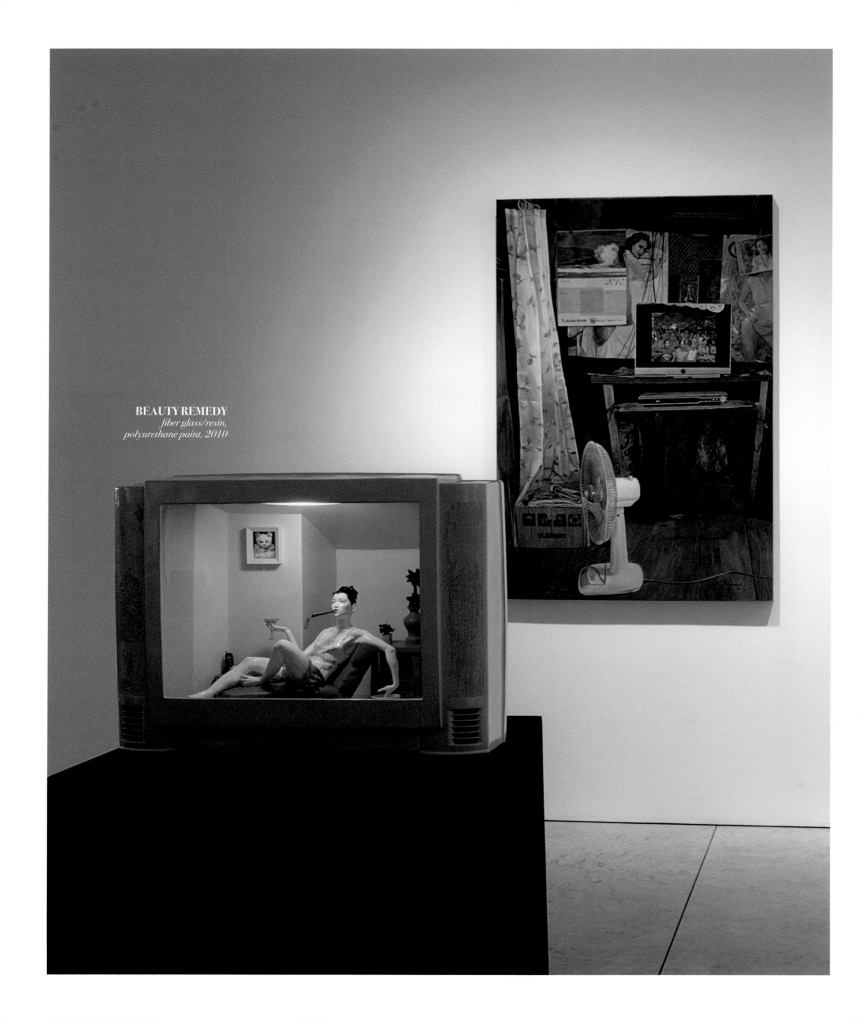

BEAUTY REMEDY
fiber glass/resin,
polyurethane paint, 2010

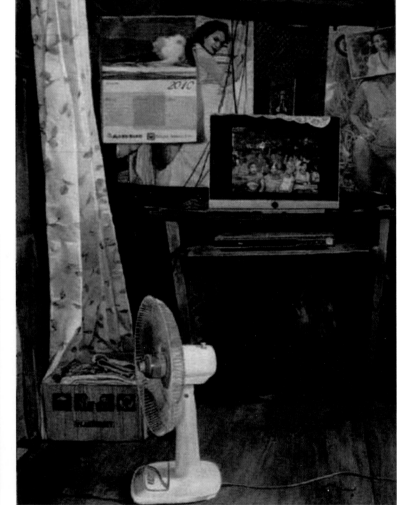

NOON TIME
oil on canvas, 2010

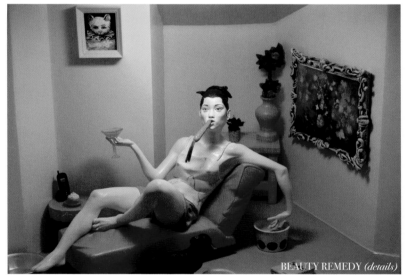

BEAUTY REMEDY *(details)*

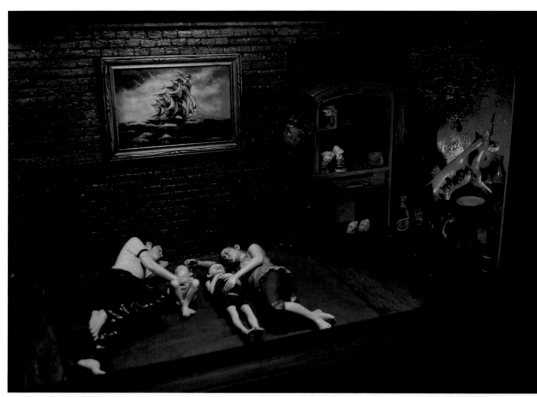

HOME THEATER
fiber glass/resin,
polyurethane paint, 2010

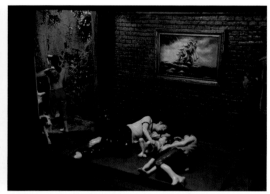

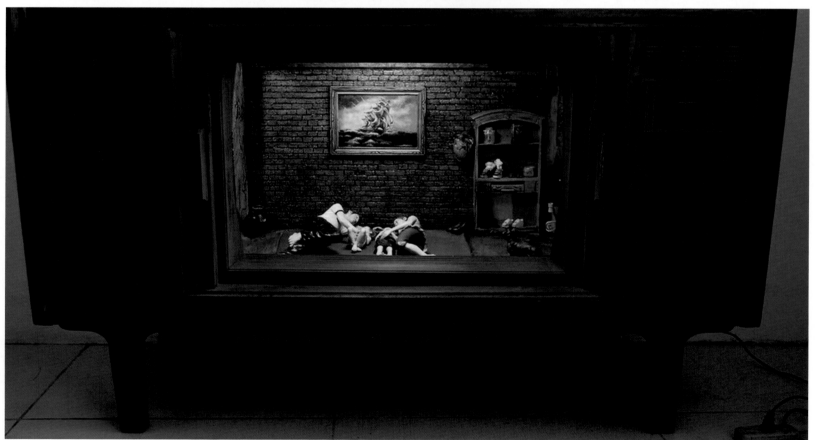

It elucidates the disjuncture between modernism and contemporary art

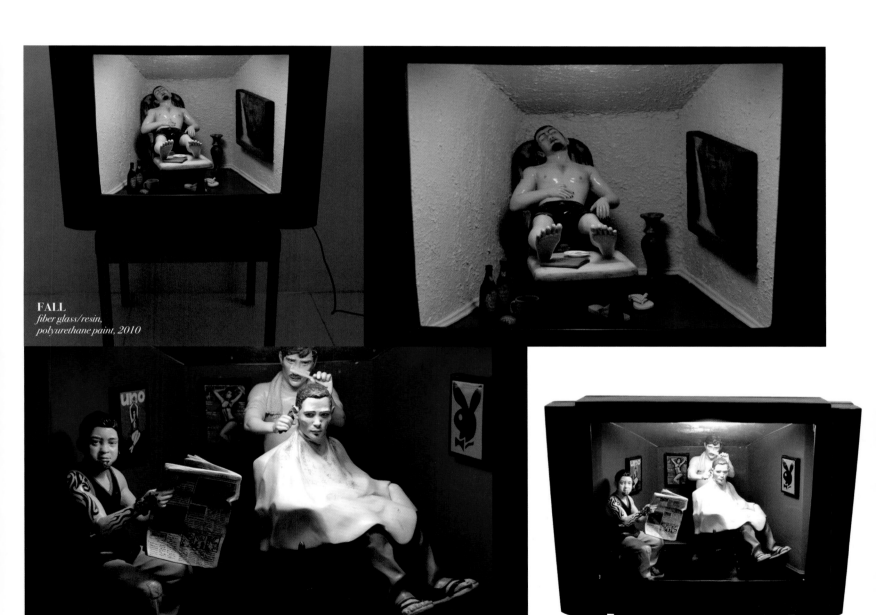

FALL
*fiber glass/resin,
polyurethane paint, 2010*

**KWENTONG BARBERO
(BARBER'S STORY)**
*fiber glass/resin,
polyurethane paint, 2010*

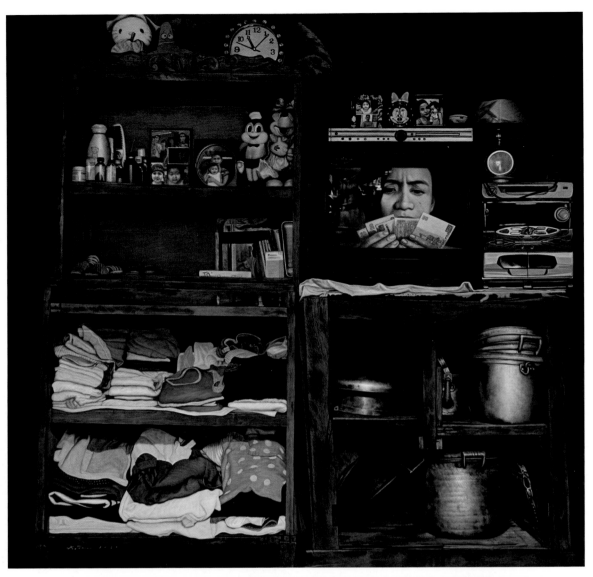

TREASURE (1)
152 x 152 cm
oil on canvas, 2010

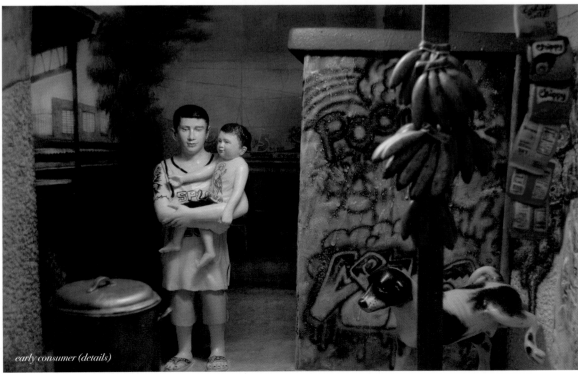

early consumer (details)

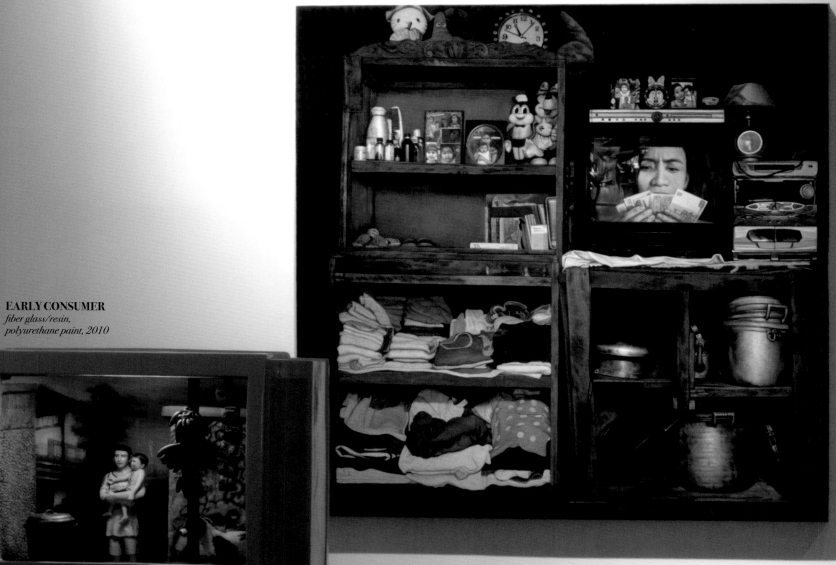

EARLY CONSUMER
fiber glass/resin,
polyurethane paint, 2010

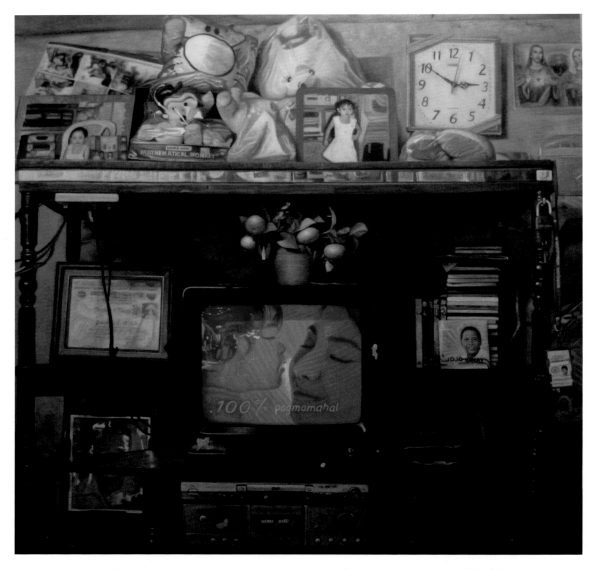

TREASURE (2)
152 x 152 cm
oil on canvas, 2010

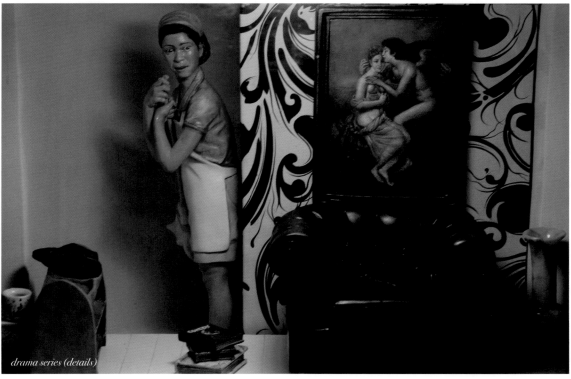

drama series (details)

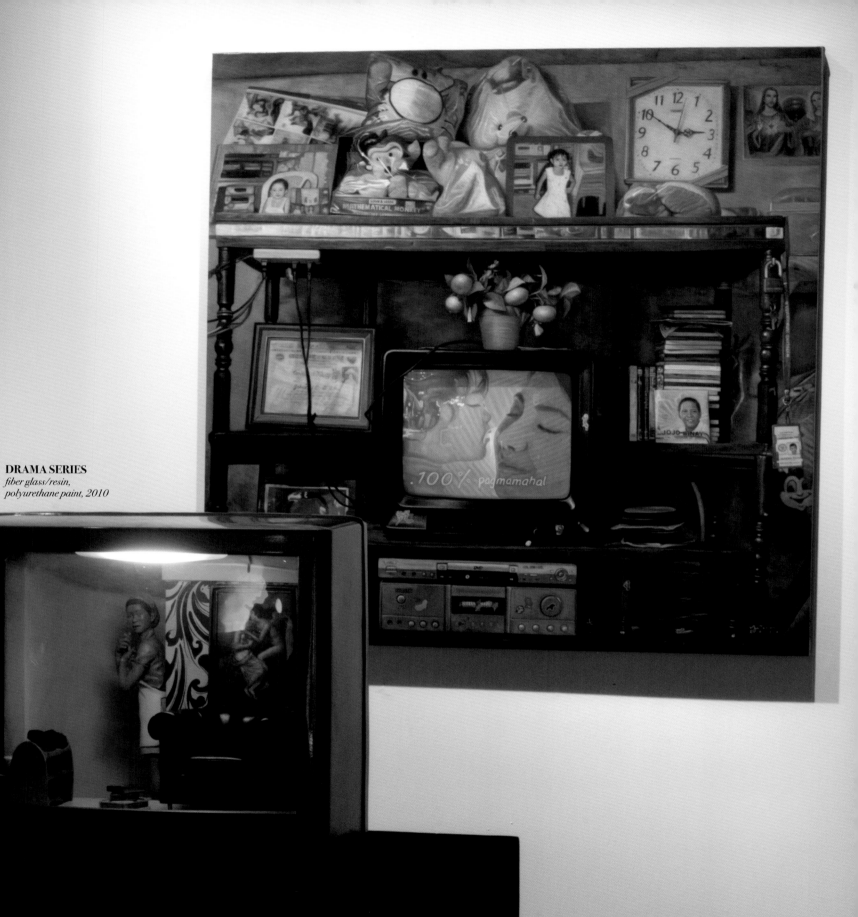

DRAMA SERIES
*fiber glass/resin,
polyurethane paint, 2010*

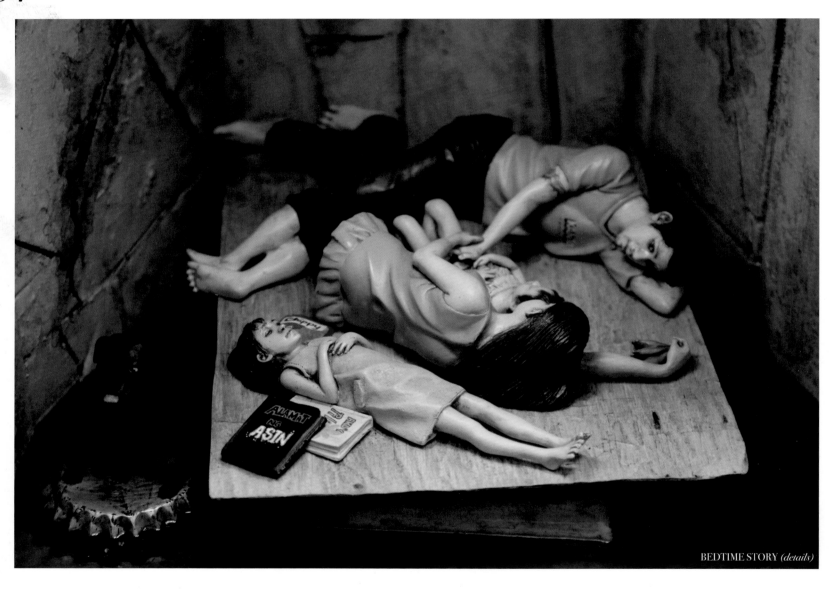

BEDTIME STORY *(details)*

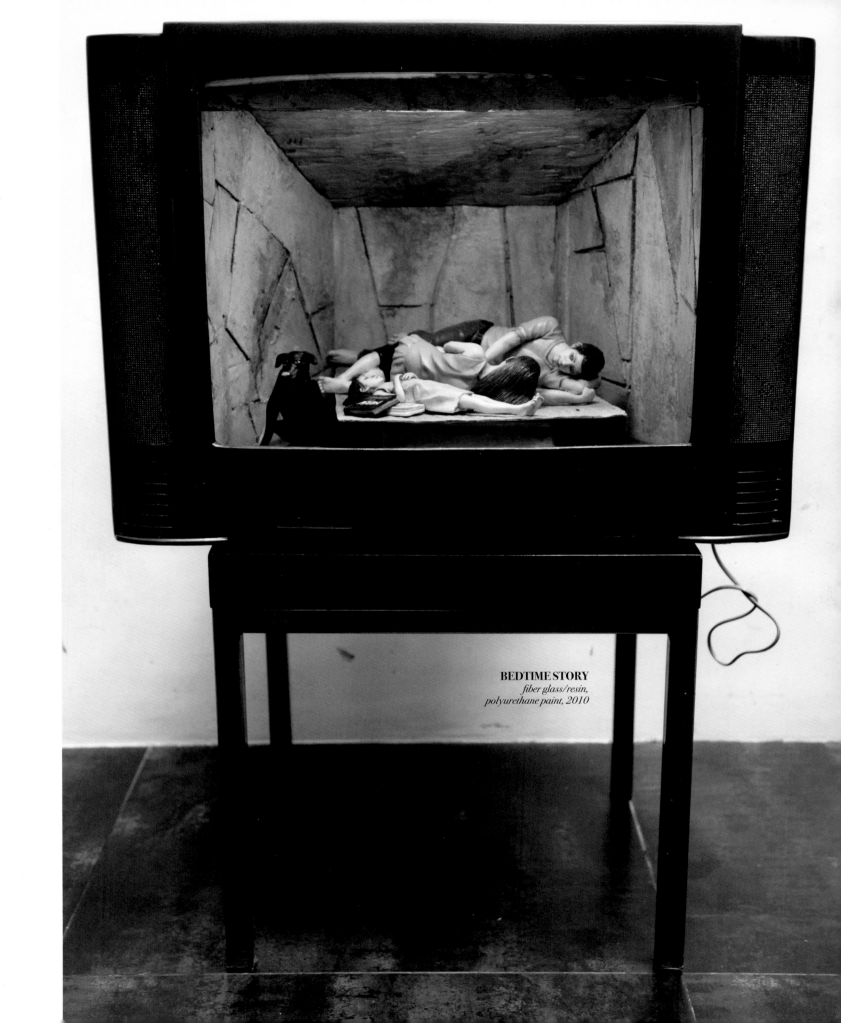

BEDTIME STORY
fiber glass/resin,
polyurethane paint, 2010

When seen together, there is a sense of how "Fragmented Channels" switches the perception of viewers where, much like in Reed's installation, the subject looks at the object

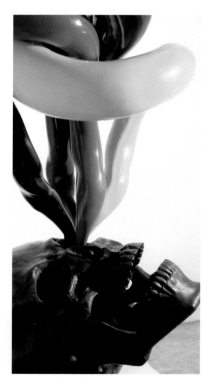

When seen together, there is a sense of how "Fragmented Channels" switches the perception of viewers where, much like in Reed's installation, the subject looks at the object, and the object in turn looks back at the subject who also turns out to be the object. It is in this shifting of frameworks that the art of Ronald Ventura ventures beyond the analog transmission of straightforward narrative - concluding in the end-of-episode pale of history referred to by Danto - to embark upon a new course that is at once perplexing in its speculation as it is digitally brilliant, connected and altogether unexpected.

Ramon E.S. Lerma is Director and Chief Curator of the Ateneo Art Gallery, and the founder of the Ateneo Art Awards.

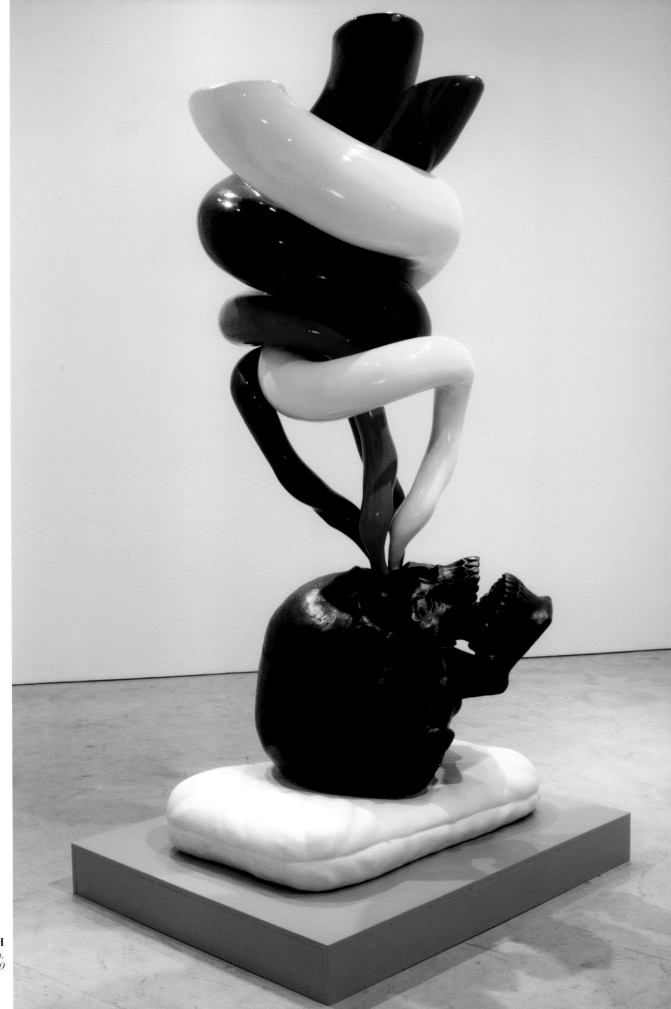

VISION OF DEATH
fiber glass/resin,
polyurethane paint, 2010

Biography

RONALD VENTURA

Born 1973 in Manila, Philippines. Lives and works in Manila.

EDUCATION
1993 B.F.A. in Painting, University of Sto. Tomas, Manila.

SOLO EXHIBITIONS
2011 *Thousand Islands*, Tyler Rollins Fine Art, New York, USA
2010 *Converging Nature*, The Drawing Room, Makati City, Phillipines
 Fragmented Channels, Primo Marella Gallery, Milan, Italy
2009 *Metaphysics of Skin*, Tyler Rollins Fine Art, New York, USA
 Major Highways, Expressways and Principal Arterials, Ark Galerie, Jakarta, Indonesia
2008 *Mapping The Corporeal*, Museum of the National University of Singapore
 Zoomanities, The Art Center Megamall, Mandaluyong City, Philippines.
2007 *Illusions & Boundaries*, The Drawing Room, Makati City, Philippines.
 Under The Rainbow, West Gallery Megamall, Mandaluyong City, Philippines.
 Antipode, The Human Side, Artist Residency, Artesan, Singapore.
2006 *Cross Encounter*, Ateneo Art Gallery, Quezon City, Philippines.
 Dialogue Box, West Gallery Megamall, Mandaluyong City, Philippines.
2005 *Human Study*, The Cross Art Projects, Sydney, Australia.
 Morph, West Gallery Megamall, Mandaluyong City, Philippines.
 Human Study, The Art Center Megamall, Mandaluyong City, Philippines.
2004 *Dead-End Images*, The Art Center Megamall, Mandaluyong City, Philippines.
 Black Caricature, Big & Small Art Co., Megamall, Mandaluyong City, Philippines.
 Contrived Desires, West Gallery Megamall, Mandaluyong City, Philippines.
2003 *X-Squared*, West Gallery Megamall, Mandaluyong City, Philippines.
2002 *Visual Defects*, West Gallery Megamall, Mandaluyong City, Philippines.
 Body, The Drawing Room, Makati City, Philippines.
2001 *The Other Side*, The Drawing Room, Makati City, Philippines.
2000 *Innerscapes*, West Gallery Megamall, Mandaluyong City, Philippines.
 All Souls Day, The Drawing Room, Makati City, Philippines.

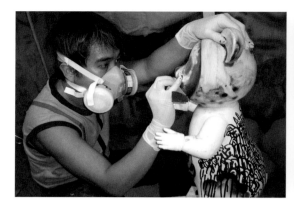 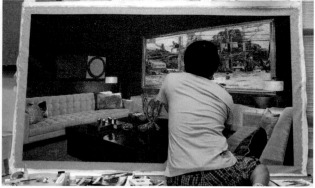

GROUP EXHIBITIONS

2011 *Surreal vs. Surrealism*, Ivam Museum, Valencia Spain
2010 *A Duad at Play: Francis Ng & Ronald Ventura*, Lasalle College of the Arts, Singapore
2009 *South East B(l)ooming*, Prague Biennal 4, Czech Republic
 Post-Tsunami Art, South East B(l)ooming, Primo Marella Gallery, Milan, Italy
2008 *Filipino Art Exhibition*, Singapore Art Museum
 Asian Sculpture Exhibition, OITA Japan.
2005 *Cross Encounters: The 2005 Ateneo Art Awards Exhibition*, Power Plant Mall Rockwell Center, Makati
 City, Philippines.
2004 *Korea Asian Art Festival*, Inza Plaza, Seoul, South Korea.
 19th Asian International Art Exhibition, Fukuoka Asian Art Museum, Japan.
2003 *13 Artists Awards Exhibition*, Main Gallery, Bulwagang Juan Luna, Cultural Center of the Philippines,
 Pasay City, Philippines.
2002 *Philip Morris Asean Art Awards*, Nusa Dua, Bali Indonesia.
 Soft: Tresacidos, Art Center, SM Cebu, Philippines.
2001 *The 8th Annual Filipino-American Arts Exposition*, Yerba Buena Center for the Arts,
 San Francisco, California.
 Tresacidos: Small Works, The Enterprise Center, Makati City, Philippines.
2000 *Guhit I, II & III*, Ayala Museum III; Museum
 Espana; Jorge B. Vargas Museum, University of Philippines.
 Mad About Lithographs, Ayala Museum, Makati City, Philippines.
1999 *Philip Morris Asean Art exhibit*, Hanoi, Vietnam.
 9th International Biennal Print and Drawing Exhibit, Taipei, Taiwan.
1998 *1st Lithograph Competition Exhibition*, The Drawing Room, Makati City, Philippines.

SELECTED AWARDS & CITATIONS

2008 Award of Excellence by the 8th OITA Asian Sculpture Exhibition
 Open Competition 2008, Japan
2007 Artist in Residence, Artesan Gallery + Studio, Singapore
2005 Winner, ATENEO ART AWARDS & Recipient, Ateneo Art Gallery Studio
 Residency Grant, Sydney, Australia
2003 Thirteen Artists award, Cultural Center of The Philippines
2003 Juror's Choice Award, Philip Morris Philippine Art Awards
2001 Artist of the Year, Art Manila Newspaper
2000 Finalist, Philip Morris Philippine Art Awards
2000 Finalist, Taiwan International Biennale Print and Drawing Competition
1999 Finalist, Taiwan International Biennale Print and Drawing Competition
1999 Jurors' Choice awards, Windsor & Newton Painting Competition
1998 First Place, Lithograph Competition National Commission for Culture & Arts 1998
 Jurors' Choice Award, Philippine Philip Morris Art Award
1993 Jurors' Choice Awards, Art Association of the Philippines Art Competition
1990 First Place, Shell National Students Art Competition

Acknowledgments

A special thanks to:
Miguel Rosales for his professionalism and
for his great and irreplaceable help

All the collectors who have been following Ronald Ventura
since the beginning of our collaboration and
have been pivotal for this book:
Jim Amberson
Alfredo Bona
Giancarlo Belluzzi
Gabriele Burato
Kenneth Choe
Marcel Crespo
Francesco Giovanelli
Paolo Mollo
Marino & Paola Golinelli
Howard Tam
Umberto & Samanta Vitiello
Ruggero Fiorini & Rebecca Russo
Brian Villanueva

Primo Marella Gallery Milan:
Livia Facchetti
Elena Micheletti
Ruggero Ruggieri
Elisa Tumminello

For the design of this book:
PUSH Associates, Inc.

Prepress:
Lorenzo Tugnoli